1950s Radio *in Color*

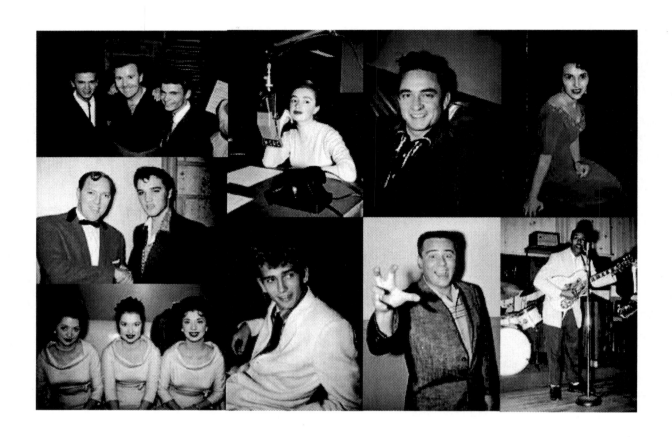

Christopher Kennedy

The Kent State University Press Kent, Ohio

1950s Radio in Color

The Lost Photographs of Deejay Tommy Edwards

© 2011 by Christopher Kennedy
All rights reserved
Library of Congress Catalog Card Number 2010035839
ISBN 978-1-60635-072-0
Manufatured in China

Library of Congress Cataloging-in-Publication Data
Kennedy, Christopher, 1967 Aug. 9–
1950s radio in color : the lost photographs of deejay Tommy Edwards / Christopher Kennedy.
 p. cm.
Includes index.
ISBN 978-1-60635-072-0 (hardcover : alk. paper) ∞
1. Edwards, Tommy, 1921–1981. 2. Rock music—Ohio—Cleveland—Pictorial works. 3. Rock musi-
cians—Ohio—Cleveland—Pictorial works. I. Title.
ML3534.3.K46 2011
781.6609771'32—dc22 2010035839

British Library Cataloging-in-Publication data are available.

15 14 13 12 11 5 4 3 2 1

For Keith

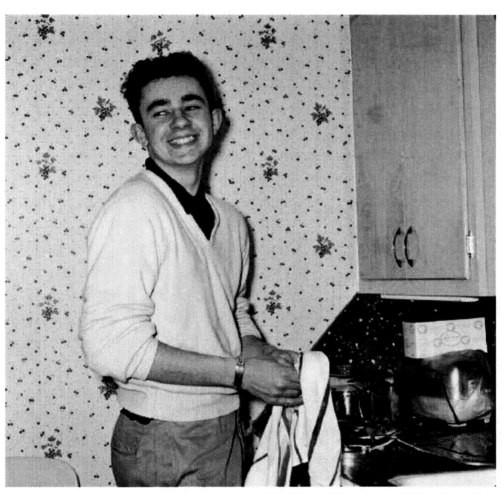

Keith Winters, fifteen years old, Uncle Tommy's house, 8025 Parmenter Drive, Parma, Ohio, July 1954

Contents

Foreword Terry Stewart

. .

In the early days of the music that was first christened here as rock 'n' roll, Cleveland was blessed with a bevy of groundbreaking disc jockeys, including Alan Freed, Bill Randle, and Tommy Edwards. Each moved the needle, so to speak, for various reasons: Freed blazed the way for so many artists and jocks and became the first publicly acclaimed king of rock 'n' roll; Randle broke and produced many records, introduced Elvis for the first time on national TV, and helped create the concept of white cover records; and, finally, Tommy Edwards owned a prominent record store, made records himself, and is credited with bringing Elvis to Cleveland for his first gig north of the Mason-Dixon Line.

In this pantheon, Tommy is often the forgotten one. With this tome, Chris Kennedy will go a long way in making sure that his legacy is never lost again.

Everyone has seen the famous photo of Elvis and Bill Haley together for the first and maybe only time. Few know that the photographer was Tommy Edwards. Bill Randle produced this legendary show at Brooklyn High School in a suburb of Cleveland. The lineup was unprecedented then and now, with Pat Boone headlining, complemented by Bill Haley and the Comets, the Four Lads, Priscilla Wright, and a largely unknown Elvis. To top it off, the show was filmed in Technicolor.

This mythical hour or so of celluloid film, *The Pied Piper,* was Bill's attempt to capture a day in his life with the biggest musical stars of the day. The film remains the Holy Grail of rock 'n' roll, sought by crusading sleuths for over five decades, including the ingenious and assiduous Chris Kennedy. In fact, while writing this foreword, I couldn't help but think of one of my favorite Leiber-Stoller compositions, "Searchin'," with Chris playing the multiple roles of Bull Dog Drummond, Charlie Chan, and Boston Blackie.

I wish I could report that Chris has found *The Pied Piper.* Unfortunately, that's not the case, but it doesn't mean he won't someday. What he has done is uncovered another mother lode and brought back to life the glorious archive of color photos taken by Tommy Edwards over a five-year period at the height of his prominence. These color shots truly run the gamut of Tommy's sphere of influence: country, pop, and, most important, rock 'n' roll. In addition, he has buttressed these images with Tommy's own descriptions of what was going on behind the scenes, as taken from the weekly "T.E. Newsletter."

All I can say is "Wow!" So dive in and experience a time capsule of a period when rock 'n' roll first started to change the world, while en route to becoming one of the most powerful art forms of all time.

Rock and Roll Hall of Fame and Museum
Cleveland, Ohio

Preface Discoveries

· ·

I've got pictures of almost everybody that came through Cleveland. The reason I was taking these color slides was I was taking them along to record hops and I was showing them at intermission. I brought my own screen along or if it was in a nice place where they had a big blank wall I'd project them on the wall, twelve feet high. Can you imagine? At that time color TV wasn't here, these kids had never seen pictures of their favorite artists in color. But could you imagine when I showed the pictures of Presley or when I showed the pictures of Pat Boone or any of the other current top pop favorites? Why, they'd go crazy. There'd be a lot of mumbling by the kids when I'd say we're gonna have a little intermission here, we're gonna show you some slides, have a big slideshow. They'd say nah, we don't want to see any damn slides, we wanna go on dancing, ya know. The minute I flashed that first picture on the screen, they were mine.

—Tommy Edwards interviewed by Rick Whitesell, January 1981

The photographs you hold in your hands and stories they tell are the most personal, comprehensive, and visually thrilling account of the five years that encompass the rise, reign, and fall of rock 'n' roll's first wave. A great number of things happened, both on purpose and accidentally, to make their discovery and this book a reality.

First of all, before anything, my father exposed me to the sound that would fuel my passion and appreciation for all forms of music and inspire me to become a musician. One lazy Sunday afternoon back in my young buck days, I was called into the

den and asked if I wanted to hear "something good." As my dad and I sat on the floor, the record player's clunky needle scratched down on an orange-labeled disc. A somber acoustic guitar followed by a scary cello introduced me to a song called "In the Ghetto." I heard something incredibly powerful, and I've been a fan of Elvis Presley's music ever since.

The aftershocks of this little episode between father and son are being felt today as I look back on a successful recording career and across the room at my guitar, patiently waiting for whatever's next. For inspiration, I often to turn to my record

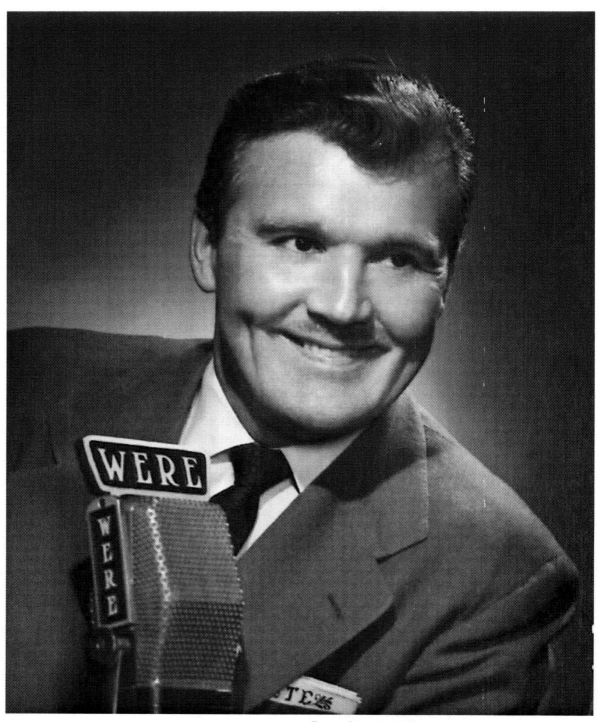

Tommy Edwards, 1957

collection, which over time has grown to include a wide variety of artists, many of whom are found within these pages.

Fast forward to July 9, 2004. I learn that legendary Cleveland deejay Bill Randle has passed away. I'm reminded of his 1955 movie short, *The Pied Piper of Cleveland,* which costarred a pre-fame, untamed Elvis and the fact that it has never been seen. Spurred on by simple curiosity, I'm determined to either find the film or at least unravel its mysteries.

By November 2006, my research has yielded some exciting discoveries and I've debunked many of the myths that shroud *The Pied Piper,* though I have yet to find the film. The investigation turns to Tommy Edwards (born Thomas Edward Mull), a deejay at WERE-AM in Cleveland who worked alongside Randle. The two talented and ambitious men shared the station's hallways, but that's about all. Their relationship was one of intense competitive rivalry, with Edwards's undemonstrative efficiency often clashing with Randle's perceived intellectual snobbery. More succinctly, they hated each other with a passion, according to WERE overnight jock Carl Reese. Whatever animosity may have existed between them, Randle did invite Edwards to make a cameo appearance in *The Pied Piper,* crediting him as being the first deejay in Cleveland to recognize and promote the talents of Elvis Presley. It's Edwards's color photograph of Bill Haley and Elvis taken backstage on the day of shooting that most people are familiar with, although he has rarely received credit for it.

Information gleaned from the deejay's 1981 obituary leads me to his nephew, one of the most inspiring individuals I've ever met. Keith Winters reads my email inquiring about his uncle's photographs and says to his partner, Susan Gaspar, "If this bird-dog tracked me down, let's hear what he has to say." I quickly learn that Keith is a no-bullshit straight shooter, a business-savvy success, and a big sweetheart. Conversations with Keith reveal that his father, Gerald Winters, was Tommy Edwards's half brother. Upon Edwards's death, Gerald inherited five Ektachrome slides, photographs of recording stars Edwards had taken in the 1950s. Keith had the five Ektachrome slides, including the famous Haley-Presley shot and a few photos of Tommy. My discovery of Tommy Edwards's small cache of photos was a nice coup for a novice rock 'n' roll detective but it was nothing compared to what was to come.

Within a few weeks of our first communications, I receive an excited, late-night call from Keith, who asks if I'm sitting down. While looking for Christmas decorations, he found treasure stashed away under a basement workbench: several dusty cardboard boxes with the family name "Mull" handwritten on the sides, containing *1,790* more slides. Gerald Winters had, in fact, inherited *all* of his deceased half-brother's photographs. Sometime around 1988, Gerald gave the slide collection to his son Keith to thank him for all that he had done for his parents over the past thirteen years. Keith simply had forgotten he had them.

Shortly thereafter, I board a plane armed with a trusty old 35 mm slide projector on loan from my father. I'm welcomed into Keith and Sue's home just outside Milwaukee to experience the photographs firsthand. As I see the amazing lost images of my musical heroes projected onto the basement wall in breathtaking color, I'm surprised to find myself overcome with emotion. The collection's candid beauty and historical importance convince me that it should be shared with music fans everywhere. In that moment, this book is conceived.

With Keith and Sue's enthusiastic support, my foray into the uncharted waters of authorship commences. The research sends

T.E. NEWSLETTER

News Of The Radio - Music Business In Cleveland

Tom Edwards

T. E. POP SHOW
10:30 a.m. to 2:00 p.m.
Monday thru Friday

T. E. HILLBILLY JAMBOREE
10:30 a.m. to 2:00 p.m.
Saturdays

EMCEE OF THE CIRCLE THEATRE JAMBOREE

WERE cleveland 15, ohio

Vol. 2 No. 47 September 2, 1955

RAMBLINGS: It pays to advertise! Last week I asked for any sample
records you boys might have lying around to use as giveaways at my
teen age dances -- the response was terrific. My thanks go to the
following people who have sent me records as of this writing: Kenny
Myers (Mercury), Frank Abramson (Republic), Buddy Kaye, Bernie Miller
(RCA), Irwin Schuster (Trinity Music), Jack Spatz (Bregman, Vocco and
Cohn), Warren Ketter(Wing), Lennie Hodes (Criterion Music), George
Pincus, Woodie Fleener (Sage & Sand), Eddie Kleinbaum (local Cosnat),
Dave Kapp, Don Bohanan (local King), Charles Ross (Redd Evans), Red
Latham (Hansen Pubs.) ------ My HOUSEWIVE'S RECORD OF THE WEEK has been
Eddie Dexter's VERSE OF STARDUST -- just made my TOP TEN this week --
very cute rendition ----- Watch to see if Jimmy Wakely changes labels -
in New York now talking ----- Understand that Dick Noel has been offer-
ed his own hour long show on WMAQ, Chicago ----- Is the Breakfast Club
coming to the end of its rope in Chicago ? ----- Paul Brown pens that
he'll be bringing Frank De Vol to town Spet. 9th ----- Archie Bleyer,
Joe Delaney and Jimmie Hilliard in town last Sunday nite for Nate Kul-
kin's wedding -- Nate now honeymooning in California ----- Bill Farrell
sang for the wedding services ----- My apologies to Johnny Farrow for
calling his Farrell in this sheet a few editions ago ----- Joni James
at the Fair Grounds in Detroit starting Sept. 5th ----- 4 Lads open at
home in Toronto for the Canadian National Exposition the 5th -----
Eileen Rodgers opens at the Alpine Village here on the 5th ----- Johnny
Van does the Cabin Club here this weekend to be followed by Laurie
Anders ----- Nat Cole's next is FORGIVE MY HEART ----- Gene Davis now
working in Dayton -- formerly here in Cleveland and Akron ---- My new
hobby is taking pictures of all stars who come in to visit on the show -
----- R & B TUNES TO WATCH: I'M SO GLAD, Mickey & Sylvia; IT'S OBDACIOUS,
Buddy Johnson; IT'S YOU, YOU, YOU, The Charms.
PLUGGERS OF THE WEEK: LARRY GREEN in from the coast with Jimmy Wakely
working on ROCK A BYE by the 4 Huss - which is showing much action -
also brought in the new Champ Butler wax on Coral, SOMEONE ON YOUR MIND;
NORMAN RUBIN in covering the territory for Marks Music formerly cover-
ed by the late Larry Norrett - his plug tune is SOLDIER BOY; JACK PERRY
and LUCKY CARLE both in - Jack has the Canadian tune - GAMBLER'S LAST 7
which has a great potential and Lucky working on SATISFIED MIND and Alan
Dale's WHAM; GENE GOODMAN & PHIL CHESS in last Friday with their newest
R & R tune $64,000 QUESTION -- it had to happen; DICK LINKE in on his
first road trip for Columbia.

GUESTS OF THE WEEK: We were loaded this week: JIMMY WAKELY with his
PINE TOP'S BOOGIE; A most interesting time spent with ANDRE KOSTELANETZ
stopping by and on his way to Japan with his new album of CALENDAR GIRLS;
PEGGY KING in town with her LEARNING TO LOVE; ELLA MAE MORSE stopping by
with her record of AN OCCASIONAL MAN; RUSTY DRAPER came in on the promo

your own his record of SHIFTING, WHISPERING SANDS; The 4 LADS were their usual exuberant selves when they stopped by to visit on the show -- their MOMENTS TO REMEMBER IS A DEFINITE SMASH !!; BERNADINE READ came in with Dick Linke with A CHANCE AT LOVE.

PHONE CALLS OF THE WEEK: AL GALLICO on the phone with news of a new release by Mitch Torok titled COUNTRY AND WESTERN; ALAN DALE called to get reaction on his latest ROCKIN' THE CHA CHA -- it's another good one for Alan; DOC BERGER now associated with AVAS MUSIC with a tune of TOP TEN caliber -- HE by Al Hibbler -- Doc just got out of the hospital again -- keep well, Doc; DUKE NILES called with the story on his ORANGES OF JAFFA -- Duke now with a European firm, Rayven and Paris Music - will be publishing tunes from overseas -- he just got back a few weeks ago; GEORGE JAY buzzed in with his client's plugs like FAIRY TALE, and 2 new Teddy Powell properties -- HONESTLY by Bob Manning and ALL I NEED IS YOU by the Hilltoppers. George should take full credit for calling our attention here in the midwest to Gogi Grant's SUDDENLY THERE'S A VALLEY which is BIG here now.

SONGS TO WATCH: YOU ARE MY LOVE, J. James; ONLY FOREVER, K. Kallen; FLAT TOP, B. Bennett; I'M SO GLAD, J. Desmond; I HEAR YOU KNOCKIN', Gale Storm; CHE SARA SARA, G. Van; BELONGING, G. Mitchell; WITHOUT A SONG, K. Starr; COME HOME, Bubber Johnson; TOWARDS EVENING, Cathy Carr.

COUNTRY STYLE

Pee Wee King does his last ABC TV shot from Cleveland on Monday (5th) - -- he just signed a long contract for his WBBM TV airer ----- Sorry I won't be able to make the DJ Convention in Nashville -- some year I'll be able to do it ----- Murray Nash writes that he's getting good reaction to Ferlin Huskey's DON'T BLAME THE CHILDREN -- I'll be doing it onstage at my Circle Theatre Jamboree next week -- I don't sing but do recitations every once in a while ----- Our Circle Theatre Jamboree has Dave Woolum as a guest tomorrow nite (3rd) ----- Tom Tall won many friends on our show last week -- knocked 'em dead.----- Jimmie Skinner coming in on the 17th.

SONGS TO WATCH: DON'T POINT YOUR FINGER, J. Wilson; GAMBLER'S LAST 7, Curly Crowe; WHO AM I TO CAST THE LAST STONE ?, H. Locklin; LOVE, LOVE, LOVE W. Pierce; THANK YOU LORD, T. Tommy; FOOLISH ME, E. Zack; FALSE PRIDE, J. Dean; FORGET MY BROKEN HEART, D. Owens; I THOUGHT OF YOU, J. Shepard;

LATE NEWS: GLORIA VAN in town to make my show this morning.

•

Songs listed here are not based on record sales, but on importance on show

No. weeks on list:	TOP POP TEN		TOP COUNTRY TEN
(6)	1. LOVE IS A M. SP. THING - 4 Aces	(13)	1. SATISFIED MIND - Wagoner/Foley
(3)	2. MOMENTS TO REMEMBER - 4 Lads	(13)	2. I DON'T CARE -- Webb Pierce
(4)	3. AUTUMN LEAVES - R. Williams	(4)	3. HAWKEYE - Bobby Lord
(7)	4. LONGEST WALK - J. P. Morgan	(7)	4. DON'T BLAME THE CHILDREN - Huskey
(2)	5. SUDDENLY THERE'S A VALLEY -	(8)	5. SO LOVELY BABY - R & D/J & J
	G. Grant/J. La Rosa	(3)	6. YOU THOUGHT I THOUGHT - Browns
(3)	6. I WANT YOU TO BE - Briggs/Gibbs	(4)	7. GO BACK YOU FOOL - F. Young
(2)	7. SHIFTING WHISPERING SANDS	(2)	8. ORPHAN'S PRAYER - Eddie Dean
	B. Vaughn/R. Draper	(7)	9. THAT DO MAKE IT NICE - E. Arnold
	8. GOODNITE SWEET DREAMS - Jenkins	(30)	10. MAKIN' BELIEVE - Kitty Wells
(7)	9. YELLOW ROSE - M. Miller		
(1)	10. VERSE OF STARDUST - E. Dexter		

some pretty colorful characters my way, such as the affable Sheriff Porter of Epps, Louisiana, who goes knocking on farm doors for me, searching for elusive rockabilly star Sanford Clark. And it provides rousing encounters with Pennsylvanian rocker George Darro, who gave me the very much appreciated initiation into his exclusive "Friendly Force" club. Interviews with Pat Boone, Wanda Jackson, country music legend Sonny James, and many others enhance the collection's intimate portraits.

Not that it is all fun and games. There were many blind alleyways, and countless doors were slammed in my face, perhaps none so discouraging as my attempts to locate surviving copies of the "T.E. Newsletter." During the 1950s, Tommy Edwards self-published a weekly, two-page recap of Cleveland radio and record news for music business insiders. Only two complete runs of the newsletter are known to exist: Tommy's original bound copy, which vanished upon his death, and a duplicate, requested by Bill Randle for research purposes sometime in the 1970s. My numerous attempts to locate Randle's copy through his survivors prove fruitless.

Soon after signing a publishing deal with Kent State University Press in April 2009, I receive a call from Cleveland journalist David Barnett. We'd kept in touch since 2005, when David conducted a radio interview with me regarding my quest for *The Pied Piper*. I bring him up to speed on the Tommy Edwards book and my futile newsletter search. David reveals that in the 1990s, Randle, his friend, let him copy a few key pages from the "T.E. Newsletter" that concerned Elvis Presley's 1955 Cleveland appearances. When I express my excited disbelief, Barnett readily offers to share them with me.

Upon review, my suspicions are confirmed. The wealth of information and dates contained in the newsletters are the photo collection's indispensable companion piece. Although I am glad to have whatever crumbs were available for research, this tantalizing view into Tommy Edwards's diary from the trenches of 1950s radio only heightens my exasperation over the newsletters' disappearance.

A few days later David sends an email with the opening line "Oh . . . I forgot." Here we go again. Just prior to his death, Randle had bequeathed to the journalist a tattered and frayed loose-leaf binder, the duplicate copy containing *every single issue* of the "T.E. Newsletter." David had simply forgotten he had them, tucked away in some closet. This kind of thing happens quite a lot, apparently.

From its inspired October 13, 1953, beginning to its heartbreaking conclusion on February 15, 1960, the "T.E. Newsletter" is unprecedented in its scope. Essential facts and anecdotal quips, spanning 577 pages, allow the reader to step into Tommy Edwards's shoes and sense the wonder and excitement he must have felt every day while bearing witness to a cultural revolution marked by intense creativity and groundbreaking moments.

So there you have it. It's my hope that this book, chronicling one man's life's work, respectfully fulfills Keith Winters's wish for his uncle: Tommy Edwards's recognition as not only one of early rock's most effective champions but also the deejay responsible for perhaps the most important photographic and written documentation of twentieth-century music that has ever been produced.

Christopher Kennedy,
Warwick, New York, October 2009

1955

The Pink Cadillac Roars North

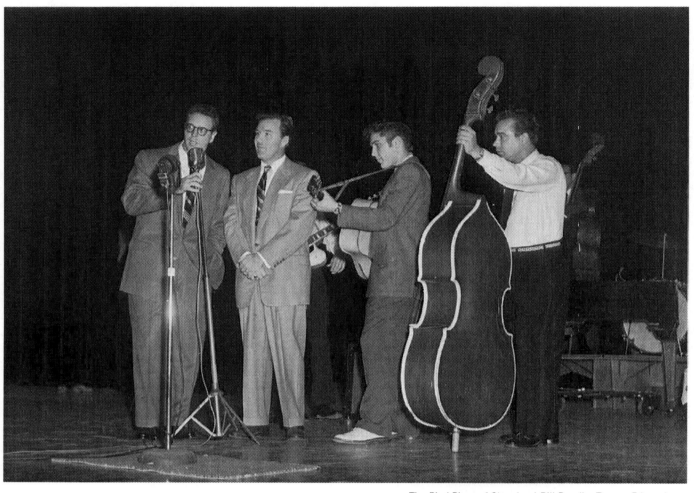

The Pied Piper of Cleveland, Bill Randle, Tommy Edwards, Elvis Presley, and Bill Black at Brooklyn High School, Brooklyn, Ohio, Thursday, October 20, 1955

In the waning days of summer 1955, the best-selling record in the country was Mitch Miller's "Yellow Rose of Texas." Columbia Records' head of artists and repertoire, Miller holds sway over his stable of singers with a Svengali-like power, squashing any bursts of creative spontaneity and controlling all artistic decisions with a totalitarian iron grip. Don't take my word for it. Just listen to "Yellow Rose of Texas," which sounds like it was recorded by the cast of Orwell's *1984*. Within a year, a punk-ass introvert with an exhibitionist streak and a voice fueled by sex and rebellion will liberate the country. His name is Elvis Presley.

While it's true that no one in 1955 could have predicted the coming cultural phenomenon that was Elvis, thirty-four-year-old Tommy Edwards is partly responsible for the Memphian's rise to nationwide prominence. In January 1955, Edwards knowingly became the first northern deejay to throw his considerable influence behind Presley, then just a regional sensation in the south. Calling himself the "City Slicker Turned Country Boy," Edwards spun the latest releases by country music stars such as Roy Acuff, Kitty Wells, and Bill Monroe on his WERE radio show, the *T.E. Hillbilly Jamboree,* which included Elvis's first singles for Sun Records. The show, heard Saturdays from 10:30 A.M. to 2:00 P.M., had a playlist that placated the portion of Cleveland's population who had come up from West Virginia, Tennessee, and Pennsylvania to work in the auto factories and consequently had no outlet for their music. Very few deejays dared to play hillbilly music north of the Mason-Dixon line. Tommy Edwards recognized and satisfied the demand.

Out of the radio show evolves a Saturday night *Hillbilly Jamboree* at the Circle Theater, on Euclid Avenue and East 105th Street, with the deejay booking acts as well as handling the emcee and comedic chores. On February 26, 1955, Elvis takes the Circle stage, making his debut before a northern audience to enthusiastic response. He returns for a second Circle appearance in October, cockier and more determined, his hair now permed to resemble the style of

rhythm and blues shouters like Roy Brown and all those colorful characters prowling the Beale Street juke joints in downtown Memphis.

These successful Cleveland appearances are significant because they disprove something the bigwigs at record labels closely watching Presley's advance are convinced of. The kid's popularity is not some freak musical accident of the southern states. Apparently he drives teenage girls nuts all over the country, and that potentially means huge record sales with crossover appeal. RCA buys out his contract from Sun in November 1955. Elvis puts the advance money to good use and has his road-weary pink Cadillac reupholstered.

His finger on Cleveland's pulse, Edwards heard a new and exciting sound and intuitively sensed a coming shift in the nation's musical landscape. This "City Slicker Turned Country Boy" opened the gates wide, letting rock 'n' roll's pink Cadillac drive through, changing us forever.

1955 has much more to offer than just Elvis Presley. In January, Bill Haley and the Comets rule Edwards's record hops with "Dim, Dim the Lights," and the Penguins' "Earth Angel" is the biggest rock wax in town. Every Thursday night, Tommy takes his tape recorder to the wards at Crile Veterans Hospital. He talks to the boys and then lets them introduce a song of their own choosing. The staff then plays the tape back on the hospital radio circuit.

Come February, Edwards is booked solid for the next three months for Friday night record hops. The new Hooper ratings are in, and the *T.E. Pop Show,* heard Monday through Friday, 10:30 A.M. to 2:00 P.M., is the highest it's ever been, second in the morning only to fellow redhead Arthur Godfrey. The program's format is oriented toward housewives and selling soap, so all rockers and hillbillies need not apply. The deejay does a week of remote shows from

the first Cleveland Automobile Show in eighteen years. After hearing Rosemary Clooney's "Where Will the Dimple Be," Tommy reinstates two of his more popular listener response gimmicks, the "T.E. Dimple Club," which boasts fifteen thousand be-dimpled card-carrying members, and its sister act, the "T.E. Freckle Club."

March brings a letter from Tom Diskin, writing on behalf of a pre-Elvis Colonel Tom Parker: they both enjoy reading the "T.E. Newsletter" each week. A real old-fashioned blizzard on Saturday the twenty-sixth prevents country star Mac Wiseman from breaking the Circle Theater's *Hillbilly Jamboree* attendance record. There's a local outbreak of suggestive lyric censorship, with churches taking the lead. On April 17, Bill Randle emcees a big rock 'n' roll show at the Masonic Temple, featuring Pat Boone and Bill Haley and the Comets. Two thousand fans attend, and Decca engineer Paul Cohen records Haley's performance. "Rock Around the Clock" takes off in May, and the current issues of *Who's Who in the Music Business, Record Whirl,* and *Country and Western Jamboree* feature pictures and articles on Tommy Edwards. Seventeen-year-old Wanda Jackson packs in the rockabilly fans at the Circle Theater over Memorial Day weekend, just four days before she returns to Oklahoma City to graduate from high school.

Tommy's successful June pilgrimage to Nashville for the *Mr. Deejay Show, U.S.A.* is overshadowed by his unforgivable failure to photograph sex siren Julie London when she drops by WERE. The kids go wild over the latest installment of the deejay's popular "Picture Pac," four black and white wallet-size photos of hit recording artists; the sets sell for ten cents and have been a regular summer vacation feature on his radio shows for a few years. Featured this month are Bill Haley, Pat Boone, Bill Hayes, and Jaye P. Morgan—also available

is the countrified version, spotlighting Hank Williams, Wanda Jackson, Tommy Collins, and T.E. himself. Edwards has so much paperwork to do with his gimmicks and promotions that he recruits awestruck teenage girls from his audience to help stuff envelopes and open mail. In return, the eager beavers receive copies of the latest records and enrollment in the "Tom Edwards Fan Club." Tony Bennett sends a postcard from Glasgow, saying that things are going well with his "Stranger in Paradise" disc.

Summer's in full swing when Eddie Fisher snubs T.E. during his "new campaign to romance deejays." In turn, T.E. snubs jock Bill Randle by giving WERE sales manager Chuck Dunbar the credit for digging up Mitch Miller's hit "Yellow Rose of Texas." Edwards gets all his out-of-this-world cufflinks and custom-made shirts from New Yorker Lew Magram, the most hep haberdasher in the world. This July, the newest music trend is "oat tunes going pop," country songs crossing over to the pop charts. Eddy Arnold starts the ball rolling with his latest RCA Victor release, "Cattle Call," and Tennessee Ernie Ford's "Ballad of Davy Crockett" on Capitol is one of the best-selling singles in the nation. It looks like a few record shops devoted solely to hillbilly music will be opening in Cleveland.

Everyone's going gaga over this St. Louis songwriter named Chuck Berry, so Tommy decides to venture downtown one hot August evening to hear what all the hubbub's about. It's been a busy few weeks for the deejay, with attending church carnivals and bazaars and emceeing dances, so T.E. hits up promotion men and record executives for unwanted sample records; he gives away hundreds of 45s at every record hop.

Posing as a warm-up act for headliners Slim Whitman and Mac Wiseman, Tommy takes to the Circle Theater's stage on September 10 and performs Ferlin Husky's "Don't Blame the Children," a weepy recitation number. Jocks from all over the country deluge Edwards with requests to be put on the "T.E. Newsletter" mailing list after a praiseworthy article appears in RCA's *Deejay Digest* magazine. In October, he shoots down rumors that he's leaving Cleveland for New York and then struts his stuff in Bill Randle's movie short, *The Pied Piper of Cleveland.* For just fifteen cents and a self-addressed, stamped envelope, many listeners of the *T.E. Hillbilly Jamboree* Saturday radio show are sporting 2¼-inch buttons that brag, "I'm a good hillbilly." Now that school is back in session, Tommy is booked solid for Friday-night record hops at various schools and churches throughout the WERE listening area. "Witchcraft," by rhythm and blues group the Spiders goes over big at the hops.

November braces for Liberace fever to descend on the city; country artist Sonny James writes Tommy about his new Capitol release, "Pigtails and Ribbons"; and RCA reissues Johnnie and Jack's hillbilly record "S.O.S."—without the sound of the Morse code distress signal, which is against FCC regulations for air use. So many people have asked to receive the "T.E. Newsletter" that Edwards starts a waiting list. His output is limited to the copies he can legibly run off one set of stencils. Another country song, "Are You Satisfied?" by Sheb Wooley, on MGM, goes pop, and "Speedo" by the Cadillacs is one of Cleveland's hottest rock 'n' roll songs.

December 3 sees a standing-room-only affair at Hawkshaw Hawkins and Jean Shepard's shows at the Circle. The *T.E. Hillbilly Jamboree* weekend radio show has a higher listener rating than the jock's weekday pop show, and there's a chance that he'll be doing a country music show on TV in the near future. The latest edition of *Jamboree* magazine carries a column written by Edwards, as does *Top Hit Record News*. A professor at the University of

Southern California wants samples of the "T.E. Newsletter" for his course on promotion. There'll be no regular Circle Theater *Jamboree* performance on Christmas Eve this year: too many in Cleveland's country music audience go back to West Virginia for the holidays.

Some of 1955's stellar country songs are "Makin' Believe," by Kitty Wells; "Live Fast, Love Hard, Die Young," by Faron Young; and "Hillbilly Heaven," by Eddie Dean. Under the pop radar fly Nat King Cole's "The Sand and the Sea" and Billy Vaughn's "Shifting, Whispering Sands, Parts I & II." "Nip Sip," by the Clovers, and "I Hear You Knockin'," by Smiley Lewis, are choice rock 'n' roll sides.

Hawkshaw Hawkins and Jean Shepard

Saturday, June 25, 1955

Trusty camera in tow, Tommy Edwards left Cleveland the day before at 11:30 A.M. bound for Nashville and the *Mr. Deejay Show, U.S.A.* WSM, the powerful station that broadcasts the Grand Ole Opry from the Ryman auditorium on Saturday nights, has invited him to guest host its *Friday Night Frolics* program, an hour-long broadcast from Studio C before a live audience of about five hundred people.

After checking into the Andrew Jackson Hotel, a massive brick colossus over on the east side of Memorial Plaza, Edwards takes in some sites, a city slicker turned hillbilly caught up in the excitement of country music's ground zero.

Just friends or possibly lovers? A few months ago, twenty-one-year-old country music singing star and songwriter Jean Shepard (Ollie Imogene Shepard) met this tall glass of water on ABC-TV's *Ozark Jubilee*, a live country music program out of Springfield, Missouri. Harold Hawkins, a thirty-three-year-old honky-tonk troubadour known to fans as "Hawkshaw," affectionately hugs Jean and his Gibson SJ-200, one of which he'll make an honest woman out of in 1960. The couple enjoys marital bliss until March 5, 1963, when the small Piper Comanche carrying Hawkins and fellow passengers Patsy Cline, Ramsey Hughes, and Cowboy Copas crashes in the dusk-lit Tennessee woods, killing all onboard.

But tonight is all cozy smiles backstage at the Opry, just two close friends happy

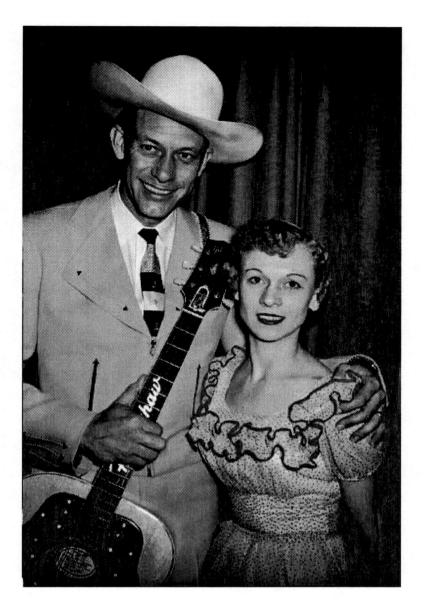

to share the stage with such country music headliners as Carl Smith, Jimmy Newman, and Goldie Hill.

Well, fellas, I'm finally going to get to see what the capitol of Hillbilly-land looks like—I'll be doing the MR. DEEJAY SHOW, U.S.A. on Friday, June 24th. So mark the date down—and I'll be seein' you in Nashville.
　—"T.E. Newsletter," Vol. 2, No. 26, April 8, 1955

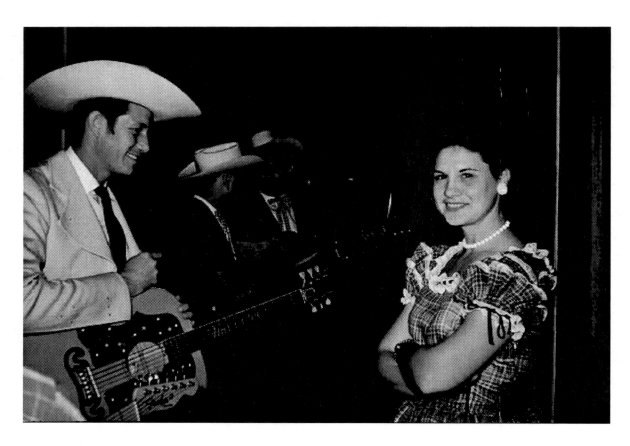

Hawkshaw Hawkins, Johnnie and Jack, and Kitty Wells

Saturday, June 25, 1955

Waiting in the wings at the Grand Ole Opry in Nashville is thirty-three-year-old West Virginian giant Hawkshaw Hawkins, a brawny-voiced veteran honky-tonker who is new to the Opry this month. Her plaintive wail has established Kitty Wells (Ellen Deason) as hillbilly royalty at thirty-five, and the vocal duo checking their tuning in the background is forty-one-year-old Johnnie Wright and Jack Anglin, thirty-nine. Johnnie and Kitty have been married for seventeen years, their relationship enduring endless tours and the suffocating microcosm of life on the road. Now that's love.

At this writing my memories of Nashville are very pleasant and I certainly want to thank everyone down there for making my stay a pleasant one. The Opr'y lived up to everything I expected it to be and I hope I get down again real soon. I spent a great part of Sunday afternoon with Eddy Arnold and his fine family and had a most enjoyable and informative time—watch for Eddy's next country release titled THAT DO MAKE IT NICE—it's the punch line of an old joke. Visited with Audrey Williams and friends at her spacious home on Friday evening— she has a new record coming out. Everyone in Nashville seems to sense a "blow-up" backstage at the Opr'y—this could be atomic.

—"T.E. Newsletter," Vol. 2, No. 38, July 1, 1955

Jackie Jocko

August 1955

"Love you madly!" Twenty-six-year-old pop singer Jackie Jocko, "Mr. Excitement" (John Giaccio), shouts one of his many great catchphrases to the kids gathered around his pumping piano. A beautiful moment frozen in time, faces of joy flush with excitement in those precious seconds when friends and music are all that matter.

Jackie entertains on an Arthur cabinet-grand upright piano in a tiger-oak finish, a battered relic from the early 1900s. Around his neck hangs a lipstick microphone (Altec-Lansing Model 21), cutting-edge audio technology courtesy of record-hop host Tommy Edwards. The cocksure Italian boy from Buffalo, New York, once had dreams of becoming a concert pianist. He now lovingly dissects the notes of jazz greats Oscar Peterson, Ahmad Jamal, and Erroll Garner instead. Their influence is felt on his latest disc for Unique Records, "And So I Do."

JACKIE JOCKO in town for the weekend Cabin Club show.
> —"T.E. Newsletter," Vol. 2, No. 45, August 19, 1955

on Vincent, the Cabin Club across the street from Alhambra (movie theater). One of my managers was from Ashtabula, Ohio, and knew Bill Randle. Randle set up my first record deal with Mercury and suggested I change my name. He thought there were too many Johnnys out there. Between you and me, T.E. was a better guy than all of them. They used to break more records in Cleveland, oh my God! Cleveland was dynamite! I remember him always having a camera around! If he thought you were a talent, he'd take your picture, not just anybody. I would shoot the baloney with him. He was quite witty, way ahead of his time, even then.
> —Jackie Jocko, Eggertsville, New York, October 2008

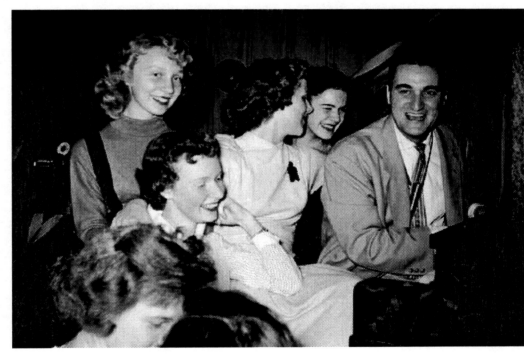

My God, I looked so good! Terrific disk jockey, Tommy Edwards. He was a good man. He had a beautiful way. He was dynamite! I liked him. When you performed in Cleveland, they would break hits by the carload. To me, Cleveland was the superior city at that time. Everybody came to Cleveland. I played at Moe's Main Street, the Theatrical Grill

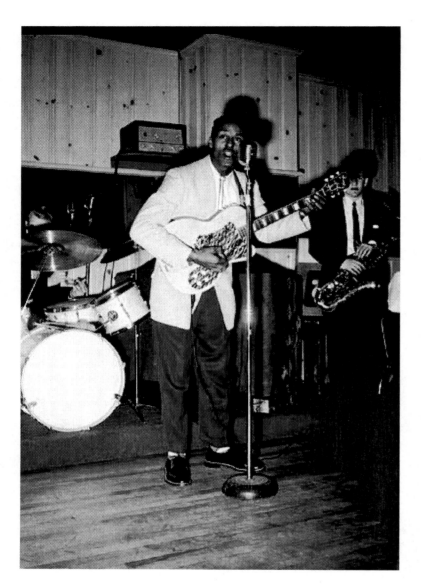

Chuck Berry

August 15–21, 1955

The gutsy Kay Thin Twin electric guitar bursts out a raw opening riff, and heads turn, drinks spill. Tonight they've all come to hear a twenty-nine-year-old former hairdresser named Chuck Berry play his fantastic new record, "Maybellene."

The words come next, something that feels like poetry to local tenor sax star Sammy Dee, who watches from the bandstand as a camera's flash for an instant illuminates the breathless faces of the audience. The singer smiles over the Shure 55 Unidyne microphone and strikes another chord, inviting the rapture only rock 'n' roll music can bring, as an electricity that feels like falling in love rushes through the crowd.

This is Gleason's Musical Bar on Woodland Avenue, and tonight a new kind of American poet has come to Cleveland, his exceptional songwriting skills and archetypal musicianship ensuring the future of rock 'n' roll by influencing all who follow his blueprint.

Biggest new R & B record in town is MAYBEL-LINE by the Chuck Berry Trio on Chess.
—"T.E. Newsletter," "Ramblings," Vol. 2, No. 40, July 15, 1955

Jimmy Wakely

September 1955

Looking more like a Las Vegas nightclub crooner than a hillbilly hit-maker, a dapper forty-one-year-old Jimmy Wakely (Wakeley) stops by WERE to promote his latest Coral single, "Pine Top's Boogie." The record's B-side, "I Belong to You," was heard over the roar of Ferraris and Maseratis earlier this year in the Twentieth Century Fox CinemaScope Production of *The Racers,* starring Kirk Douglas.

During the 1940s, Wakely's heartbreaking good looks, flirtatious charisma, and seductive voice were wasted in a string of forgettable B-western movies. In 1950, at the height of his recording career, the singer made love to the microphone stand as if it was a beautiful woman, suggestively batted his long lashes at the girls in the front row, and presented himself as the Sinatra of country music. But one couldn't help but sense that he, unlike Sinatra, was withholding his full potential from us. Now Jimmy finds himself in the midst of a hitless dry spell from which he'll never rebound. By decade's end, it's time to mount up and gracefully ride off into the sunset, as all obsolete cowboys must.

Wakely's spent cigarette will quickly be replaced by another just like it, culminating in the singer's 1982 death from emphysema.

Mac Wiseman

Saturday, September 10, 1955

It's the weekend, and Euclid Street is jumpin'. Mac Wiseman and his Country Boys raise the roof at the Circle Theater's *Hillbilly Jamboree*. The thirty-year-old former deejay from Virginia strums a G-major chord as the Shure Unidyne Multi-Impedance Model 55 microphone carries the drowsy sweetness of his high, beautiful voice into the far corners of the old theater.

The easy flowing music is the effortless union of bluegrass, country, and pop, a unique blend that is Wiseman's signature. Clevelanders love it, helping his recent Dot single, "The Ballad of Davy Crockett," dent Billboard's top 10 country chart. Some at the *Jamboree* have been hardcore Wiseman fans since the forties, when he lent his gui-

tar and vocals to bluegrass royalty such as Bill Monroe and Flatt and Scruggs. Some are brand-new disciples, thanks to Tommy Edwards's *Hillbilly Jamboree*, content to lose themselves in the music for just a few hours tonight.

We had 2 packed houses for Slim Whitman and Mac Wiseman at my Circle Theater Jamboree last Saturday (10th).
> —"T.E. Newsletter," Vol. 2, No. 49, September 16, 1955

Tommy Edwards was a maverick. He stuck his neck out and made inroads to the country music market and his input was invaluable. He was a kind person, very loyal. A lot of payola back then—Tommy didn't take part. The Circle Theater was a wonderful venue and I held the attendance record, we'd just pack the house and fill the aisles. We'd come and play about two or three times a year. I had a four-piece band at the time. I was most impressed with him as a person; he was very real, most generous. I was pleased to be an acquaintance.
> —Mac Wiseman, Nashville, Tennessee, September 2008

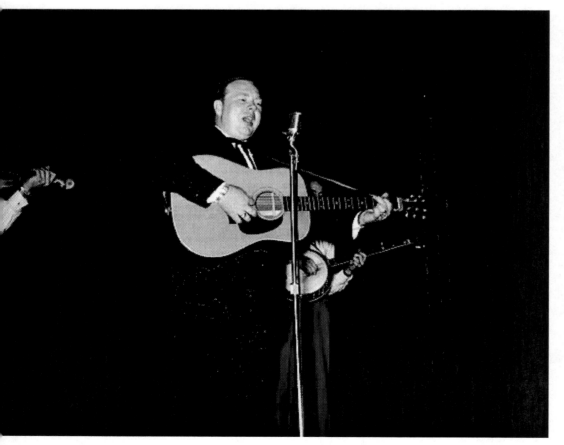

Lola Dee

September 1955

Pop singer Lola Dee's robust voice defies her petite frame. Dwarfed by the hulking RCA Ribbon Velocity Model 44BX microphone, the pretty, five-foot-tall Chicagoan laughs off some nerves and sings a few bars of "Paper Roses," the sprightly A-side of her latest Wing wax.

This solo rendition would be much preferable to the recording, on which the Jack Halloran Choir stomps all over the singer with its corny back-up vocals. On the flipside is Lola's straight reading of the Platters' recent smash, "Only You (and You Alone)."

I do remember meeting Tommy Edwards. He was so handsome, and, in addition, a nice friendly person. I appeared at Moe's Main Street quite often back then. As to my age in the photo, I'm in my early twenties.

—Lola Dee, Oak Brook, Illinois, May 2009

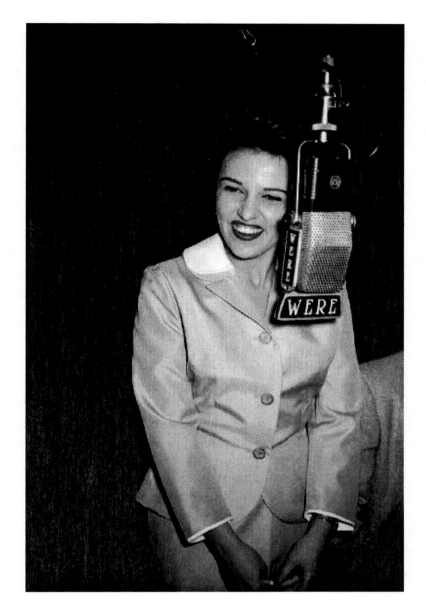

Goldie Hill

Tuesday, October 4, 1955

On November 7, 1953, Tommy Edwards starts producing live country and western stage shows at the Circle Theater. Following his intuition, he senses an audience starved for this kind of countrified entertainment. He's right.

Soon the biggest names in the business are packing them in at the *Hillbilly Jamboree* once a week, two shows a night, with a movie sandwiched in between. Tonight twenty-two-year-old Grand Ole Opry star and trailblazing artist Goldie Hill (Argolda Voncile Hill) takes the Circle's stage, places her glamorous self in front of the Shure Model 55 microphone, and sings for the honky-tonk-music-hungry Yanks.

I stopped in to see Pee Wee King on his show last week—a very nice guy. Has a splendid show with a different name guest every week—last week it was the beauteous GOLDIE HILL—she's a real pipperoo.
—"T.E. Newsletter," No. 11, December 21, 1953

Ray Price, Goldie Hill, and Linda Price

Tuesday, October 4, 1955

For some, he's still that somber-looking kid from Perryville, Texas, who once dreamed of becoming a veterinarian. Tonight the Ray Price Show rolls into town for the Circle Theater's *Hillbilly Jamboree*.

The twenty-nine-year-old Columbia recording artist relaxes in the wings with Nashville's "Golden Hillbilly," Goldie Hill, and his wife, Linda, enjoying the sounds of popular songwriter Redd Stewart and King Records act the Morgan Sisters. Tommy Edwards is in his usual role as emcee, even trying his hand at some comedy routines between band set-ups.

Price is still a few months away from the release of "Crazy Arms," a hugely influential record whose innovative shuffle beat turns the Hank Williams protégé into a country music superstar, seemingly overnight.

Elvis Presley

October 19–20, 1955

Elvis Presley drove the little girls wild last week.
—"T.E. Newsletter," Vol. 2, No. 21, March 4, 1955

Presley's Saturday, February 26, 1955, appearances at the Circle Theater's *Hillbilly Jamboree* marks a northern audience's first exposure to the coming cultural revolution called rock 'n' roll. Music will never be the same. Nothing will ever be the same—and all because of some pimply punk from Memphis.

By the time the twenty-year-old singer returns to the Circle in October, all the pieces are in place, all the fuses lit. The truth is, only a select few know the real story behind Presley's adventures in Cleveland.

There were always little girls hanging out backstage, sisters or girlfriends of our musicians. We had a couple of little hot tomatoes that were about fourteen years of age, and after Presley got through with his first show, these girls corralled him and they went out in the back parking lot. . . . I don't know if they drove away or if they just made it in the parked car. But he came back—he was wearing black slacks and those white buckskin shoes, and a Robert Hall red jacket—and I looked at him and said "What the hell have you been doing?" He had pecker tracks down the front of his leg on his black slacks so I said "you better get cleaned up before you go back on stage." So he got himself cleaned up and those two little girls were sitting down in the front row when he came out there. He was really working, really sweating, and he couldn't keep his eyes off these two girls. He was doing the show especially for them, and I don't know what happened after that."
—Tommy Edwards, interviewed by Rick Whitesell, January 1981

We're getting set for big business on the 19th and 20th when Roy Acuff, Kitty Wells, Johnny and Jack and Elvis Presley come in to our Circle Theater——Elvis will appear with me in the movie short which will be filmed the morning of the 20th.
—"T.E. Newsletter," Vol. 3, No. 1, October 14, 1955

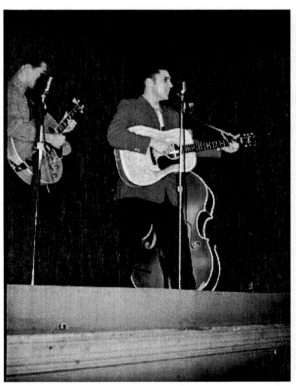

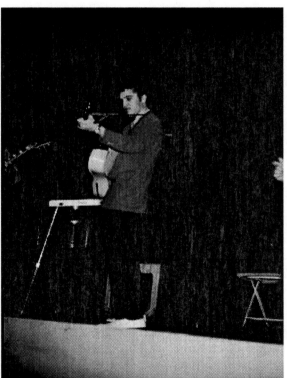

Boyd Bennett

October 1955

Thirty-year-old rock 'n' roll singer-song-writer Boyd Bennett and His Rockets have beaten the sophomore slump with a follow-up hit to their popular King single, "Seventeen," which chronicled a day in the life of a teenage girl. This time around, it's from the male's perspective, revamped as "My Boy—Flat Top."

The Rockets' sound is a competent enough assimilation of rock 'n' roll, topped by the uninteresting voice of some guy who looks like your dad's drinking buddy. Boyd is a little too old and a lot too square to compete with the young ruffians kicking up dust.

Boyd Bennett stopped up to say hello—I don't play his type of music on the air—only at dances where it's a must.
—"T.E. Newsletter," Vol. 3, No. 1, October 14, 1955

Pat Boone

Thursday, October 20, 1955

Dashingly handsome Pat Boone (Charles Eugene Patrick Boone) obligingly signs an autograph for a star-struck fan. Pat hears the call and comes running, as all recording artists must when powerhouse WERE deejay Bill Randle requests their presence.

Earlier today, the singer appeared in Randle's *Pied Piper of Cleveland* movie short at Brooklyn High School, alongside Bill Haley and The Comets, The Four Lads, Priscilla Wright, and Elvis Presley. A second shoot featuring the twenty-one-year-old Boone, Wright, and Presley will take place later this evening at St. Michael's Hall.

Still flush with the success of his No. 1 smash "Ain't That a Shame," Pat's latest Dot single is a double-sided hit, a cover of the El Dorados' rhythm and blues chart-topper "At My Front Door (Crazy Little Mama)" coupled with "No Arms Can Ever Hold You." Ridiculed by twenty-first-century rock elitists for his sanitized cover versions of black artists' hits, there is a richness and beauty to Pat Boone's music found underneath all the controversy. Forget his admittedly tepid interpretation of Little Richard's "Long Tall Sally," and listen instead to the pop perfection of his 1956 hit "Don't Forbid Me." During the upcoming Million Dollar Quartet session in December, Elvis Presley professes his admiration for the song and his remorse over failing to record this melodic gem.

Pat Boone's artistry deserves our respect for its undeniable breadth of quality, and also for playing its part in the dismantling of racial barriers in American popular music.

Tommy was exceptionally nice to me in the early days of my career. Obviously, if Bill Randle and the other guys at WERE proclaimed any record a hit, it was a done deal. They did that for several of my early records, "Tutti Frutti," "Ain't That a Shame," "At My Front Door," even "I'll Be Home," firmly establishing me as a recording artist, both R&B and pop, just before Elvis hit with "Heartbreak Hotel" in February of '56. I remember being with Tommy while we were on the air, and somebody had come up a fire escape and was banging on the door of the studio. I don't remember if he was let in or shot dead, but it was an interruption we had to deal with. Those were good days, and the guys were sure good to me.

—Pat Boone, Los Angeles, California, November 2008

Bill Haley and Elvis Presley

Thursday, October 20, 1955

A simple handshake between two friends—one of rock music's most iconic and defining images. Bill Haley and Elvis Presley stand backstage at Brooklyn High School, 9200 Biddulph Road, Brooklyn, Ohio.

The event is music's first rockumentary, a movie short personally financed by WERE deejay Bill Randle as a self-promot-

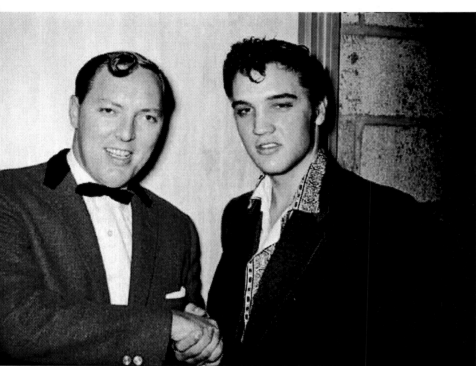

ing look at his undeniable influence on and off the airwaves. Known today as *The Pied Piper of Cleveland,* this yet unreleased film is the lost Holy Grail of Rock 'n' Roll.

Thirty-year-old Bill Haley, our first rock superstar, never personifies the sexual rebellion his new sound promises. In a

few short months, twenty-year-old Elvis Presley will be deemed the anti-Christ, youth corrupter, a generation's savior, and forever the King of Rock 'n' Roll.

Haley's brilliant music survives, but his legacy is lost. In this photograph, though, time stops as deejay Tommy Edwards captures Haley at his pinnacle and at his eclipse.

This has been quite a week for me what with the Grand Ole Opry in town for two nights, appearing in Bill Randle's short movie subject and attending my regular teen age record hops and my usual Saturday Circle Theater emcee chores—we're thinking of making 26 hour day—In town to do the picture with Bill Randle were Priscilla Wright, The Four Lads, Bill Haley's Comets, Pat Boone and Elvis Presley (watch this kid in the pop field now).

—"T.E. Newsletter," Vol. 3, No. 2, October 21, 1955

I will probably go to New York soon to refilm a portion of the Bill Randle feature film with Elvis Presley—he's getting a bigger part in the film now that he's on his way to becoming a pop as well as country performer———I first booked Elvis up here in Cleveland about a year ago at my Circle Theater Jamboree.

—"T.E. Newsletter," Vol. 3, No. 9, December 9, 1955

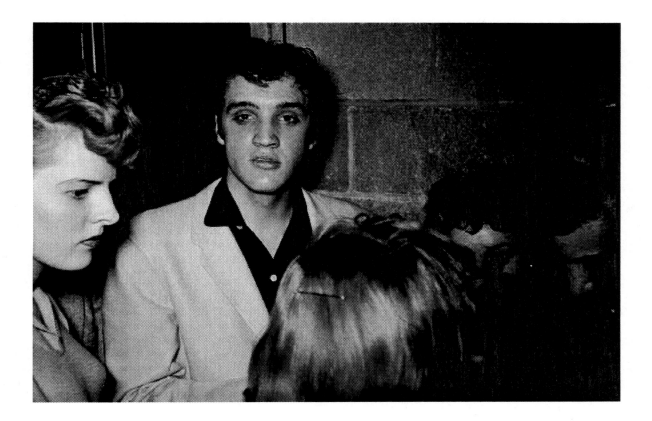

Elvis Presley

Thursday, October 20, 1955

Tommy Edwards surprises Elvis Presley as he signs autographs backstage at St. Michael's Hall, 10004 Union Avenue in Broadview Heights. The young musician shares the stage tonight with headliner Pat Boone and teenage Canadian pop star Priscilla Wright, film cameras capturing their performances for *The Pied Piper of Cleveland.*

Although the A-side of the singer's latest and last Sun single, "I Forgot to Remember to Forget," will hit No. 1 on the Billboard country chart in a few weeks, it's the rec-

ord's B-side that is the stunning culmination of all the raw potential producer Sam Phillips first heard in Presley. "Mystery Train" is Elvis Presley's first masterpiece, his riotous acoustic guitar threatening to derail the performance, his last honest recording until his post-Army sessions in 1960.

Elvis Presley, country artist on SUN, is being wooed by 5 or 6 of the big labels——the kid is a sensation on stage——kids go wild over him.
 —"T.E. Newsletter," Vol. 2, No. 46, August 26, 1955

Priscilla Wright

Thursday, October 20, 1955

A busy fall afternoon finds Canada's newly crowned Princess of Pop and her mother smiling in the middle of the studio clutter. Earlier today, fourteen-year-old singing sensation Priscilla Wright, accompanied by her maternal chaperone, Lillian, traveled by rail on the London & Port Stanley Railway, then by ferry across the choppy waters of Lake Erie to Cleveland. During their journey, the pair most likely chatted excitedly about the success of Priscilla's debut international hit single on Unique Records, "Man in the Raincoat," in which the scandalously young Wright laments about some cad with "laughing eyes" who steals her heart and money.

All the WERE deejays seem quite smitten with the perky teen, none more so than star-maker Bill Randle. Randle has deemed her worthy to appear in his self-financed autobiographical *Pied Piper of Cleveland*. In the film, Wright shares the Brooklyn High School stage with Bill Haley and The Comets, Pat Boone, and fellow Canucks The Four Lads. Alone in the wings, Priscilla comes face to face with a handsome bundle of nervous energy who flashes her that crooked smile and says, "Hi . . . I'm Elvis."

An often overlooked participant in the still-missing film, Priscilla's clear and descriptive memories bring us right back to the sights, sounds, and thrills of those fabled October 20 concerts at Brooklyn High and St. Michael's Hall. Until the footage surfaces, her remembrances, coupled with Tommy Edwards's beautiful photographs, are the next best thing.

I can tell you that of all the radio stations I visited in North America during that time, Tommy Edwards and the DJs at WERE-AM were my favorites. Always they welcomed me so warmly. I remember vividly Carl Reese. I had a schoolgirl crush on him—thought he was gorgeous and asked him for an autographed picture, which he gave me! I was so shy with him, but he was always wonderful to me. Phil McLean was also terrific to me and always did very positive interviews on air with me. He also hugged great!!!! Of course, the third one I remember vividly is Bill Randle. His personality was a bit more aloof than the others, but he gave me such kindness and of course, was the one who invited me to come to Cleveland for the filming of *The Pied Piper.* Being the only female artist invited to participate was truly a great honor. When Bill Randle went on "Man in a Raincoat," it soared in the charts. And then there's Tommy. I am so delighted to have the picture of my mother and me. It is the only picture I have of her at that time. Usually, my father accompanied me on singing trips then (being a minor, I had to be accompanied on all trips!) so I regard the picture as precious. It shows how lovely my mother was. She had a beautiful nature and was highly intelligent. That all shows in the picture. THANK YOU, Tommy Edwards, for taking it and preserving that memory for me. The jaunty, little hat with the red feather my mother made for me. It matched the dress I had on. Fun to remember that. I'd forgotten all about that little hat!

—Priscilla Wright, Toronto, Ontario, Canada, March 2009

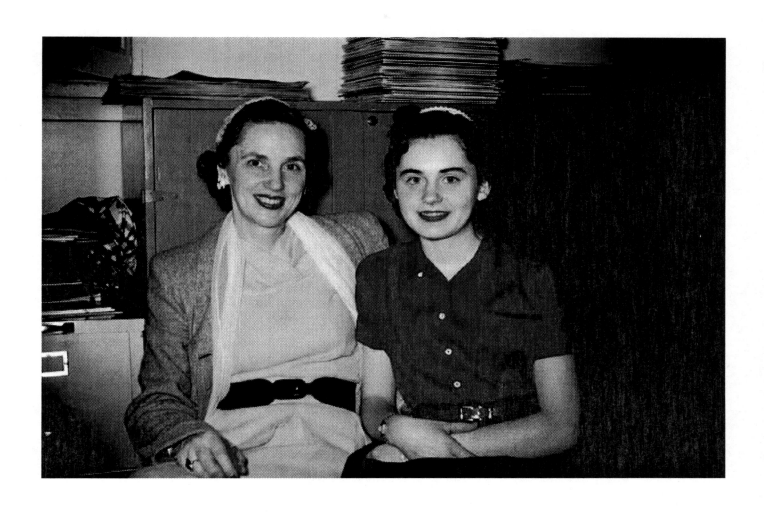

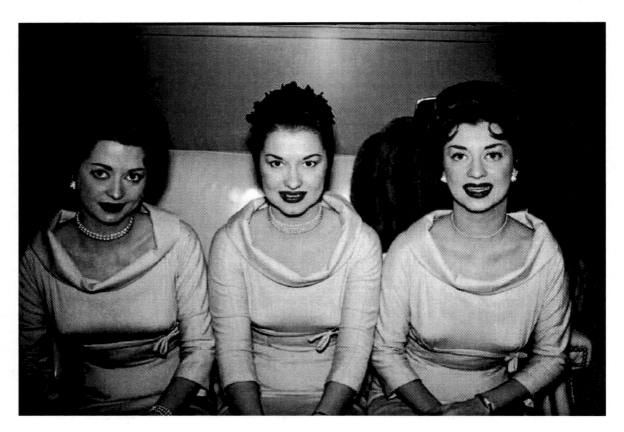

The De Castro Sisters

October 1955

"Snowbound for Christmas," the latest single on Abbott Records by Cuban American vocal group the De Castro Sisters (from left, Cherie, Babette, and Peggy), has failed to heat up the holiday cash registers. Perhaps a bit desperate, the girls are still searching for that elusive follow-up hit to their September 1954 smash, "Teach Me Tonight."

De Castro Sisters passing through town and we had a wild time with them on the air—their Christmas record sounds good.

—"T.E. Newsletter," Vol. 3, No. 3, October 28, 1955

Our manager talked us into dyeing our hair red; he thought it would look good onstage. We hated it. I remember Tommy Edwards wanted to date one of us, Babette, I think. Ya know, he was a good-lookin' guy.

—Cherie De Castro, Las Vegas, Nevada, May 2008

Liberace

Tuesday, November 8, 1955

Tommy Edwards interviews thirty-six-year-old superstar Liberace (Wladziu Valentino Liberace) backstage at the Allen Theater as his older brother and confidant, George Liberace, hovers protectively in the background. The odd-looking microphone is an Altec salt-shaker 633A, a favored workhorse of broadcasters.

The Wisconsin brothers have come to the Playhouse Square theater district on Euclid Avenue as part of a thirteen-city tour promoting Liberace's much hyped debut motion picture, *Sincerely Yours*. In the campy film, "Mr. Showmanship" suitably portrays a pianist who thinks he's God. In its December 12, 1955, issue, *Time* magazine calls it "one of the year's biggest box-office flops."

George will soon grow tired of tending to the twinkling lights of his kid brother's candelabrum and will walk away in disgust from Liberace's secret circus of closeted homosexuality and decadence.

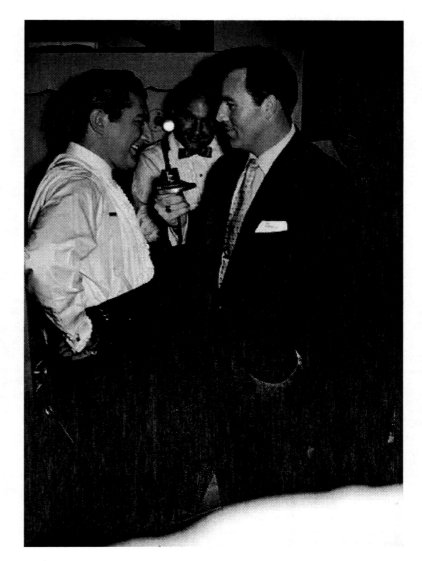

Liberace wowed the girls last Wednesday—he almost got himself messed up while waiting to go onstage——a sandbag weight in the flies ripped open and the downpouring sand just narrowly missed him—he was wearing that glistening jacket at the time——one of the nicest fellows I've met in the business.

 —"T.E. Newsletter," Vol. 3, No. 5, November 11, 1955

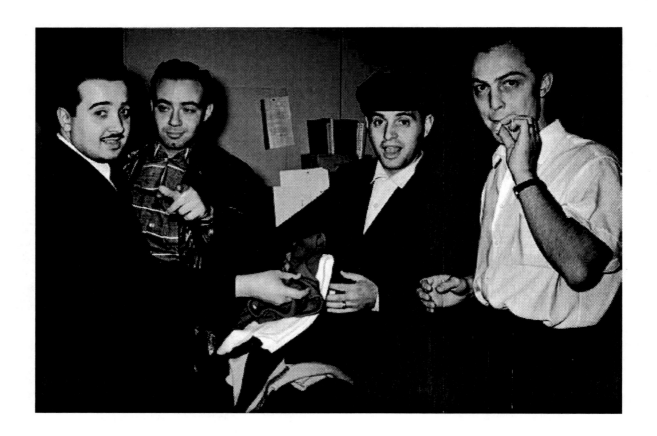

Ronnie Gaylord, Sandy Beck, Burt Taylor, and Phil McLean

November 1955

From the look of things, a gathering of hipsters engaged in some sort of clandestine exchange has just been caught redhanded. A more plausible scenario holds less intrigue.

Reserve Records owner Sandy Beck stands witness as pop singer Burt Taylor of Essex Records shows off some stylish new threads to twenty-five-year-old Wing recording artist Ronnie Gaylord (Fredianelli). Reserve is a new local label, and Sandy's working "Flip Flop" by Cleveland's cute

Tracey Twins and "Dance of the Elephants" by local bandleader Wendell Tracy. On Sunday, November 6, Gaylord completed a successful weekend engagement at the Cabin Club, and Taylor's stay at the 10616 Euclid Avenue nightspot begins on Friday, November 11.

It's just business as usual at 1300 on the AM dial. Then again, considering that mischievous glint in deejay Phil McLean's eyes, maybe they are up to something after all.

The Rover Boys

December 1955

The kids in the hall, showing off a bit of that Canadian razzmatazz—hailing from Toronto, pop vocal group the Rover Boys are hoping a recent move from Coral Records to ABC-Paramount triggers a much needed hit right out of the gate. It doesn't.

Doug Wells, Al Osten, Larry Amato, and Ross Bush, all in their early twenties, show "a lot of commercial savvy," according to Billboard's November 12 review of the new single "Come to Me / Love Me Again."

Nevertheless, the disc nosedives, and something's gotta give.

That something is lead vocalist Ross Bush, who unceremoniously gets the boot and is swiftly replaced with the melodramatic warbling of Billy Albert. This infusion of Brooklyn blood seems to do the trick. Their third single, "Graduation Day," will hit the bestseller charts in May 1956 despite some heavy competition from a Four Freshman copycat version.

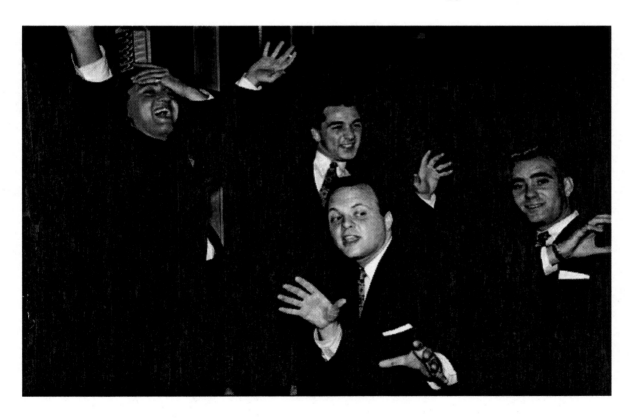

Bubber Johnson

December 1955

Like the first big stretch of the morning, like that delicious cigarette after an amazing steak dinner—like when pianist Robert "Bubber" Johnson sings: so satisfying.

All the blues, brawn, and sophistication of the New Yorker's beautifully expressive voice can be heard on the A-side of his popular new King single "Come Home" as well as onstage down at the Chatterbox, 5123 Woodland Avenue, December 5–12. Paul Bascomb's Orchestra and the Hamptones should also be in attendance. Come get satisfied.

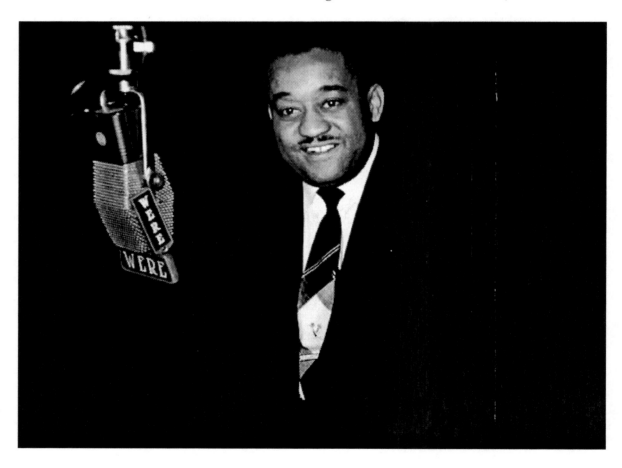

The Rhythmettes

December 1955

"America's Cutest Songsters." Really? That's a bit of a stretch, as even Jo Ann Korn, Nadine Small, and Donna Watkins would probably admit. But the Rhythmettes are stuck with the silly tag line, most likely dreamed up by their handlers or the big brains at RCA Victor.

Jumping on the rock 'n' roll bandwagon speeding by, the supper-club trio tries to sex it up a bit on its latest single, "Take My Hand / I've Got to Know." The record fails to set pulses racing and is long forgotten by the time the Rhythmettes return to Cleveland on January 12, 1956, as part of RCA Victor's March of Dimes Tour.

These are beautiful photos of my wife, Nadine. In the photo, she was twenty-four and sang alto. Donna was twenty-three and the lead singer, and I don't know about Jo Ann. Nadine began singing, tap dancing, and playing piano in Detroit, Michigan, at about age five and performed on a Detroit radio show for talented children. In her early teens, she sang with the WJR radio-station chorus, which broadcasted every weekend. She had a fabulous memory for lyrics and music. She especially loved and studied classical music. I have one of her road schedules with the Ralph Flanagan band and it was a pretty busy schedule, all by way of bus and train. Nadine was so very humble when it came to talking about her career. She told me numerous wonderful stories of the people she met and places she sang in. Like the time the trio opened the big nightclub in Cuba while the Castro guerillas where right outside of Havana. So many things to tell.

—Walter Krueger, Pompano Beach, Florida, September 2009

1956

The Big Slide Show

Members of the Tommy Edwards Fan Club, Parma Chapter, 1956

Here's news of an innovation I'm introducing at my record hops after the first of the year: At all my dances I will also bring along a portable 10 foot square canvas screen and a slide projector. For the past 6 months I've been taking color shots of all the stars who come up on the show to be interviewed—as a consequence I have compiled quite a collection of record stars' pictures. These pictures will be shown to the crowds at the dances so they can see what they look like bigger than life-size—already the reaction is sensational.

—"T.E. Newsletter," Vol. 3, No. 12, December 30, 1955

In January 1956, Tommy Edwards boasts he's booked as far in advance as April for record hops at churches and schools, the big attraction being his new gimmick, the color slide show. The deejay provides the exciting commentary while about 130 slides flash across the screen, transforming a cavernous gymnasium or drab recreation hall into a magical, intimate place.

The kids go for this fusion of sound and vision in a big way, Edwards's brainchild predating the music video explosion of the 1980s and the rise of MTV by twenty-five years. Perhaps our deejay was just a little too far ahead of his time.

With 1956 barely underway, RCA Victor sends out a trainload of their record stars on a March of Dimes goodwill tour. Brandishing a camera and tape recorder, Tommy Edwards is waiting when the caravan pulls into Union Terminal. Sadly, he and his camera are not in attendance when Billie Holiday performs at the Chatterbox Club, January 1–8. He does remember to tune in to CBS-TV's *Stage Show* on January 28 to see Elvis Presley start a four-week stint. The deejay's afraid they're going to make a

rock 'n' roll boy out of him and he'll desert the country field altogether.

Bluegrass patriarch Bill Monroe graces the Circle's *Hillbilly Jamboree* stage on February 4, and the next night deejay Bill Randle does his first locally aired TV show. Edwards somehow misses an opportunity to photograph Lucille Ball and Desi Arnaz when they're in studio but flips over Betty Page, some new chick he sees in a magazine. Little Richard plays a one-night stand at the Bandbox Club, 2902 West 25th Street, on Wednesday, February 15. Tommy introduces his listeners to a character voice, "Ned Mahon," a satire on broadcaster Ted Malone with his popular poetry readings. As Mahon languidly recites into the mic, corny organ music plays in the background. In one weekend, Edwards gives away six hundred free records at his hops, courtesy of record men and song pluggers cleaning house.

Come March, because of a contract dispute, Edwards calls it quits as emcee of the Circle Theater's *Hillbilly Jamboree*. A source of great pride for the deejay since November 1953, the Circle shows christened

Cleveland an important proving ground for country music. He is considering starting up his own jamboree at another venue, so he asks his listeners and newsletter readers to stay tuned. Attendance at records hops has more than tripled since January because of the big slide show. Meanwhile, crooner Billy Eckstine collects an expensive speeding ticket on the Ohio Turnpike while traveling to Cleveland from Detroit.

A chilly April brings a plane full of Columbia recording artists to the city on behalf of the American Cancer Society. Edwards will use pictures of their arrival on his first TV show on KYW, Sunday, April 15th at noon. He welcomes visiting record stars to come lip-synch their hits, but the show will be based on the fun of photography. He invites everyone to stop by and bring along their Brownie cameras. Nashville honcho Wesley Rose wants to keep the rock 'n' roll overtones out of country music, and T.E. agrees: "Let's face it," he says, "Elvis Presley is about as country now as Bill Haley is."

An Easter Sunday rock 'n' roll show starring Carl Perkins, the Diamonds, and Moon Mullican is cancelled because of Perkins's auto accident in Delaware. He is forced to watch from a hospital bed as Elvis steps all over his blue suedes on the April 3 *Milton Berle Show*. "Is there any doubt in anyone's mind that Presley has deserted country music?" wonders Edwards. He has a record player installed in his Buick so he can audition the new record releases while driving to and from the studios. It works like a charm, just as long as he doesn't hit any potholes. There's a growing anti–rock 'n' roll movement in the Midwest, especially in Chicago, where rock tunes are being banned and the jocks are required to stick to the top 40 records compiled by the station brass.

In May Tommy gives away two thousand pictures of Elvis at a shopping center anniversary party, and it turns into a teenage mob scene. Meanwhile, Presley's stuck out in Vegas, playing to the wrong generation at the New Frontier Hotel. Bill Haley's big rock show comes to Cleveland on Tuesday, May 8, and record hops, now considered hotbeds for juvenile delinquency, are being cancelled all over the country. Tommy has a marvelous time down in Wheeling, West Virginia, when he appears as guest country deejay on WWVA's *Command Performance* show. Bobby Darin plays the Cabin Club on May 12, followed by the Rover Boys the next weekend. Record companies are flooding the market with long-playing albums, and they're really starting to take off.

On June 15, a big rock 'n' roll show starring Pat Boone, Clyde McPhatter, and many others takes over the Hippodrome Theater downtown. Clevelanders can see the *Eddy Arnold Show* on ABC-TV shown on Wednesday nights at 9:30 P.M. *Billboard* magazine's "Vox Jox" column points out that Edwards originated the current deejay "newsletter craze." Thirty-five hundred teenage girls each send in 15 cents for Tommy's latest "Picture Pac," which features black and white photos of Elvis Presley. Pat Boone appears at Cleveland's Mentor on the Lake Ballroom on June 29.

Cleveland teens are pissed off by the way Elvis was ribbed and acted subdued on the July 1 episode of *The Steve Allen Show*. Tommy spins records and shows color slides for the wayward delinquents at Blossom Hill School for Girls and emcees a free record hop at a filling station in Parma, drawing a thousand kids. *Cleveland News* radio editor Maurice Van Metre prints a column crediting Edwards with being the first to bring Elvis to town. The newest "Picture Pac" includes photos of the late James Dean, Elvis Presley, the Diamonds, and Gene Vincent and generates five thousand requests. Edwards is completely flooded with mail.

Unfortunately, Tommy starts August out at the chiropractor, nursing a bad back. By

mid-month he's back in action, broadcasting live from the Cuyahoga County Fair. Tony Bennett writes in that he'd like to be on the "T.E. Newsletter" mailing list. Johnny Cash's "I Walk the Line," already a country hit, is getting plenty of pop airplay as well. A rash of new LPs is released by various labels in tribute to actor James Dean. To help keep up with the overwhelming influx of new wax, Edwards installs an audition record player at his desk at WERE.

The Catholic diocese polices a September church dance hosted by Edwards. No Elvis Presley photos, records, or color slides allowed. Tommy's busy "taking pictures like mad" of everyone who visits the station, and handsome overnight jock Carl Reese marries a lovely local model, Ellen Terry. Bluegrass king Bill Monroe plays the Circle Theater's *Hillbilly Jamboree* on September 15. Around 1950, polkas were big business in Cleveland, and Edwards thinks the time is ripe for a polka comeback—so he plays a few on his daily show, to favorable listener response. This October, one of the biggest breaking records in town is the Atlantic disc by Ivory Joe Hunter, "Since I Met You Baby." Patti Page writes in to tell Tommy about her Hollywood screen test, and jazz great Gerry Mulligan opens at the Cotton Club. Rockabilly pistol Wanda Jackson fills the seats at the Circle on October 13, and Mother Maybelle and the Carter Sisters star on the twentieth. As a gimmick, Edwards offers free copies of Tennessee Ernie Ford's single "First Born" to the first 25 mothers who send in a snapshot of their firstborn; 625 moms comply.

1956 closes with a flurry of activity. In Elvis's first area appearance since the Circle Theater in October 1955, a blizzardy November 23 concert at the Cleveland Arena fans the flames of an already raging Presley backlash when thousands of hysterical girls throw underwear and themselves at the singer. The Dot Records rep gossips that Pat Boone's new hit wax, "Don't Forbid Me," was written with Elvis in mind, and *Look* magazine sends out a sample tube of the new Elvis Presley Hound Dog lipstick in conjunction with a forthcoming story on the "Presley Industry." Tommy hints at a possible TV country music show in the works and travels to New York City to record his first single for Coral Records. The Chatterbox hosts rhythm and blues group the Ravens, Duke Ellington tickles the ivories at the Cotton Club, and Chet Baker blows his horn at the Loop Lounge. In December, WERE bans the rock 'n' roll single "Saturday Night" by Roy Brown. And then there's the rather disturbing news that a rat bit country star Jimmy Wakely's son. Tommy features the top ten country records of the year on his *Hillbilly Jamboree* radio show on Saturday, December 29. The list includes Marty Robbins's "Singing the Blues," Elvis's "I Forgot to Remember to Forget," and Carl Perkins's "Blue Suede Shoes." Finally, Charlton Heston, still singed from Mount Sinai's burning bush, comes in to promote his biblical blockbuster, *The Ten Commandments.*

Little Willie John's "Fever," Gene Vincent's "Be-Bop-A-Lula," and the Cadets' "Stranded in the Jungle" are some of the big rock 'n' roll sellers at Lamp's Melody Lane record shop. Country hits for 1956 include "You Gotta Be My Baby" by a very Hank Williams–sounding George Jones and "You're Running Wild" by the Louvin Brothers. "Poor People of Paris" performed by Les Baxter and the theme to John Wayne's film *The Searchers* by Danny Knight are just two of the more interesting pop titles of the year.

Richard Hayman

January 1956

Nearly three years before this photo is taken, Richard Hayman was just another hardworking musician trying to earn a living doing what he loves best. Enter WERE deejay Bill Randle, who apparently has the uncanny ability to smell hits. The B-side to Mercury 70146 is a song called "Ruby" and it's particularly fragrant. The record knocks everyone's socks off, and the harmonica virtuoso skyrockets into the heady world of pop-music stardom.

Now thirty-six years old and in high demand as a conductor, arranger, and composer, Hayman hopes his new Mercury pairing of "Street of Tears / Autumn Concerto" appeals to Bill Randle's schnoz as well. It doesn't.

This was back in the good days when you could visit deejays. Music was always fun for me, and I appreciated being on the radio. I felt honored to get the exposure. In the photo I'm playing an M Hohner Chromatic twelve-hole harmonica in the key of A—it has a larger reed for a more mellow tone. Part of my success is due to my vibrato. Most people achieved vibrato using their hands. I never liked that sound, it sounded too nervous. I created the vibrato in my throat, like an oboe player does. Growing up, every kid played harmonica. It's easy to carry around. The ring I'm wearing was purchased in 1938 or '39 during a visit to Rio De Janeiro at Casino Da Urca, a beautiful casino at the foot of Sugar Loaf mountain. It holds a blue aquamarine stone, known as the Diamond of Brazil. I bought it as a souvenir. I still have it somewhere. I wanted to be famous, but I didn't want anyone to know what I looked like. I liked the idea of having fame but still being able to walk into a restaurant and not be disturbed during dinner.
 —Richard Hayman, North Palm Beach, Florida,
 June 2009

Eddy Arnold

Thursday, January 12, 1956

Brushing an eager reporter aside, country music superstar Eddy Arnold (Richard Edward Arnold) negotiates his way through the cramped confines of the March of Dimes RCA Victor Starliner Tour train. Three special railroad cars have been reserved for seventeen recording artists as they set off on a multi-city campaign, fighting polio.

The battle against a crippling disease notwithstanding, the thirty-seven-year-old is interested in his own survival as well. Recognizing the rock 'n' roll elephant in the room, Arnold astutely senses it's time for a career intervention. So he begins to distance himself and his music from the square "Tennessee Plowboy" image, in favor of a more mainstream or sophisticated "countrypolitan" approach.

A precursor to the full-bodied Nashville Sound of the early 1960s, producer Steve Sholes sets the singer's sleepy baritone against lush, string-laden pop arrangements, positioning him at the forefront of a new era in country music.

RCA's March of Dimes trainload of recording artists comes to Cleveland on Jan. 12th—artists include Vaughn Monroe, Lou Monte, Jay P. Morgan, Terri Stevens, Diane Carroll, Teddi King, Nan Wynn, Rhythmettes, Mike Pedicin, Eddy Arnold, Rita Robbins, Joe Reisman, Richard Maltby, and others—Joe Carlton included.
—"T.E. Newsletter," Vol. 3, No. 13, January 6, 1956

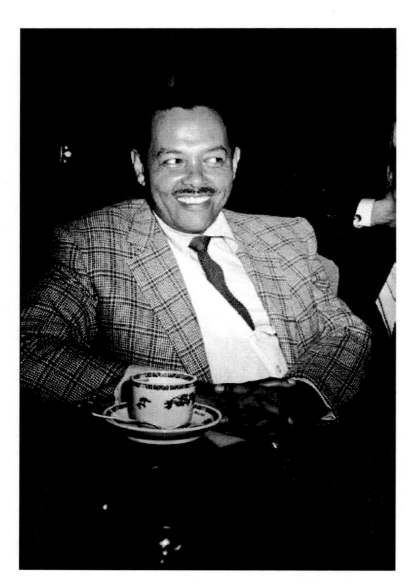

Billy Eckstine

Thursday, January 12, 1956

Ever the sharp dresser, forty-two-year-old crooner Billy Eckstine (Charles Clarence Eckstine) enjoys the hum of the rails and some hot java. A three-car special train, seventeen top recording stars, eleven major cities: polio doesn't stand a chance now that the March of Dimes RCA Victor Starliner Tour is in town.

The Fabulous Mr. B will return to Cleveland on Sunday, March 4, to sing his beautiful new ballad, "The Bitter with the Sweet," on WEWS-TV's *Bill Randle Show*. That rich vibrato will satisfy as always, holding us in its warm hug then gently releasing only when he's sure we're his.

The RCA Victor March of Dimes Tour is off to a flying start as they stopped here in Cleveland on the second day yesterday—the artists are getting little sleep—no showers—working hard both at the hospitals and then back on the train for interviews and pictures. These folks have a long way to go yet and are doing a marvelous job for the polio fund. Watch to see if RCA comes up with a showboat tour this May from Pittsburgh to New Orleans (this is for real). Phil McLean and Bill Randle both did their entire shows from the train—I taped interviews for later use——Billy Eckstine flew in from the coast to appear on the tour——Others here in town were Vaughn Monroe, Terri Stevens, Teddi King, Tony Travis, Rhythmettes, Lou Monte, Nan Wynn, Mike Pedicin, Jim Reeves, Eddy Arnold, Joe Carlton, Bernie Miller, Richard Maltby, Diahann Carroll——Jay P. Morgan joins the train in Detroit.

—"T.E. Newsletter," Vol. 3, No. 14, January 13, 1956

Jim Reeves

Thursday, January 12, 1956

There's a miniature recording studio in one railcar and plenty of booze, stinky ashtrays, and rumpled berths in the other two. That's the tight-quarters set-up aboard the March of Dimes RCA Victor Starliner Tour train, which brings 6'2" country music hit-maker Jim Reeves to Cleveland today.

The thirty-two-year-old Grand Ole Opry star has joined a caravan of recording artists united against polio for an eleven-city whirlwind tour. Swarms of inquisitive deejays, shouting newspapermen, and back-slapping city officials crowd around the singer, who could probably use a hot shower and a good steak.

Armed with an arresting baritone and carrying himself with an air of quiet dignity, Reeves is intent on moving Nashville's sound out of the barn and onto the pop charts. Great-sounding singles like "Four Walls" (1957) and "He'll Have to Go" (1960) lead country music's charge for mainstream success.

But these hits are destined to be bittersweet reminders of all the words left unsung. On July 31, 1964, a single engine plane piloted by Jim Reeves crashes during a Tennessee thunderstorm, killing the star and his manager/pianist, Dean Manuel.

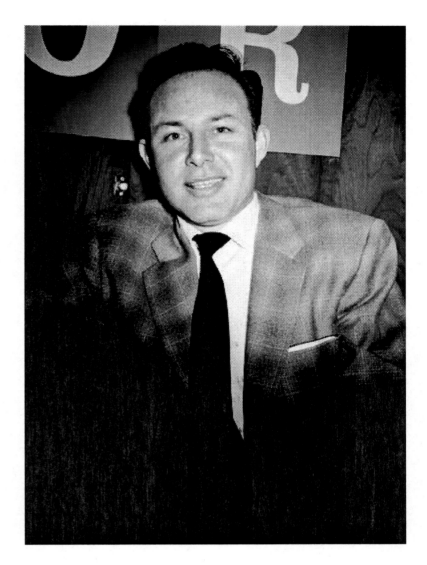

I was busy at the RCA Victor March of Dimes train yesterday afternoon and evening taking color pictures for my record hops. Chick Crumpacker of RCA is real high on Jim Reeves' IF YOU WERE MINE—with good reason, too.

—"T.E. Newsletter," Vol. 3, No. 14, January 13, 1956

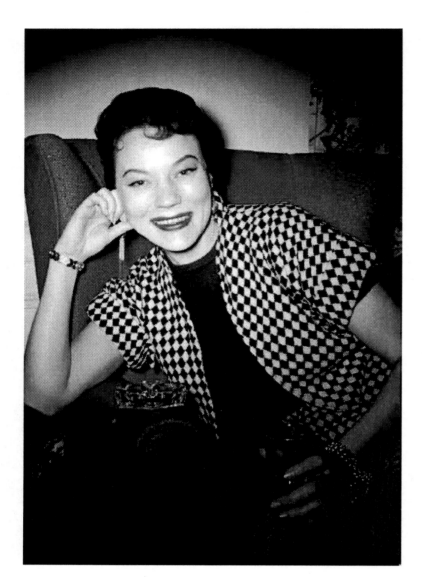

Jerri Adams

Wednesday, January 18, 1956

Twenty-six-year-old jazz singer Jerri Adams partakes of a little afternoon delight at a cocktail party thrown for orchestra leader Percy Faith, courtesy of song plugger Julie Stearn.

Adams is sure to serve up her stunning interpretation of Blackburn and Suessdorf's "Moonlight in Vermont" when she performs this week at the Theatrical Grill, 711 Vincent Avenue. Her most recent Columbia single, "Walk Fast," was recorded just weeks ago with Faith in New York City, under the critical eye of producer Mitch Miller.

Citing musical influences such as Ella Fitzgerald, Woody Herman, and Lionel Hampton, Jerri has an absolute dedication to jazz, treating the art form as sacred and never compromising or second-guessing her artistic vision. Her obvious love for the music is our gift. Simple, beautiful, timeless recordings.

I remember Tommy. Phil McLean, he was a sweetheart. Bill Randle was the one you had to see first, he made that perfectly clear. Back then, WERE was the station that could break your record wide open. I bought that outfit I'm wearing in a boutique in New York City. I liked wearing those wild looking dresses. I got high on singing. There was such a joy in being asked to express myself. I was in the right place at the right time. I was very lucky.

—Jerri Adams, Bothell, Washington, April 2009

Joanne Gilbert

Monday, January 23, 1956

Any volunteers? Looks like it's cuddle time for Hollywood starlet and supperclub singer Joanne Gilbert. The pixielike twenty-four-year-old Chicagoan sings for Decca, and her latest wax is "One Too Many Loves / Sweet Georgia Brown."

When appearing at the Waldorf in New York or the Mocambo in Hollywood, Joanne prefers sexy, glamorous dresses. One can only hope the former fashion model will feel compelled to wear what the *Los Angeles Times* calls her "famous short pants" when she performs next month at the San Souci nightclub in hot and steamy Havana, Cuba.

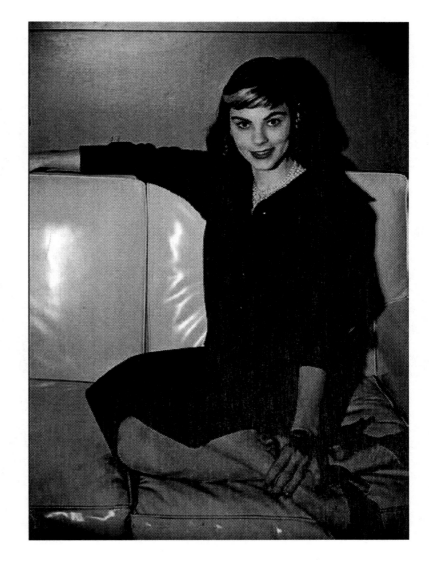

The Mello-Larks

February 1956

Keeping any marriage together is challenge enough. But see what happens when you add to the mix two ambitious artists, their egos, and a wide age gap.

As the husband-and-wife half of the Mello-Larks, one of the nation's hardest working vocal groups, twenty-two-year-old Jamie Dina and thirty-four-year-old Tommy Hamm (lower left) know all too well what happens. You're in for a bumpy ride. The quartet's less volatile pair, Joe Eich and Bob Wollter, must be hoping the two lovebirds can keep their claws off each other, at least until this deejay fella with the camera snaps this picture.

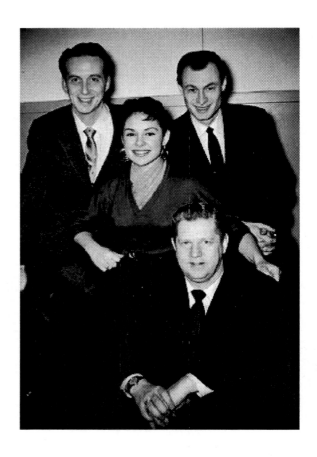

We were promoting "Mr. Wonderful" on Epic. The arrangements were by the great Neal Hefti. We had worked with Neal on the Mel Torme Show in '51-'52. Right after we got our deal with Epic, I was walking down the street and ran into Neal. He asked what we were up to. He had never heard of Epic; it was a brand new label. About a month later, when our A&R guy asked who we wanted to work with I said, "Neal Hefti." The guy laughed and said, "You can't get Hefti, he's too big." I called Neal and just handed the phone to the A&R guy. When this photo was taken, Jamie and I were married. She had joined the group when she was just eighteen, she was too young, hadn't learned to live yet. She eventually found a trumpet player she liked better than me. But Jamie was incredibly talented. I kept marrying singers. I finally married a dancer, and that lasted thirty-five years.

—Tommy Hamm, Pinehurst, North Carolina, August 2009

I was just a little girl from Brooklyn who wanted to be a dancer. My first audition was for the Mello-Larks in 1952. I was eighteen years old and got the job as lead singer and traveled with the group for five and a half years. We played the Copa in New York City two times, once with Harry Belafonte and then with Tony Bennett. We also played in Vegas; we even played a chic gambling casino in Cuba, a little before Castro took over. It was wild. In between nightclubs, we constantly did radio stops. We did many radio interviews with Bill Randle in Cleveland. The clothes I am wearing in the photo are AWFUL! They are typical, put-together road garb. The earrings were clip-ons and cheap junk. We drove around the country in a big Cadillac and lived out of a suitcase. I would NEVER tell a young and enthusiastic girl or guy NOT to take that route. It was a great learning experience. It was my college! As far as getting married so young, I really didn't know what I was doing back then. It seemed like the right thing to do. It was very difficult being married on the road. But Tommy was a very nice man, you know.

—Jamie Dina, Lagrangeville, New York, August 2009

Marguerite Piazza

February 1956

She had been the Metropolitan Opera's favorite prima donna; a breakout star on Broadway; songbird glamour girl beside Caesar and Coca on NBC's *Your Show of Shows* as well as a natural brunette.

It's time for thirty-year-old singer-entertainer Marguerite Piazza to reinvent herself yet again. The sophisticated supper-club sound of her new ABC-Paramount single, "My Dream / The Devil, the Angel, and You," hints at what lies ahead for the soprano.

Ever the risk-taker, Marguerite will populate her act with daring onstage costume changes and controversial themes, always striving for innovation, never satisfied with second best.

I was a blond for two months of my life. I got the idea from wearing white costume wigs in eighteenth-century opera stories, and everyone loved the white wigs, but the white and blond hair was not good with my black eyes. I was performing at the Chez Paree Club in Chicago as a blond until one day an audience member wrote me a note saying, "You're not the person I came to see." So I decided to go to the beauty parlor that day, and they made me a brunette again. That night, I was myself once again and have never been a blond since. The gold key dangling from my bracelet was presented by the Pierre Hotel in New York for my engagement there. It's the key to my suite at the Pierre. I also had a gold key from the Chez Paree. I still have the pearl grape cluster brooch. It was the very first piece I bought for myself. I was on a cruise and in Jamaica I found an antique jewelry shop called Spitzer and Furman. It's very pretty. I have lost many, many pieces but not this one. I like pearls.
 —Marguerite Piazza, Memphis, Tennessee, May 2009

Barbara Ruick

February 1956

"More than your eyes have ever seen!" Although befitting the sexy twenty-five-year-old actress and singer Barbara Ruick, this tagline instead refers to Twentieth Century Fox's amazing new CinemaScope 55, the photographic innovation of filming on 55 mm and reducing to 35 mm for projection. The just-released Rodgers and Hammerstein musical *Carousel* bears the distinction of being the first film shot in CinemaScope 55 and stars Ruick as the madcap Carrie Pipperidge, the second female lead. Stumping for the studio, the starlet explains the technical ins and outs of the spectacular viewing experience awaiting moviegoers, making the case to WERE listeners with clarity and charm.

Let's hope Barbara keeps her sense of humor when she learns that *Carousel* won't be exhibited in 55 mm after all. A production schedule rushed because of competition fears has mucked up the works, and Fox mogul Darryl F. Zanuck soon shelves the cost prohibitive process.

In just a few months, marriage and babies will take precedence over her career, making *Carousel* Barbara Ruick's last movie until she resurfaces in 1974 for a cameo in director Robert Altman's *California Split*. While shooting on location in Nevada, she dies alone in her hotel room of a cerebral hemorrhage at only forty-three years old.

Jerry Vale

February 1956

Jerry Vale (Genaro Vitaliano) has come a long way from singing for tips in a Bronx barbershop. On his new Columbia Records disc, "Innamorata," he sounds like he's coming unhinged, feverishly awaiting the rapturous heaven of his Italian sweetheart's kiss. It finally comes and it's a bit anticlimactic. Dean Martin gets the hit, and the diminutive Vale gets jilted.

The ruby ring was a high school ring from Evander Childs High School in the Bronx, New York. Perry Como was my biggest influence. Cleveland was very good to me; I believe it was the Carousel Tent that I worked for years. My records did quite well because of deejays like Tommy Edwards and Bill Randle.

—Jerry Vale, Palm Desert, California, June 2009

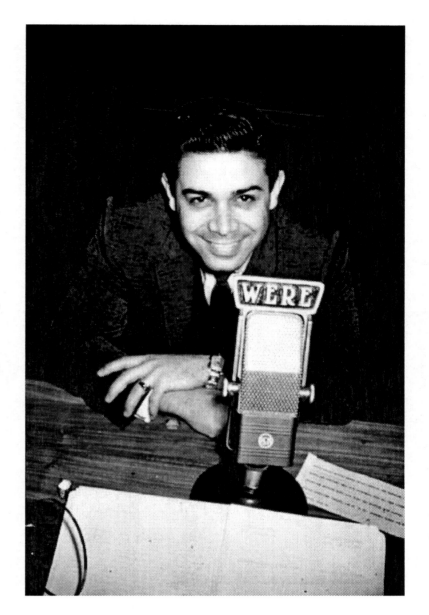

The Chordettes

February 1956

Cadence Records' premier ambassadors, the Chordettes: Jinny Osborn (tenor), Lynn Evans (lead), Carol Buschmann (baritone), and Janet Ertel (bass). Between the book-ends of their two smashes, "Mr. Sandman" (December 1954) and "Lollipop" (March 1958), comes an unusual choice.

"Eddie My Love," as originally recorded earlier this year by doo-wop group the Teen Queens, is a sweet and innocent ode to

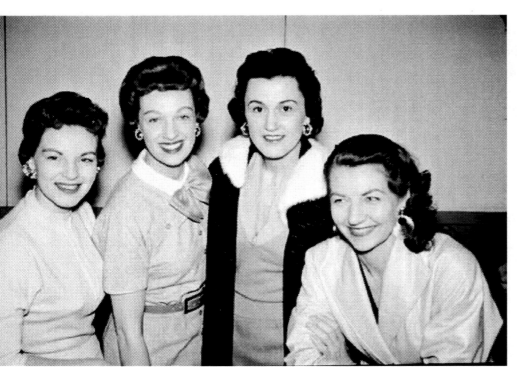

puppy love. The Chordettes' version, sung by husky-voiced bass Janet Ertel, comes off like a frisky femme fatale working her seductive charms. It's a strange record, one that leaves you feeling like you need a good scrub.

This photo brought a smile. I do remember Tommy. He was handsome, and that always went down

real well with us girls. The lead on "Eddie My Love" was sung by the greatest bass of all time: Janet Ertel. Some folks called her a good old "saloon singer." We never said that, but she did have the greatest and sometimes suggestive solo voice. Janet always wore her hair straight and long with one side covering part of her face. Here in this picture, she had it back, which was unusual. During that time we were hitting every major city, and I recall performing in Cleveland at the Sky Lounge, out by the airport. My brother Russell was in the audience. He was a fine pianist, had perfect pitch, and I was scared to death that we wouldn't be great. My lips twitched, and I knew I was really nervous. It all came out fine, but his presence really threw me at that point in time. When recording, we always used just one microphone, and that was the reason Cadence producer Archie Bleyer would become so frustrated when he couldn't get the same sound we gave in person when recording. But he did something right, as the sound has held up. Archie would alternate with lead lines now and again, depending on what the song called for. Sometimes Jinny would have the lead on a song and sometimes Carol, but most often I did the lead lines. We would spend hours recording with the orchestra or whatever instruments he wanted on the arrangement. There was no taping the band ahead of time. We were all there together many hours until the session was over. He wanted the very best arrangement of instruments that would complement the voices.

—Lynn Evans, Elyria, Ohio, January 2009

Hank Locklin

March 1956

Country music's Hank Locklin sings in a high, soulful tenor, unafraid to pierce the darkness of that hidden place inside us all, where the memories of lost loves linger. His is a brutally honest instrument, soft enough around the edges to keep us listening. When the thirty-eight-year-old RCA recording artist sings his deceptively simple honky-tonk songs, something extraordinary happens: we hurt a little bit less.

His sensational embroidered apparel is most likely a custom order from Nudie's Rodeo Tailors of North Hollywood, the same Ukrainian tailor who will outfit Elvis Presley in resplendent gold lamé next year.

Hank Locklin's GOOD WOMAN'S LOVE gets in our top ten for the first time this week—here's a record with a sound.

—"T.E. Newsletter," Vol. 3, No. 21, March 2, 1956

Grandpa Jones

Saturday, March 3, 1956

He's been wearing a fake mustache for over twenty years. Forty-two-year-old Grand Ole Opry character star Louis Marshall "Grandpa" Jones poses in heavy makeup along with his weapon of choice, a five-string banjo. Hillbilly bumpkin in the footlights only, Louis is a stalwart champion of traditional country music, a hardworking purist intent on keeping all the old songs alive. On "Rock Island Line," his latest King Records disc, he brags about smuggling pig iron through the railroad tollgate.

Tonight Grandpa brings his spunky brand of comic relief to the Circle Theater's *Hillbilly Jamboree.* He's sure to set the woods on fire with his rowdy, clawhammer-style banjo playing and flirty antics. Also on the bill is singer/fiddler Ramona Riggins, his wife of twenty years.

Jones is still ten years shy of senior citizen status when he joins the cast of CBS-TV's *Hee Haw* in June 1969. As the star of a popular recurring sketch on the show, week after week he's posed with the immortal question: "Hey Grandpa! What's for supper?"

Dick Duane

March 1956

"One of the brightest shining new lights in the music business." That's quite the introduction, especially coming from WERE's Bill Randle, moonlighting as the host of his own frantically paced half-hour television program, seen on channel 5, Sunday nights at 10:30 P.M.

Twenty-three-year-old pop vocalist Dick Duane kicks off the evening's entertainment with a melodramatic reading of his latest single, his last note followed by polite applause as he quickly exits for another all-night drive to the next gig. One of the brightest shining new lights, perhaps, but the singer's tired expression embodies the lonesomeness of late-night truck stops, cheap motels, and the miles and miles left to go. The road is murder.

Randle's March 4 show also features performances from Billy Eckstine, Nick Noble, Joe "Fingers" Carr, and the Four Coins.

DICK DUANE calling to plug his wax of TO MAKE A MISTAKE on ABC.

> —"T.E. Newsletter," Vol. 3, No. 19, February 17, 1956

Boy, this has triggered some old memories. I remember Tommy Edwards and Bill Randle very well. They were always very supportive of me and my career and promoted my records. I did a sock hop with Tommy and sang "Siboney," one of my earlier hits on ABC Paramount. On tour, most people lip-synched their records but I sang live (to the instrumental track) or sometimes to a piano and rhythm section as I did on the *Bill Randle TV Show* right before going to New York for an appearance on the *Ed Sullivan Show*.

> —Dick Duane, New York, New York, April 2009

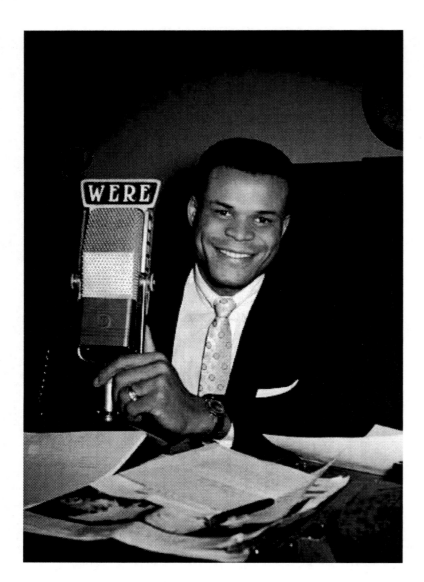

Roy Hamilton

Friday, March 16, 1956

The "Golden Boy of Song," handsome twenty-seven-year-old Roy Hamilton thrills listeners by performing a few lines a cappella from his latest Epic single, "Walk Along with Kings." The former heavyweight Golden Gloves boxer is a delicate soul, a man whose susceptibility to the ravages of the music business will end his life tragically at age forty.

Roy's contributions to twentieth-century music must be measured not only by his stellar, definitive performances but also by the respect attributed to him by his peers. Elvis Presley's personal record collection reflects his admiration for Hamilton, the unique beauty and operatic qualities of Roy's voice inspiring him to improve his own vocal range. Just listen to Presley's impassioned performance of Roy Hamilton's 1954 signature song, "You'll Never Walk Alone": you'll hear a determined fan trying to top his idol, who in the end must settle for second best.

Roy Hamilton guests on Phil McLean's BAND-STAND TV Show on Saturday afternoon (17th).

—"T.E. Newsletter," Vol. 3, No. 23, March 16, 1956

Vicki Benet

March 1956

A beautiful, but lonely mademoiselle curls up on the sofa as the exciting scents of the city dance through her apartment's open window. In the distance, the Eiffel Tower basks in the warm glow of a setting sun. Red lips parted with anticipation, she waits for your knock at the door, when you'll take her into your arms, and then . . .

Many a man has fallen under the spell of a Vicki Benet album cover. Bedroom eyes and provocative poses on LP jackets help sell records, and the savvy twenty-three-year-old torch singer gives her public what it wants.

But underneath all the commercial titillation, it's the music that matters to Benet. Born in the Montmartre section of Paris, France, she emigrates to America and pays her dues by coming up through the dives of the cabaret scene. Her sultry voice and unique interpretations of ballads eventually earn her engagements at the best nightclubs around the world. She is an artist and a street-smart survivor, intent on sustaining her career through the onslaught of rock 'n' roll, which threatens to derail her dreams.

The photo has a warm feeling to it. The bracelet was given to me by my then manager and future husband, Jack Elliott. Each charm signified an important event in my career. One charm was for the release of my first single. Another, for when I opened a beautiful supper club in LA called John Walsh's 881. There's one commemorating my London Savoy gig. I still have it, and it brings back happy memories. I was on Tommy's show promoting my Decca album called *Woman of Paris: Introducing Miss Vicki Benet*. All the deejays liked to have my albums because there was always a sexy photo on the cover. It was glamorous, and I loved it. I don't sing anymore, sometimes at parties. When I do, I say, "Aaahhh, what a great feeling, I remember that!" When you give up something that was so close to you, part of you dies.

—Vicki Benet, Los Angeles, California, April 2009

The Shepherd Sisters

March 1956

Real blonds, real furs, real talent—and real sisters to boot. Martha, Gayle, and Mary Lou Shepherd open Tommy Edwards's personal dog-eared copy of the March 31, 1956, issue of *Cash Box* to the glowing review of their fine new recording for Melba Records, "Gone with the Wind."

If one could forget Frank Sinatra's beautifully tragic rendering of the song featured on his album *Only the Lonely* (Capitol, 1958), the girls from Middletown, Ohio, deliver what must be considered the definitive version of the Wrubel-Magidson composition. A punchy arrangement replete with fun, swooping harmonies and two cocky, honking sax solos courtesy of Melba owner Morty Craft, the sisters marvelously shape and stretch the arrangement for all its worth.

The ladies have many memories of Cleveland, WERE and all of the deejays. They remember them all, but don't ever talk about that part of their lives. They all went on to other careers. That was only an early part of their lives. As for their ages, no comment. In the current vernacular, "We don't go there."

—Patrick Peduto, Shepherd Sisters representative, La Quinta, California, May 2009

Andy Williams

Sunday, April 1, 1956

Apiologists, or those people who enjoy studying honeybees, have a rather unscientific term for it: "nectar coma," which refers to the lethargic stupor bees fall into after too many hits of nature's powdery elixir. Comparably, listeners who are overexposed to the sweet baritone of twenty-eight-year-old Cadence recording artist Andy Williams may experience such symptoms.

"Walk Hand in Hand / Not Anymore," the pop singer's second release for Archie Bleyer's Cadence Records, is making small noises on the charts, though nothing much to write home about. Come September, however, "Canadian Sunset" hits the top 10, and Williams goes on to successfully pollinate a flourishing career teeming with sugary-sounding hits, signature sweaters, and Christmas TV specials ad infinitum.

Two of the stars on Bill Randle's TV show here on Easter will be Helen Merrill and Andy Williams.
—"T.E. Newsletter," Vol. 3, No. 25, March 30, 1956

When I first started recording for Archie Bleyer in the '50s, I would often come to Cleveland and do the rounds of deejays like Tommy Edwards and Bill Randle and sometimes do record hops, too. It was a way for unknowns like me to get my records played. They could break a record, and many times did just that. Thank God for deejays.
—Andy Williams, Branson, Missouri, November 2009

Mona Carol

April 1956

Tommy Edwards may be ten years married, but he's not blind. The thirty-five-year-old deejay seems quite smitten with raven-haired pop-song stylist Mona Carol, referring to her as a "real beauty" and a "beautiful girl" in the April 6 and August 24 issues of the "T.E. Newsletter."

By the time "Miss Juke Box of 1956" appears at 10616 Euclid Avenue's Cabin Club on October 26, it looks like her career has peaked. She drops in on the boys at WERE, presumably affording T.E. with his second and last opportunity to do some flirting.

HOUSEWIVE'S RECORD OF THE WEEK: The Casino record by Mona Carol, WILL YOU ALWAYS BE MY SWEETHEART was pick of the week for the 5 consecutive plays on my show.
—"T.E. Newsletter," Vol. 3, No. 21, March 2, 1956

MOE PRESKELL calling to say that WILL I ALWAYS BE YOUR SWEETHEART is showing some encouraging action—Mona Carol out on the road with it.
—"T.E. Newsletter," Vol. 3, No. 26, April 6, 1956

The Louvin Brothers

Saturday, April 7, 1956

Thirty-two-year-old Ira and twenty-nine-year-old Charlie Louvin (Loudermilk) are spiritually proud men who'll smile and harmonize tonight for an appreciative crowd attending the Circle Theater's *Hillbilly Jamboree.*

While the Louvin Brothers' gospel recordings warn that Satan is real and prayer is a weapon, obsession with death and themes of fear plague their best secular work as well. Stellar samples are the suicidal narcissism of 1955's "When I Stop Dreaming" and the boys' latest Capitol single, a paranoiac's love letter, "Hoping That You're Hoping."

Over the next few months, the brothers' personal relationship rapidly deteriorates as their archaic, searing bluegrass harmonies fall out of sync with the rock 'n' roll explosion happening around them. Ulti-

mately, Charlie will walk away from his alcoholic brother in an act of defiance and self-preservation, and the Louvin Brothers will cease to exist. A June 1965 wreck on the highway kills Ira, thwarting any plans for a reconciliatory reunion.

The Louvin Brothers' celestial sound, made by voices responsible for some of the most frightening American music of the twentieth century, must be experienced. Find a copy of the 1956 LP *Tragic Songs of Life.* Turn the lights down low and let the needle drop on "In the Pines." Feel the cold wind blow, and watch the ghosts gather.

Understand that the Louvin Bros. drew big last week but didn't endear themselves to the people they worked with—a little too big for their britches they tell me.
—"T.E. Newsletter," Vol. 3, No. 27, April 13, 1956

We performed for Tommy at the Circle Theater. It was a great audience that night. I remember there was some controversy over us being offered another show, but Tommy said, "No, if you're on my radio show, that's all you need to fill the theater," and he was right. We always loved to record real songs, songs real to life. All a great song needs is three chords and honesty. Ira could be a real perfectionist when it came to recording. It took someone with authority, a producer, not a brother, who would make the call and say, "That's the take." Did you know we toured a hundred days with Elvis when Elvis was an "also" on the bill? The Colonel would go to the local Woolworth and give the teenagers, young girls, free tickets if they promised to scream "We Want Elvis!" all through the show. It became very difficult for us to get through a song, to do our show with all that screaming going on. Ira got mad and drank too much. We were in a Carolina high school where one of the classrooms served as a dressing room for all the acts. Elvis came in and sat at the piano and said, "Now this is what I like" and proceeded to play a gospel song. Ira said something back to him that I feel should never be said, but the truth is the truth and this is what he said: "You fucking white nigger, then why do you play that stuff on-stage?" I don't think Elvis ever forgot that, and he never recorded one of the Louvin Brothers' songs. My wife is from Memphis, so we knew Elvis's mom quite well. Whenever we passed through, we'd take her a copy of our latest gospel album. I believe we were one of her favorites.

—Charlie Louvin, Manchester, Tennessee, December 2008

Tony Bennett and Lu Ann Simms

Tuesday, April 10, 1956

With Cleveland Municipal Stadium as their backdrop, Columbia recording artists Tony Bennett (Anthony Dominick Benedetto) and Lu Ann Simms wield wooden swords and share a good laugh on this cold spring day.

The two singers have just stiffly piled out of a United Airlines streamliner onto the tarmac of Burke Lakefront Airport, ready to fight the good fight as Flying Crusaders on behalf of the American Cancer Society. The whirlwind ten-city junket promoting cancer awareness also gives the thirty-year-old former singing waiter from Queens the opportunity to sell a few copies of his latest single, the jaunty "Sing You Sinners." Twenty-three-year-old Lu Ann's platter "Nosey" features some tasteful backing from the Percy Faith Orchestra.

The Cancer plane came in last Tuesday with Percy Faith, Mitch Miller, Lu Ann Simms, Guy Mitchell, Tony Bennett and Peggy King—I will use pictures of their arrival on my first TV show here on KYW on Sunday, April 15.

—"T.E. Newsletter," Vol. 3, No. 27, April 13, 1956

Peggy King and Ann Mull

Tuesday, April 10, 1956

Yes, the show must go on, even as exhaustion sweeps over twenty-six-year-old pop vocalist Peggy King. One plane, ten cities, three shows a day: dubbed the "Flying Crusaders" by the press, King and fellow Columbia recording artists Tony Bennett, Lu Ann Simms, Percy Faith, Guy Mitchell, and Mitch Miller battle fatigue and discord on tour for the American Cancer Society.

The "Venus in Furs" is a thirty-four-year-old former restaurant hostess named Ann Mull (Ann Marie Lengle), Tommy Edwards's thirty-four-year-old wife, who enjoys stopping by the radio station to

soak up a little of her husband's glamorous lifestyle. Married ten years this November, Ann and Tommy are very much the well-synchronized team, with the pretty, sociable wife making the more reserved deejay look good. Sinking just a bit deeper into the cushions, Peggy listens as the opinionated

Mull raves, possibly about "Learning to Love," a recent single on which King cops the no-vibrato sound of her idol Margaret Whiting, with stellar results.

Peggy King tells us that she is building a ten unit apartment house in her hometown of Ravenna, Ohio, and she will have her folks live there and manage it for her—it's about 45 miles from downtown Cleveland.

—"T.E. Newsletter," Vol. 3, No. 27, April 13, 1956

You know, it's amazing. I took one look at that pin I'm wearing, and it all came flooding right back. We all wore that sword pin on the cancer awareness tour. As a matter of fact, there was a life-size version of the pin that fell in front of the airplane's bathroom door, and I couldn't get out! It was a tough, stressful tour. As it progressed, so did Lu Ann Simms's cursing. She was not cut out for the business. She sort of lucked into her success and never really wanted it like the rest of us. Guy Mitchell is quite mad. He was supposed to be our chaperone on the trip. What we needed was a chaperone for the chaperone. Mitch Miller didn't get along with anybody. Mitch first heard my singing on a Hunt's Tomatoes radio jingle while driving. He thought I was the most commercial voice he'd ever heard. Nearly went off the road into the Hudson. He called and said, "This is Mitch Miller" and I said, "Oh, really? This is Snow White" and hung up. You know, deejay Bill Randle had a terrible crush on my roommate, Debbie Reynolds. He would write to me, asking about her. He was absolutely gone on her.

—Peggy King, Philadelphia, Pennsylvania, May 2009

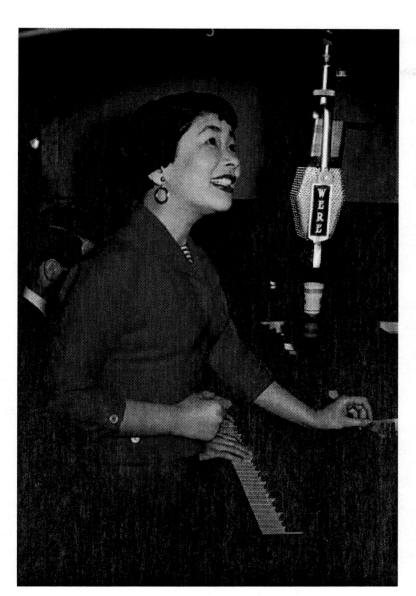

Miyoshi Umeki

April 1956

Twenty-seven-year-old singer and actress Miyoshi Umeki delicately delivers Irving Berlin's "How Deep Is the Ocean," the A-side of her debut Mercury single. On March 26, 1958, listeners will enjoy recalling this afternoon's on-air performance when she graciously accepts the 1957 Academy Award for Best Actress in a Supporting Role in Warner Brothers' *Sayonara*.

HOUSEWIVE'S RECORD OF THE WEEK: This week we give the nod for record of the week to the Japanese girl, Miyoshi Umeki and her record of HOW DEEP IS THE OCEAN.
—"T.E. Newsletter," Vol. 3, No. 27, April 13, 1956

Guest stars on Bill Randle's TV show this weekend will be The Hilltoppers, Miyoshi Umeki, Joe Sullivan and perhaps Vickie Young.
—"T.E. Newsletter," Vol. 3, No. 28, April 20, 1956

Miyoshi Umeki sent along a thank you note written in Japanese.
—"T.E. Newsletter," Vol. 3, No. 30, May 4, 1956

Bert Convy

May 1956

The kid with the very likeable face is twenty-two-year-old singer and actor Bert Convy. Last year, he scored a faux rock 'n' roll hit with his group the Cheers, a campy Leiber and Stoller number called "Black Denim Trousers and Motorcycle Boots." He's back now with some surprisingly solid vocals on his latest solo effort, "Heaven on Earth," for Capitol.

Contrary to what he tells Tommy Edwards during their interview, it seems his part in the upcoming Lancaster-Curtis flick *The Sweet Smell of Success* wound up on the cutting-room floor.

My dad had been a performer most his life. He always worked hard and enjoyed success. By the time he arrived on Broadway in 1961, he was a seasoned singer/actor and went on to star in the original cast of *Cabaret* and *Fiddler on the Roof.* When he moved back to Los Angeles years later, he appeared on countless TV shows and in films while also becoming an Emmy award-winning game-show host. He's best remembered for *Tattletales, Super Password,* and *Win, Lose or Draw.* He was handsome, charming, generous, personable, funny, and warm. He always had that twinkle in his eye.

—Jennifer Convy, Los Angeles, California, November 2009

Nellie Lutcher

May 1956

What resplendent creature honors us with her regal presence? None other than forty-four-year-old rhythm and blues vocalist and pianist Nellie Lutcher, dressed to kill in her grey fox-fur stole and best Sunday crown.

You can just hear the laughter and gasps of amazement as Nellie probably recounts a few screwy adventures from her early days on the road. The party continues tonight at the Loop Lounge, Cleveland's longtime jazz mecca located at 614 Prospect Avenue. It's May 7–13, and Nellie's holding court there with her jazz trio. With no cover or drink minimum, you can't afford not to go. Count on hearing hits like "He's a Real Gone Guy" and "Hurry on Down," as well as selections from her new Mercury LP of jazz standards, *Our New Nellie*.

Patti Page

May 1956

A superstar with the sniffles? Most likely nursing springtime allergies, twenty-eight-year-old pop singer Patti Page (Clara Ann Fowler) crumples a tissue while her latest Mercury single, "Allegheny Moon," burns up the pop charts.

Acknowledging the ever-percolating rumor mill, this daughter of a Claremore, Oklahoma, railroad worker assures deejay Tommy Edwards she'll be marrying "very soon," although her wedding to dance director Charles O'Curran won't take place until December.

Song plugger Kappy Jordon accompanies the blue-eyed "Singing Rage" and dishes the dirt on crooner Julius La Rosa. Apparently the singer was arrested for speeding last month, en route to his own Francis Creek, Wisconsin, wedding.

HOUSEWIVE'S RECORD OF THE WEEK: Patti Page's ALLEGHENY MOON was the pick this week. My "housewive's jury" listening at home marked their ballots unanimously in saying that they thought the song would be a hit—many complimentary remarks on the song.
—"T.E. Newsletter," Vol. 3, No. 33, May 25, 1956

The Diamonds

Friday, June 15, 1956

A cappella singing is like being up on the highwire with a tank of hungry sharks circling below. To keep a performance from unraveling into a sour-sounding disaster, the first thing you must learn is how to be a really good listener.

The Diamonds are good listeners, generous with each other, blending their voices into one cohesive wave. This morning Ted Kowalski (tenor, twenty-six), Dave Somerville (lead, twenty-three), Bill Reed (bass, twenty), and Phil Levitt (baritone, twenty-two) sing a standard, barbershop, or spiritual number from their well-rehearsed repertoire.

The Diamonds' almost soulful sound, heavily influenced by Detroit rhythm and blues group the Revelaires, markedly differentiates them from rival groups such as the Crew Cuts and the Four Lads. This isn't your typical milquetoast fare, there's some sex and respect in the grooves, as testified to by their gusty 1957 cover of the Gladiolas' "Little Darlin'"—no small feat for a couple of white guys from Toronto.

The Hippodrome at 720 Euclid Avenue will be the place to be today, Saturday, and Sunday, when the Diamonds take part in a "Giant Rock 'n' Roll Revue." Playing on the Hipp's screen during intermission are the Universal movie short *Cool and Groovy*, narrated by WERE deejay Bill Randle, and United Artists' stodgy western *The Broken Star*.

Bill Randle emceeing a three day Rock and Roll stage presentation at the local Hippodrome Theater this weekend—starring Don Cherry, Lonnie Donegan, Frankie Lymon, Clyde McPhatter, The Diamonds, Jodimars, Chuck Berry and others—most of them will also appear on his TV show Sunday night in addition to Meg Myles.

—"T.E. Newsletter," Vol. 3, No. 35, June 15, 1956

When we first came to Cleveland, in 1955, it was all four of us in one room of a funky hotel out on Euclid Avenue. We came to town because we

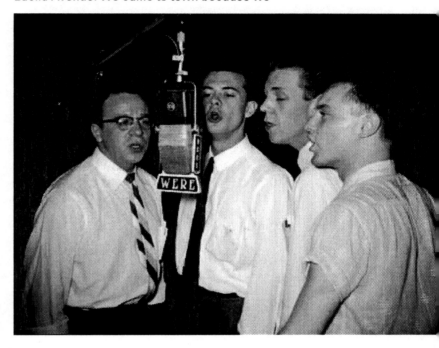

wanted Bill Randle to do for us what he did for the Crew Cuts; make us stars. On our final day in town the phone rang out in the hotel hall, and I picked it up. It was Randle, asking us to come sing at a dance he was putting on. Next thing we knew, we had a deal with Mercury Records and three hits in a row. In June of '56 we were promoting our third recording, "Every Night about This Time / Love, Love, Love" on Mercury. Shows like the Hippodrome were amazing and very exciting. We'd all be onstage around one mic, all the kids hollering. Hormones and testosterone ruled at that age, and there were some wild times. Why music? I loved it. I liked to hear the chords ring.

—Dave Somerville, Hollywood, California, August 2009

Meg Myles

June 1956

A cozy, dimly lit apartment; two chilled glasses brimming with pink champagne; a duo of just-lit cigarettes at the ready; one beautiful woman, her eyes sleepy with the warmth of a satisfied lover. Ah, if it were only possible to disappear into the fantasy world of a Meg Myles (Billee Jean Jones) album cover.

But who exactly is this pretty twenty-two-year-old? Is she the serious actress from Seattle whom Hollywood has yet to embrace? Perhaps she's the fine singer of standards known to frequent the Black Knight Cocktail Lounge over on Larchmere Boulevard in Shaker Heights. Or maybe she's just the sexpot pin-up queen from those nasty magazines, nothing but tits, ass, and delusions of grandeur. One listen, one encounter with the real Meg Myles sets you straight. She's a triple-threat artist: brains, beauty, and moxie to spare.

This photo was taken on a Capitol Records promo tour for my single "Past the Age of Innocence." Radio promo appearances were fun because I was smart and I had something to say. They didn't expect that.

— Meg Myles, New York, New York, December 2008

Hamish Menzies

July 1956

As a strapping young lad back in Weem
Perthshire, Scotland, Hamish Menzies had
big designs on becoming a classical pia-
nist. But his humor won out. All those very
important-sounding musical notes were
just a wee bit too serious for the showman
in Hamish. Stints as a nightclub owner in
Paris and two years in the Intelligence Sec-
tion of the British Army during World War
II suitably toughen him up for his migration
to America and recording career. As the
Theatrical Grill's eclectic clientele can at-
test, the "Rogue with the Brogue" sings up-
tempo numbers from his new Kapp Records
LP with the nasal authority of Al Jolson and
wrings the whimsy out of any Scotch ballad.

 Menzies's engagement at the Vincent
Avenue nightspot coincides with his July 8
appearance on deejay Bill Randle's Sunday
night WEWS-TV show. Dizzy Gillespie and
Chris Connor are also scheduled to perform.

Johnny Mathis

August 1956

Recorded March 1956 in New York City, *A New Sound in Popular Song* is the debut album by Johnny Mathis. The twenty-one-year-old singer may well be all the rage in San Francisco's jazz clubs, but his "new sound" fails to excite, forcing the former Olympic-caliber athlete back to the drawing board. It'll take a few recording sessions with Columbia Records' whip-wielding Mitch Miller to set the kid on the straight and narrow path to superstardom.

Patience and Prudence

September 1956

The kids are alright. Under their best velvet Sunday hats and the watchful eyes of chaperoning parents, eleven-year-old Prudence McIntyre cradles a fluffy new friend as sister Patience, fourteen, self-consciously smiles through her braces. The girls' sweet rendition of "Tonight You Belong to Me," a song they recently learned at summer camp, has exploded into an international smash on Liberty Records.

I broke the song by PRUDENCE AND PATIENCE wide open here in Cleveland last Wednesday by playing it 6 times during the course of my show— the song, TONIGHT YOU BELONG TO ME had been in the hands of other deejays for 3 or 4 days and no one had done anything with it—it will be the biggest on the Liberty label.
　　—"T.E. Newsletter," Vol. 3, No. 40, July 13, 1956

I remember the white dog. It was a gift from the station. My mother, Audrey McIntyre, recalls that Tommy Edwards "was very sweet to you," which could have been said of most of the deejays on that particular trip in August-September 1956. We had no plan or desire to be singers or performers. We had no vocal training, only exposure to good music. My father, Mark McIntyre, was trained in the classical repertoire and was consistently listed in the top 10 of LA jazz pianists. Mom and Dad were very concerned about the perils of being "professional children." After all, they knew Judy Garland. They turned down almost every offer, including commercials, movies (*An Affair to Remember*), et cetera. We did one promotional tour by train from LA to New York and back. The New York trip was the one TV appearance we selected: the *Perry Como Show.* So the deejay visits were made along the way. During the time we recorded, we missed a total of two days of school.
　　—Patience McIntyre, Toluca Lake, California,
　　　　April 2009

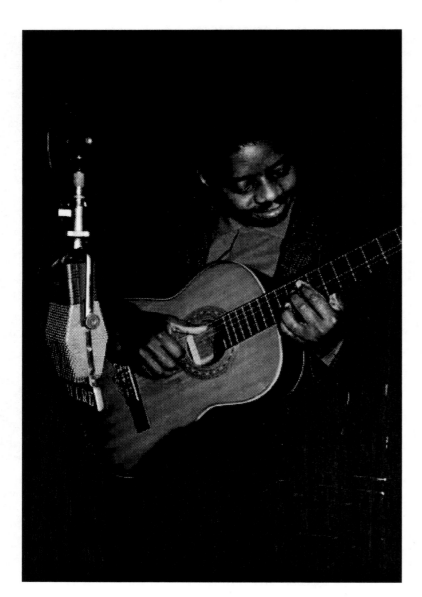

Bill Harris

October 1956

As the Tatay classical guitar's nylon strings softy sound, a radio station's austere surroundings suddenly melt away, leaving only the intimacy of an after-hours jazz club and a superb thirty-one-year-old musician at work.

A recently released self-titled EmArcy album spotlights Bill Harris's flawless technique on solo jazz instrumentals, a far cry from his bread-and-butter gig as guitarist and arranger for top rhythm and blues vocal group the Clovers.

On the LP's B-side you'll find the torch standard "I Can't Get Started." Listen as Harris and his guitar deliver one of the most stirring performances of songwriter Vernon Duke's somber melody.

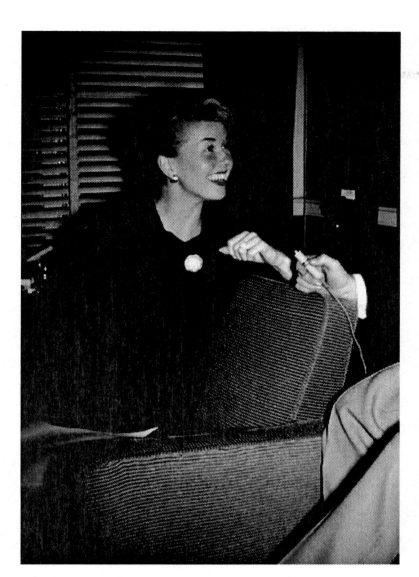

Doris Day

Friday, October 12, 1956

The seemingly ever-effervescent Doris Day (Doris Mary Anne von Kappelhoff) offers her undivided attention to an unidentified interviewer. The thirty-two-year-old native Ohioan lights up the cheerless surroundings with Hollywood sunshine at an MGM press junket for her new thriller, *Julie*.

The real Doris Kappelhoff's private darkness of physical abuse, divorce, and suicide shares a hidden coexistence with the meaningless adoration of millions of strangers. America's girl next door and top box-office draw, this "professional virgin" at the height of her fame, will soon transmogrify into a celebrity recluse who regards her music and film career as irrelevant. We'll always need Doris Day, but she never needed us.

Doris Day proved herself to me last weekend as being one of the most gracious artists I've had the pleasure to meet—just nice people.
—"T.E. Newsletter," Vol. 4, No. 2, October 19, 1956

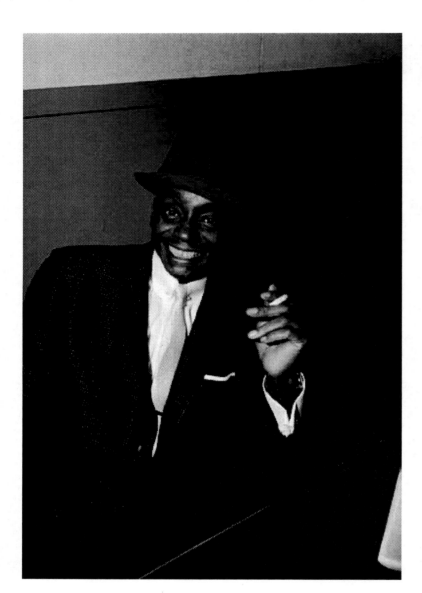

Billy Williams

Friday, October 19, 1956

The engaging voice of forty-five-year-old tenor Billy Williams (Wilfred Williams) rings with sincerity as it soars above the Dick Jacob Orchestra on his latest Coral effort, "Don't Cry on My Shoulder." Unfortunately, the mediocre ballad fails to measure up to the fine singer, and another disc joins his growing stable of flops.

It wasn't always so. Beautiful recordings abound in Williams's influential work with the Charioteers, a gospel-pop vocal group he previously fronted. In a few months, the Texas troubadour's wildly successful resuscitation of "I'm Gonna Sit Right Down and Write Myself a Letter" will momentarily breathe some life into a rapidly waning career.

In the meantime, the Billy Williams Quartet still has another week to go at the Chatterbox Bar, 5123 Woodland Avenue. Let's hope he'll be wearing that awesome hat.

Billy Williams just stopped up and said he's looking around for some good "pop" material to record. I told him we had a lot of publishers and writers who read this sheet and they might have something for him. He'll be here in Cleveland through the 27th at the Chatterbox Bar. Send him your songs in care of Coral Records or call him here in town. Guests on Bill Randle's TV shot this Sunday will be Billy Williams, Wild Bill Davis and Joe Valino.

—"T.E. Newsletter," Vol. 4, No. 2, October 19, 1956

Lou Monte

October 1956

The button clipped to the cover of Elvis's just-released second album reads "Elvis Presley for President; Lou Monte, Campaign Manager." The giveaway is an RCA Victor gimmick centered on the thirty-nine-year-old singer's latest wax, "Elvis Presley for President." Popular for his Italian-themed novelty recordings, Lou's disenfranchised constituents rally, causing the single to misfire and forcing the entertainer to withdraw from the race.

Come the November presidential elections, one write-in vote for Elvis will be cast in Blount County, Tennessee. Given its dismal sales, this voter may also be the only person who actually bought the Monte disc.

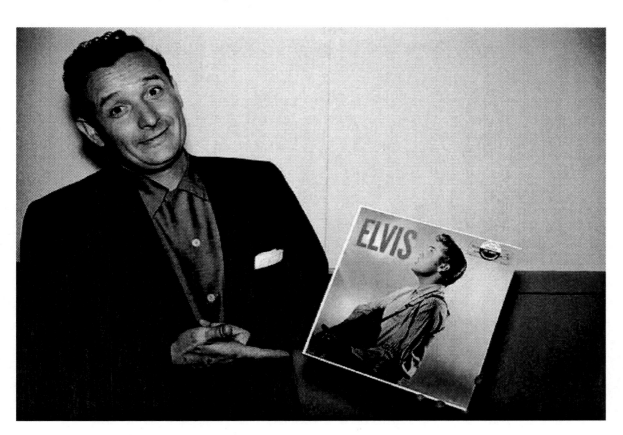

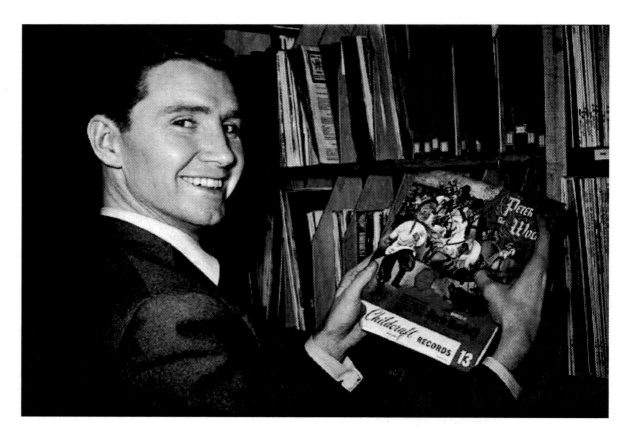

Peter Hanley

November 1956

Who better to narrate composer Sergei Prokofiev's unsettling tale of *Peter and the Wolf* than Boris Karloff, whose name alone invokes visions of sinisterness and horror?

Entertainer Peter Hanley, a regular performer on the *Ernie Kovacs Show,* met the sweet gentleman who is the real Boris Karloff just three months ago, when the venerable actor guested on the program.

A stalled Verve single, "I Wanna See You When You Weep / Dedicated to You," does little to recapture the fleeting momentum of April 1953, when Hanley charted with the stomping, Cajun-flavored "Big Mamou" on Okeh Records.

Pete Hanley is appearing this weekend at Al's Lounge, a new club just starting up.

—"T.E. Newsletter," Vol. 4, No. 7, November 23, 1956

Leroy Van Dyke

November 1956

Speed, rhythm, excitement: These are the three key ingredients to any successful auctioneer's chant, and twenty-seven-year-old singer and songwriter Leroy Van Dyke can chant with the best of them.

Van Dyke makes do with a rolled-up paper gavel and rattles off a few lines of his semi-autobiographical single, "The Auctioneer." With a fluke crossover hit on the pop chart, Van Dyke enjoys his newfound fame, but his heart belongs to country music.

During his on-air interview, he more than likely recounts growing up on a Missouri ranch with no electricity: he'd watch his father, moving like a ghost in the grey, early morning light, power up the radio; a low, static hum is replaced by the spellbinding sounds of Gene Autry, Sons of the Pioneers, the western swing music of Johnny Lee Wills. And a little boy prays for the radio battery to hold its charge for just one more song.

Thanks to Paul Cowley and Bailin' Wire Bob Strack for calling our attention to the Leroy Van Dyke record of AUCTIONEER in their "newsletters"——we started playing it country and pop here and it is really taking off with all the jocks getting on it—looks like a pop smash (on the Dot label).

> —"T.E. Newsletter," Vol. 4, No. 5, November 9, 1956

Leroy Van Dyke's record of AUCTIONEER is breaking for a big hit. I was responsible for it here in this area as I started it on my country show on Saturdays.

> —"T.E. Newsletter," Vol. 4, No. 7, November 23, 1956

There's my gold tooth in the photo. This was in the days before they capped teeth. My dad was a livestock man and rancher. He also did furniture moving. I was helping him one day, moving a big piece of cast-iron metal. A bee stung me on the ear, and I hit the cast iron and cracked my tooth. Busted my lip and bled like a stuck hog. I eventually did have it capped. I did sock hops in Cleveland with Tommy Edwards. They'd play the record, and I'd lip sync. Dot Records was a maverick-type independent label. The common procedure was I'd fly in, usually on my own dime and the Dot Records promotion man would pick me up at the airport. At lunch would be the deejay, the distributor, the promotion man, and me. I never

smoked, drank, or did drugs. I was a greenhorn; I didn't know anything about the music business. I wrote "The Auctioneer" in an army tent in Korea. It was fun, and it was new to me. Here I was with my journalism and animal science degrees on the road with Gene Vincent, Frankie Lymon and the Teenagers, and Pat Boone. Gene was a little jerky, a little nervous. I remember he had his leg in a brace. My manager's name was Buddy Black. He was a liar, a cheat, and a thief. He rushed me into signing some papers that I did not get the opportunity to read, wherein he received half the publishing and all the performance rights to "The Auctioneer." He's dead now, so I guess I won.

—Leroy Van Dyke, Smithton, Missouri, December 2008

Charlton Heston

November 1956

"Where's your Moses now?" So asks the great Edward G. Robinson as the cunning and opportunistic Dathan in Cecil B. DeMille's epic blockbuster *The Ten Commandments*. Well, he happens to be right here in Cleveland.

Thirty-three-year-old Charlton Heston (John Charles Carter) thrills listeners with tales of vengeful Gods and creeping pestilence as a publicity photographer readies his shot in the background. The prestigious actor's fervent portrayal of the Bible superhero earns accolades from moviegoers as well as a surprising Oscar snub at the 1957 Academy Awards ceremony.

The woman behind the dependable RCA Ribbon Velocity Model 77D microphone is on-air personality Louise Winslow, whose lack of broadcasting skills prompt WERE jock Carl Reese to brand her thirty-minute radio program as "silly and inconsequential."

Ginny Scott

November 1956

In the dark confines of the WERE studios, nightclub singer Ginny Scott's flawless skin seems to sparkle iridescently next to the drab, industrial RCA Type 77-DX microphone, as she bats her lashes bewitchingly like some mischievous fairy. The Detroit enchantress must have cast some heavy spells on Flair-X Records A&R man Ralph Stein, because her singing on "Why Say Goodbye? / Crossing My Fingers" is not very luminescent. In a few months Ginny will lose her ability to glow in the dark as well as her record deal, and her career will quickly fade to black.

Freddy Morgan

November 1956

Forty-six-year-old singer, banjoist, and comedian Freddy Morgan (Morgenstern) pays the bills making silly faces and plink-plucking strings in satirist bandleader Spike Jones's troupe, the City Slickers.

But it's with his own group the Sunnysiders that Morgan gets to hone his songwriting chops and display his prowess on the Vega Vegaphone Professional Model four-string banjo. The trio scored an unlikely hit with the bouncy ditty "Hey, Mr. Banjo" in June 1955 and hope their latest Kapp wax, "Banjo Woogie," packs the same punch.

Knowing where his bread is buttered, the former Clevelander makes sure to plug his boss's new Verve album, *Spike Jones Presents a Xmas Spectacular.*

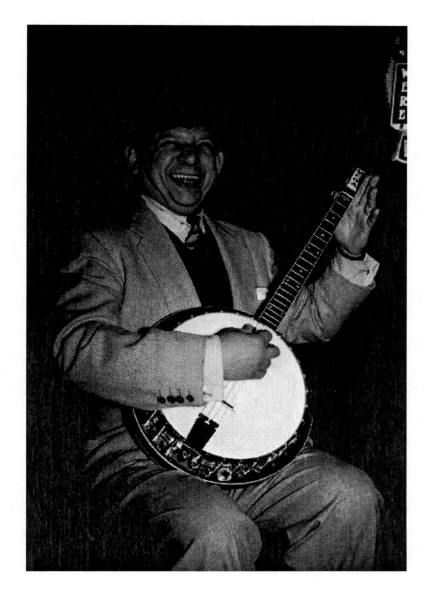

1957

Barbarians at the Gate

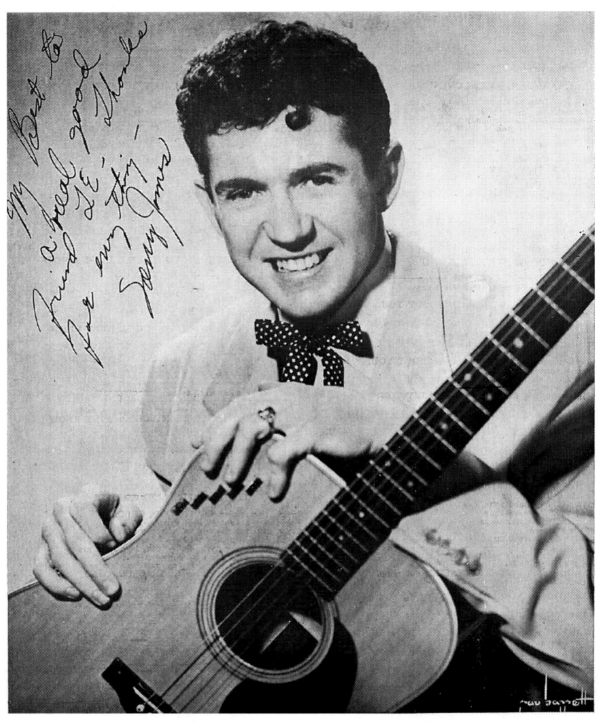

"My best to a real good friend, T. E.—Thanks for everything.
Sonny James"

Big show coming in on March 14th— Sonny James, Gene Vincent, Sanford Clark, George Hamilton IV, Carl Perkins and many others—I'll emcee the show.

—"T.E. Newsletter," Vol. 4, No. 20, February 22, 1957

'14 of the great recording artists in a big jamboree!" screams the ad in the *Plain Dealer,* a "Rock A Billy Spectacular" if there ever was one. Ask any rock 'n' roll fan that digs slap-back echo to put together a 1950s "dream bill," and it would probably look a lot like this two-show event at Music Hall: Capitol recording artists Sonny James and Gene Vincent, Liberty Records' new acquisition Eddie Cochran, Dot's Sanford Clark, ABC-Paramount's George Hamilton IV, Coral Records' Johnny Burnette Trio, Roulette's stars Buddy Knox and Jimmy Bowen, Vik Records' Lee Denson, and Jubilee's Gene Nash. And despite Sam Phillips's unceasing cash-flow troubles, Carl Perkins, Roy Orbison, and Warren Smith have hit the road for Sun.

Spurred on by RCA Victor's unprecedented sales success with Elvis Presley and the emergence of the teenager as a potent economic force, record companies have signed up anybody with sideburns and a smirk, hoping to challenge the combustible charisma of the boy from Memphis. In the wake of a lipstick-colored pink Caddy,

beat-up Fords and Lincolns carrying artists arguably more talented than Presley scream down the highways, penetrating the far reaches of the nation's subconscious with the new sound.

So all you squares better plug your ears and hide your daughters. The barbarians at the gate have their amps cranked all the way up. And by the way, the "Spectacular's" cheap seats are just $1.

1957 starts off right with celebratory cocktails on the evening of Thursday, January 3, when Tommy Edwards walks in on a surprise party thrown by his wife, Ann, and the local Coral Records people. The occasion is the release of his debut single, "What Is a Teen Age Girl? / What Is a Teen Age Boy?" both recitation, non-singing affairs, lyrics by Tommy and music by veteran songwriter Buddy Kaye. The songs, while corny by today's standards, are intriguing when you consider how Edwards thought it necessary to comment on this new breed of teenager that rock 'n' roll had birthed. The world is changing before his eyes, and the deejay finds himself uniquely

positioned to understand the teenage mindset, surrounded by hundreds of kids and every weekend at his record hops spinning the music they love. Hopes are high for the topical disc's success. Overnight WERE jock Carl Reese stops by for a few snorts as well as Akron deejay Scott Muni.

On Saturday, January 19, Johnny Cash sings his bitter, brokenhearted hit "There You Go" at the Circle Theater's *Hillbilly Jamboree*. RCA sends a thank-you note to Tommy for starting Lou Monte's "Roman Guitar" as a nationwide hit; acknowledgments like this are the only kind of payola he accepts. Twenty-one different deejay newsletters have sprung up since T.E. started the kick three years ago. The local Cabin Club changes its name to the Modern Jazz Room and hosts sax star Stan Getz, and local police authorities are up in the air because of teenage riots at a weekend showing of the rock film *The Girl Can't Help It*.

In February "What Is a Teen Age Girl?" reaches a respectable No. 60 in *Billboard*'s top 100, but Tommy is beside himself because Coral Records has dropped the ball, failing to widely distribute the record. Sales suffer because of their mistake, and the very real possibility of scoring a hit has been snuffed. "Party Doll," by rocker Buddy Knox, is banned on WERE airways. And in one weekend, Edwards gives away six hundred free records at three hops.

The incomparable country music star George Jones swings through Cleveland for a March 9 Circle appearance, and the *Birdland Stars of 1957* comes to town on the thirteenth, starring such jazz luminaries as Count Basie and Billy Eckstine. Calling it his "Color Slide Show Service," T.E. makes his library of some 250 photographs of record stars available for other jocks around the country to show at their record hops. Larry Kane at KNUZ in Houston is the first in line. Pianist George Shearing opens at the Modern Jazz Room on

the twenty-first. Tommy complains about getting the cold shoulder from a visiting Robert Mitchum then heads to New York to cut his second single for Coral.

It's April, and Tommy Edwards is fed up with calypso but digs the Everly Brothers. Tony Bennett wires that he's getting great reaction on his new wax, "One for My Baby." Edwards informs his readers that his second Coral record should hit the racks soon. The Louvin Brothers make the Circle Theater on May 4, and *The Sammy Davis Jr. Show* arrives in Cleveland on May 19. Edwards imposes a temporary moratorium on conducting live, on-air interviews; too often a young record artist with a hit record turns out to be a dud interviewee. On May 21, he begins hosting duties on WEWS-TV's *Farm Bureau Jamboree,* which airs live on Tuesday nights at 10 P.M., featuring local talent and the occasional country or rockabilly star. The deejay hopes his show will be the opening wedge for country music on TV in the Cleveland area. *The Pat Boone Show* draws a slim crowd at the Cleveland Arena on the twenty-third, and Mother Maybelle and the Carter Sisters star at the Circle Theater on the twenty-fifth.

On June 24, Edwards broadcasts his show from the cruise ship *Aquarama,* which offers daily service between downtown Detroit and Cleveland. Coral Records shelves plans to release his second single, "The Story of Elvis Presley / What Is Rock 'n' Roll?" when Elvis's label RCA raises a stink over usage rights. The week of July 1 finds Edwards in the Big Apple, guest hosting the *Martin Block Show* on WABC. He comes away with a few observations about why New York deejays are so far behind music-wise. Perhaps most significant for him, no one wants to be a pioneer. Back in Cleveland, the feud between KYW and WERE continues, with WERE maintaining its No. 1 rating. The next fad to be foisted

on the public is Hawaiian music, and Tex Clark's Record Shop reports great reaction on country star Hank Locklin's "Geisha Girl."

In August WERE management decides Cleveland doesn't need country music or some "City Slicker Turned Country Boy" on Saturdays anymore. The host remains intact, but the *T.E. Hillbilly Jamboree* is replaced by *The Biggest Show on Records,* a top 50 pop show. This unceremonious end to Edwards's innovative country music program only hints at the broadcasting industry's plan to methodically strip the autonomous deejays of all their power. Tommy stays quiet and continues to toe the ever-expanding company line, but the cancellation undoubtedly deals his pride a serious blow.

At September record hops, the kids love to play mannequin while dancing to Sammy Kaye's novelty song "Posin'" and copy the dance steps they've seen on *American Bandstand.* The "Ferriday Fireball" Jerry Lee Lewis blazes through town on the strength of his Sun wax "Whole Lot of Shakin' Going On." Unfortunately, there's no photo of "The Killer" in studio. Edwards chews the fat with heavyweight boxing champion Joe Louis at a Mercury Records party while the sad news that Don Everly's wife gave birth to a stillborn child in Nashville comes from brother Phil, who was in town buying a Jaguar.

Country artists scheduled to appear at the Circle Theater's *Jamboree* are encouraged to stop by Edwards's *Farm Bureau Jamboree,* which moves to 7 P.M. Saturday nights starting November 2. The Louvin Brothers, Jimmy Newman, and Leroy Van Dyke are just some of the stars that readily comply. Soupy Hines, who used to be a deejay in Cleveland at WJW, is now in Detroit, doing very well under the name Soupy Sales. December's fading fast when Edwards travels to New York City to record his third single for Coral, "Spirit of Seventeen / Goodnight Rock and Roll." He announces there are now 342 pictures of record artists in his color slide file and that he'll be attending the March 1958 pop deejay convention in Kansas City. Country music fans flock to the Akron Armory on New Year's Eve to enjoy the *Faron Young Show.* Edwards emcees.

With the Presley phenomenon in full gear, rock 'n' roll music goes mainstream in 1957. Forming the solid foundation beneath the massive, well-known hits are Ricky Nelson's hard-driving "Waiting in School" and the cool, lackadaisical angst of his "Stood Up," one of the year's best couplings. Gene Vincent's "Important Words" shimmers and Cochran's "Twenty Flight Rock" just slams. Pop heard round the dial includes "Love Story" by Merv Griffin, "Dark Moon" by Bonnie Guitar, and "With All My Heart" by Jodi Sands. Country music reaps the pop rewards, as George Jones discovers his own voice with the beautiful "Yearning" and Faron Young crosses over with "The Shrine of St. Cecelia."

Steve Lawrence

January 1957

"So, how did you get started in this crazy racket, er, business?" "Who do you most sound like?" "Is there any truth to the rumor that you once shot your mother?"

Taking some time out from his New Year's week engagement at Al Naiman's Zephyr Room, 16706 Kinsman Road, twenty-one-year-old singer Steve Lawrence (Sidney Leibowitz) has some fun conducting a mock interview with Tommy Edwards. The smooth- and easy-sounding Brooklynite's new hit Coral wax is "The Banana Boat Song / Long before I Knew You."

Steve turned the tables on me—he played deejay and interviewed me as a new record artist— using the usual cliché questions that have been asked by deejays for so long—very clever.

—"T.E. Newsletter," Vol. 4, No. 13, January 4, 1957

Eydie Gorme

January 1957

The Bronx firecracker tells another dirty joke and breaks all the radio boys up. Twenty-five-year-old pop star Eydie Gorme (Edith Gormezano) can deliver the bawdy punch lines like a pro, her infectious laugh making a dreary winter day in Cleveland seem a tiny bit brighter.

One can imagine her, between giggle fits, teasingly scolding Tommy Edwards for not coming to see her show during New Year's week at the Statler Hotel over on East 12th and Euclid. The deejay smiles back at his friend, asks for forgiveness, and promises to give her new ABC-Paramount single, "It's a Pity to Say Goodnight," a few quality spins during his next shift.

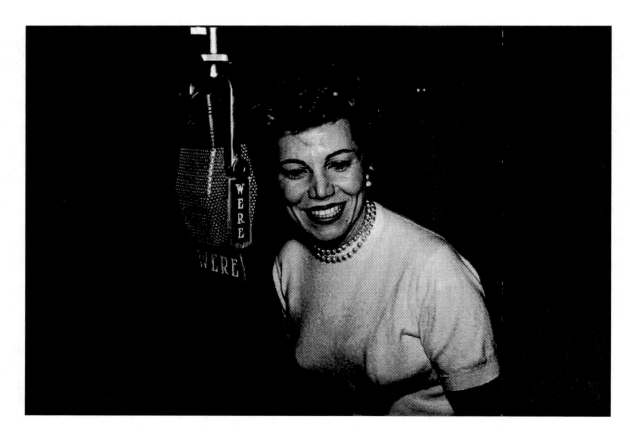

Trudy Richards

January 1957

Easy, smoky, swingin'. Thirty-six-year-old Capitol recording artist Trudy Richards's (Gertrude Moreault) voice wraps itself around you like a great big hug from a favorite aunt.

A survivor of the big band era, Trudy's been shuffled around by a few labels, her uniquely laid back phrasing spicing up jazz standards and rarer pop excursions such as her latest single, "Next Time / All of My Life."

Preceding a self-imposed exile, the singer's a frequent visitor at WERE during 1955–57, promoting new releases, appearing on *The Bill Randle Show* on September 23, 1956, and playing some Zephyr Room gigs.

Helene De Lys

January 1957

Big Apple style meets Cleveland radio muscle. Manhattan advertising executive turned jazz singer, Helene's spicy new MGM single, "I Couldn't Care Less / More Than That," sweats with the booze and desperation of a smoky cabaret club.

De Lys must have read with disdain *Billboard*'s slight, "counter interest looks scant," when reviewing her wax in their December 29, 1956, issue.

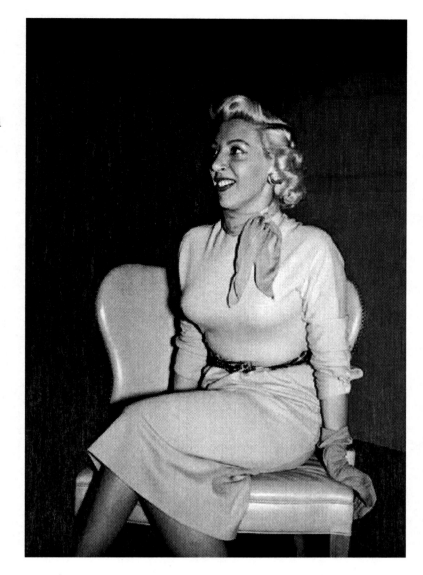

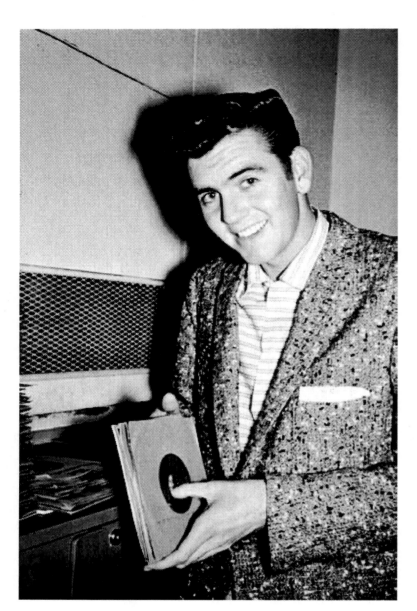

Sanford Clark

February 1957

Anyone tuning into the Sunday, July 22, 1956, premiere of *The Bill Randle Show,* the deejay's WEWS-TV program, must have heard something awesome. Guitarist Al Casey grinds out a riff that sounds like something mean and hungry scratchin' at the back door. Then a tall, handsome kid starts to sing a sad, sad drinking song about some crazy fool who told his baby goodbye and then wonders why he let her go.

Casey and rockabilly artist Sanford Clark created something perfect when they cut "The Fool" in a hot, cramped Phoenix recording studio in May 1956. The only direction to go from perfect is down, though, and that's just where twenty-two-year-old Clark now finds himself. The suits at Dot Records are panicking, unable to fathom why his latest single, a cover of Merle Travis's "9 lb. Hammer," won't sell. So they call in the stylists and coiffeurs with the intent of transforming Sanford into a non-threatening robot for the teenybopper brigade.

The suits soon stand down. Clark's a wild child who won't be tamed.

I toured a lot with Carl Perkins and his brothers. They were great guys. Drinkin' and partyin' all the time. I remember eatin' bologna and cheese in the backseat with them, gettin' drunk. Carl's brother Clayton played the upright bass. He'd be onstage and he'd get behind that big ol' bass and pull his dick out and keep playin' with it out, just to be crazy. We'd run a tube up from our boot to our lapel so we could drink. We'd go onstage sober and come off drunker than a skunk.

—Sanford Clark, Epps, Louisiana, June 2009

Alan Dean

February 1957

What do you do when you're Britain's most popular male singer (*Melody Maker* popularity poll, 1950–52) and you need a change of scenery? If you live in the fast lane and crave challenges, you head for the Colonies and hope for the best.

The way thirty-three-year-old Alan Dean (Herbert Lamb) figures it, winning over some rambunctious revolutionaries with smooth love songs should be a piece of cake. And he's right. Americans are buying his plaintive offerings in respectable numbers. His latest mover is "The Memory Followed Me Home / The Letter I Never Mailed" on Rama Records.

The smart Brit chats with Tommy Edwards on the air, possibly revealing his harrowing childhood escape from polio's death grip and an appreciation for the thrills and spills of Grand Prix motor racing. Just before their visit comes to an end, the deejay invites Alan to take a peek at some 35 mm slides through an Escot viewer—just some photographs he's taken of the celebrities who've dropped in over the years.

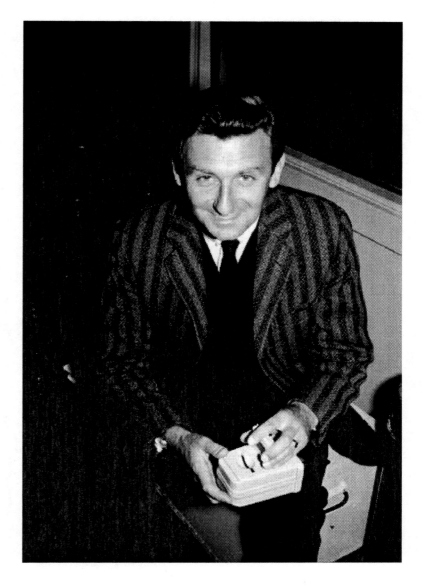

Roger Coleman to the Zephyr Room on the 15th to be followed by Cathy Carr on the 22nd and Alan Dean on the 29th.

> —"T.E. Newsletter," Vol. 4, No. 14, January 11, 1957

I did know Tommy Edwards. I remember him as a very nice, laid-back person. I lived in the U.S. from 1951 to 1961 and was booked into most U.S. cities to perform (mostly in nightclub cabaret), Cleveland being one of these. My agent told me that WERE was the top station in Cleveland as far as getting your records played and sold, so it was important to get an interview on that station. I was interviewed by Tommy and subsequently got to know Bill Randle and another deejay, Phil McLean. The jacket I'm wearing brought back fond memories. I had been having suits and such tailor-made when someone recommended a men's store in Manhattan to me, and I found that their readymade suits and jackets fit me perfectly. The jacket was my first purchase, and from then on I bought all of my suits from them.

—Alan Dean, Sydney, Australia, April 2009

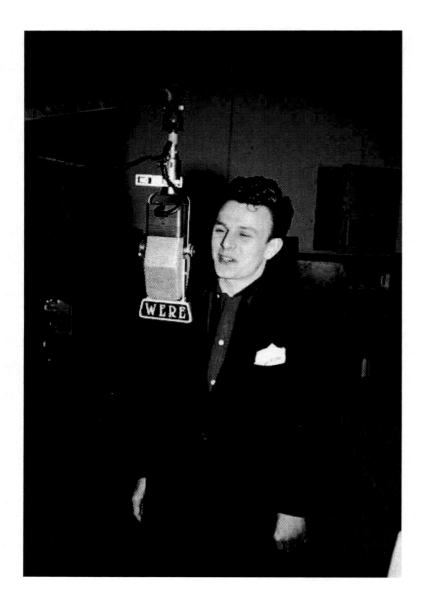

Charlie Gracie

February 1957

The hero of South Philly, twenty-one-year-old Cameo recording artist Charlie Gracie (Graci) looks a bit naked without his beautiful sidekick, a Guild X-350 electric guitar.

Speaking shyly into the RCA 44BX microphone, Charlie invites all rock 'n' roll fans down to the Alpine Village to hear him sing his smash hit "Butterfly" and enjoy some bratwurst. The jolly eccentric who runs Alpine Village Supper Club on Playhouse Square is Herman Pirchner, familiar to Cleveland teenagers for the nice fuss he makes when they drop in for sodas after senior prom.

When I looked at this picture, I chuckled!!! I can still recall that red and black shirt (I loved to wear those colorful sport shirts back in the '50s). My future wife, Joan, probably gave me the monogrammed handkerchief you see in the pocket of my sport coat. I remember stopping by WERE for interviews with Tommy Edwards and Bill Randle, two very nice gentlemen. The radio jocks back then were such pros and wielded a lot of influence. Tommy and Bill were no exception, and I recall a pleasant visit with both of them, and they treated me like royalty. I remember the kindness of the fans in Cleveland too, very respectful and down to earth. I actually traveled to Cleveland to perform and promote my discs as early as 1956, a year or so before I became famous. Those were great times. Of course, we never made the kind of money the kids make today, not even close, but I wouldn't trade that era for anything. Where have the last fifty-plus years gone? It really does seem like yesterday.

—Charlie Gracie, Drexel Hill, Pennsylvania, November 2008

Robbin Hood

February 1957

A platinum-dipped Maid Marian? Not quite. It's former Coral recording artist Wendy Waye, now struggling MGM pop singer Robbin Hood. The Brooklyn bombshell should worry less about her name and more about losing her breath in the middle of a phrase and turning in stiff performances.

Tommy Edwards slyly passes his guest a copy of his own debut single on Coral Records, "What Is a Teen Age Girl? / What Is a Teen Age Boy?" to display alongside her latest flop, "Don't Promise Me (The Can Can Song) / Kisses."

Danny Knight

February 1957

If you happen to be passing by John Ballard's Chatterbox Show Bar over on Woodland between Monday, January 28 and Sunday, February 10, you just may hear the beautifully warm voice of jazz vocalist Danny Knight (Danford Lee Knight) mingled with the busy street bustle. New in the racks is "Falling Star / I Still Believe," the thirty-year-old's latest on MGM.

Knight's third set at the Chatterbox should finish up around 2 A.M., leaving half an hour until last call. That's plenty of time to end an evening of exciting music right.

I don't where to begin. I knew all of Danny's inner thoughts. Dizzy Gillespie once told me, "He's a singing motherfucker, ain't he, man?" Charlie Parker would come to hear him sing, just to unwind. We worked many a gig together, and our adventures are numerous. Danny sang because he was a born jazz singer. He sang because it was his life. He was the best of the best. He was a product of his times, as in drugs. Danny used heroin, but I never saw him disheveled nor did he have the trappings of the street junkie. In fact, people remarked how well he performed when he was "sick." Danny was a gentleman, on drugs or off. Charlie Parker loved Danny Knight because of the incredible texture and tone of his voice. It was rich, just marvelous. His lack of mainstream success was due to smack. He had no influences that I know of. He was an entity unto himself. In a word, Danny was superb.

—Drummer John Gilbert (Johnny Jazz), Ventura, California, May 2009

Fay Morley

February 1957

It's a miracle that twenty-six-year-old singer and actress Fay Morley is alive, let alone looking fabulously chic for her on-air interview, a leopard fur handbag part of the ensemble. An Altec-Lansing Model 21 condenser microphone brings her frightening story to millions of WERE listeners.

On the night of January 3, 1953, Morley was returning from a singing engagement in Las Vegas when the car she was traveling in failed to negotiate a sharp curve and veered into oncoming traffic, somewhere just outside Barstow, California. Her screams preceded a horrific head-on collision, in which four persons were killed and several injured. Her pelvis smashed and leg broken, she was pulled from the twisted wreckage unable to speak, her vocal chords paralyzed. For seven months she listened as the doctors prepared her for the worst. She'd never sing again.

"My Reputation / Donde Esta El Mio" on Decca is proof that doctors aren't always right, and the recording is a nod to the operatic aspirations Fay held at the start of her promising career. The future holds some bit parts in film and television. But she'll never be the same, not since the sound of screeching tires pierced the cool desert night.

My whole life I've lost gloves. I have a drawer full of fifty of the most exquisite gloves, but I just have one of them, no pairs. We all have our certain eccentricities, and mine is I happen to lose gloves. I refuse to throw them out. When I go out in the evening and have to dress up I wear just one glove."
—Fay Morley, New York, New York, May 2009

Gloria Mann

March 1957

Damn the torpedoes. There's a lot riding on ABC-Paramount recording artist Gloria Mann's (Rosenberg) debut platter for the label, "My Heart Has a Mind of Its Own / Why Can't I Make You Understand." Success means a return to the limelight she so craves; failure means a one-way ticket to Palookaville.

So she gets busy, showing off her ample assets to the slack-jawed WERE jocks and sweet-talkin' the call-in fans, reminding them that it was her voice they loved on "Earth Angel" and "Teenage Prayer," a lifetime ago in 1955.

But tight sweaters only tease, and fans are fickle. Let's hope the Philadelphian stunner likes long, bumpy bus rides to nowhere.

Have you noticed all the bosomy girls on album covers lately? (I'm not complaining, just asking.)
—"T.E. Newsletter," Vol. 4, No. 27, April 12, 1957

Fantastic photo. Mom was a good girl, compared to many others that would do anything to get their songs on the air.
—Bob Rosenberg, Palm Beach, Florida, August 2009

Anna Maria Alberghetti

March 1957

Two beautiful works of art: WERE's majestic RCA Ribbon Velocity Model 44BX microphone and former child prodigy Anna Maria Alberghetti. Twenty-one years old, the Italian-born actress and singer dutifully informs listeners about her role in Dean Martin's soon to be unanimously panned film, *Ten Thousand Bedrooms*.

Tommy Edwards was a really lovely person, very generous with his time.
　　—Anna Maria Alberghetti, Palm Springs, California, May 2008

El Boy

March 1957

Any 1950s record collector will appreciate those beautiful towers of 45s stacked behind thirty-seven-year-old Rama recording artist El Boy (Juan Ramón Torres).

Aimed at the pop market, the breezy calypso sounds of his new record, "Tonight My Heart She Is Crying," swirl through the

studio. Old maracas and a flask of something strong serve as back-up band.

Born near pare veintiuno en el Tren Urbano (stop twenty-one on the Urban Train) in a district of San Juan, Puerto Rico, called Santurce, Juan speaks with Tommy Edwards in almost perfect English, punctuated by knowing laughs and winks.

Most likely, talk of springtime, pretty girls, and homesickness segue into tales of a little trigueno boy who grew up listening to Afro-Cuban music on the family's short-wave radio. Almost everyone back home had a shortwave to keep up with the hip new sounds then pouring out of Cuba. The passionate music of Arsenio Rodríguez, Orquesta Casino de la Playa, and countless others electrifies young Torres and starts him dreaming.

Soon the booze is all gone, and so is El Boy, last seen in Miami chauffeuring a limousine, reluctant to share the details of a secret life.

Congratulations to the editors of Cashbox magazine for their timely editorial titled "Don't Kill Calypso" of a week ago—Ronnie Barrett (WDOK) wrote in his record column last Saturday in the Cleveland News that the calypso kick seems to be a Brill Building hype and I'm inclined to go along with him on that assumption—my audience is absolutely cold to calypso tunes (except for Belafonte)——Incidentally, the Belafonte version of MAN SMART released in the big deejay package of his tunes is "too blue" for airplay—banned on WERE.
—"T.E. Newsletter," Vol. 4, No. 22, March 8, 1957

Sonny James and Ferlin Husky

Thursday, March 14, 1957

Watch for the next big record to come out of Cleveland—It's YOUNG LOVE by Sonny James on Capitol—another one we started on our Saturday country show—it will go big popwise.
> —"T.E. Newsletter," Vol. 4, No. 8, November 30, 1956

Tommy Edwards wasn't just filling space in his newsletter when he made this prediction. Dubbed the "Southern Gentleman" by Capitol producer Ken Nelson, twenty-seven-year-old Sonny James (Loden) from Hackleburg, Alabama, has become an "overnight sensation" after signing a recording contract nearly five years ago.

Now that his ship's finally come in, Sonny plans to surround himself with powerful and talented forces to sustain success. The MCA Agency, in particular, works hard for its client, finagling high profile spots on mainstream television shows normally locked out to country artists. This early, crucial national exposure proves key in building the foundation for one of the most successful and respected careers in the history of popular music.

Headlining the "Rock A Billy Spectacular" at Music Hall tonight, the singer takes a few seconds out backstage to greet thirty-one-year-old Ferlin Husky, an industrious Missourian on the cusp of stardom via his latest Capitol single, "Gone."

I understand that Sonny James' YOUNG LOVE is going like a house afire here in Cleveland—Capitol can't get enough in the stores—this is the only territory where it has broken big—started on my Saturday "country" show.
> —"T.E. Newsletter," Vol. 4, No. 10, December 14, 1956

Ferlin and I had already been friends for years when this photo was taken. I hit with "Young Love," and a few months later Ferlin hit with

"Gone." I have many fond memories of the artists on the Cleveland show. I was real good friends with Roy Orbison. Some of Roy's first shows were in West Texas, when I was living in Dallas. Gene Vincent was on Capitol too and was hot with a new record. I was great friends with Carl Perkins; we did a lot of shows together. Same goes for George Hamilton. Johnny Burnette's brother Dorsey wrote a song I recorded, but I can't remember which one. Jimmy Bowen and I used to laugh a lot about those crazy days. Eddie Cochran was West Coast so I didn't see too much of him. I dearly loved being with the guys and girls I did shows with, hanging out with Pickers, as I call them. Up until my teenage years, music was just something my family did. I just accepted it as a part of life. I had no great ambitions in my early years, no visions of wealth and fame, no music heroes I tried to copy. My heroes were cowboys in the movies. It was good just to be able to do something I really liked and make a living doing it. After I got back from Korea, I was more serious about getting a recording contract. My roommate Chet Atkins had some pretty good connections, so that helped a bit. I do remember that Tommy Edwards was responsible for breaking "Young Love" in Cleveland on his country radio show. I was told by Capitol that Tommy could actually break a record, so I'd better get to know him. I'm a country artist by trade. I was very conscious of the fact of where I came from. I wanted to particularly hold on to my roots. I was so fortunate to have a producer like Ken Nelson and a label like Capitol. They understood me as a person. They worked me pretty hard back then but I loved it. I wanted to please the people. The only pressure I felt was what I brought on myself. I wanted to work hard for the people.

—Sonny James, Nashville, Tennessee, August 2009

Roy Orbison

Thursday, March 14, 1957

Twenty-one-year-old Roy Orbison, back-stage at the "Rock A Billy Spectacular," Music Hall, East 6th Street & St. Clair, the singer and songwriter's third release on Sun Records is "Sweet and Easy to Love / Devil Doll," a quasi-rockabilly embarrassment that weakly sputters then stalls. Sun owner Sam Phillips will soon opt to abandon Orbison rather than allocate another dollar of his label's precious resources to what he considers a lost cause.

For Roy, it's back home to Wink, Texas, and the dust and filth of the oil fields, back home to the girls who call him ugly with their eyes. This snapshot captures all of the disillusionment and despair of an unfulfilled artist on the brink of oblivion. In this business, lightning doesn't strike twice. Or does it?

Eight years later, March 23, 1965, at the Singer Concert Zaal, in Laren, Holland, international rock superstar Roy Orbison strums the bittersweet opening chords of his latest single for Monument Records, "Goodnight," and begins to sing. A television camera pans the faces of the audience, transfixed by this spectral voice, so full of beautiful sincerity. Never mind the absurdity of Orbison's appearance, that of some sickly visitor from a sunless world, standing stoically, swathed in black. The majestic voice rises in crescendo and chills run up your spine. This is art, a transcendental moment between the singer and the soul. Then it's over and the stunned faces relax as applause swells through the hall. And Orbison smiles.

Gene Vincent

Thursday, March 14, 1957

Sporting the prerequisite upturned collar and a real flippy blue cap, twenty-two-year-old Gene Vincent (Vincent Eugene Craddock) wears a grin that says it all: To all the losers back home in Norfolk, Virginia, who said I'd never make it, kiss my ass: I'm a Rock Star.

Tommy Edwards saw the early writing on the wall, having called Vincent's "Be-Bop-A-Lula" a "smash" back in the June 22, 1956, issue of his newsletter. And in a true testament to the singer's popularity, a wallet-size, glossy photo of Gene's pock-marked face was included in the deejay's July 1956 "Picture Pac," a popular ten-cent mail-in gimmick.

In support of their just-released second album on Capitol, *Gene Vincent and the Blue Caps,* the group performs tonight at Music Hall, East 6th Street and St. Clair, as part of the "Rock A Billy Spectacular." Also on the bill are Sonny James, Sanford Clark, Carl Perkins, Roy Orbison, Eddie Cochran, and others.

The destructive life and wasted career of Gene Vincent, dead at thirty-six, are somehow exquisite in their brilliance and brevity, pure rock 'n' roll at its harrowing best. By 1959, the hits stop coming as addiction and depression send him spiraling.

British fans offer Gene sanctuary in the early '60s, propping him up on various UK stages to relive former glories. It's as if they intend to breathe life back into a grotesque caricature of their hero. Tour photographs show Vincent dressed head to toe in black leather, his bloated face a grimacing mask, his body, crippled by misfortune and abuse, clinging to the microphone

stand as if it were a life buoy. Possessing none of the prowling sexuality evident in Elvis Presley's leather-clad 1968 television special, he is instead reminiscent of Roald Dahl's sinister "Child Catcher" from the film version of *Chitty Chitty Bang Bang.*

There is a more beautiful and perfect Gene Vincent, waiting to be rediscovered in the thrilling vocals of "Cruisin'" (1957) and in the desperation of 1958's "Over the Rainbow." Seek this man out.

Sonny James, Sanford Clark and Gene Vincent headlined a Rock A Billy Show here last night which was very sparsely attended. Gene Vincent has a tremendous act—he collapsed on stage—from sheer exhaustion (the real thing)—this kid had better take it easy or he'll never get back on two good feet again—leg is still in a cast.
—"T.E. Newsletter," Vol. 4, No. 23, March 15, 1957

Dick Contino and Leigh Snowden

March 1957

The press calls him the "Valentino of the Accordion," an oxymoron if there ever was one. He's the Korean War veteran convicted of draft evasion; the twenty-seven-year-old fabulously rich and famous entertainer who is forced to file for bankruptcy by year's end.

She's the stunning, twenty-eight-year-old actress who seven months ago abandoned her promising Hollywood career to marry the man she can't live without, to sing in his band, to have his babies. Dick and Leigh. They're in love.

As the couple cuddles and coos, Contino's latest, "Pledge of Love," softy swings in the background, an instrumental doing some business for the Mercury label.

Leigh liked to travel with me in those days. We teamed up and had a nightclub act. After I lost her in 1982 to cancer, I kept her wedding ring, the one she's wearing in the photo, in a safety deposit box for years. Sometime later, at the suggestion of my stepdaughter, I had a jeweler design a new setting for the stone. I wear it on my pinky finger. It's nice. It's a warm feeling to still feel close to her in some way. But you can't live back there, man. I don't even keep scrapbooks, not interested. Today I'm married to a beautiful woman named Tonia and having her in my life is the best thing that's ever happened to me. I was a really shy kid. I played music out of frustration, suppression. I don't know how much I love the accordion, per se. It's just an instrument through which I can express myself.

Colonel Parker, Elvis's manager, came to see my act. I'm innately physical with the accordion. This was right around the time they were shooting Elvis from the waist up. Parker asked a reporter, "Why do they keep giving my boy a hard time when Contino over there is humping his accordion?" It's not what you play; it's how you play it. Music has a beauty of imperfection to it. Perfect? Perfect is boring.

—Dick Contino, Las Vegas, Nevada, May 2009

Paul Evans

April 1957

Nineteen-year-old singer and songwriter Paul Evans radiates a cocky assuredness. Growing up under the "L" in Queens, New York, instills that trait in you. The kid just strolls into Cleveland like he owns the joint, proudly plugging his first record, RCA Victor's "What Do You Know / Dorothy."

It'll take Evans about two more years to hit his stride, when his self-penned "Seven Little Girls (Sitting in the Back Seat)" on Guaranteed Records hits the top 10. The song is cute, in a maddening sort of way. The flirtatious backing vocals of the Curls (Sue Singleton and Sue Terry) without a doubt contribute to the record's big sales.

Along with chart success come the pressure, demands, and sacrifices of touring, something Evans didn't anticipate and doesn't want. He'd rather be home doing the things he loves: making music with his friends, sleeping in his own bed, romancing his girlfriend. He soon quits the teen-idol circus spiraling out of control around him and sets out to write some good songs, maybe even a few great songs if he's lucky.

He's more than lucky. Elvis Presley likes the clever lyrics of his "I Gotta Know" and chooses it for the flip side of "Are You Lonesome Tonight?" in April 1960. Bobby Vinton takes "Roses Are Red (My Love)" to No. 1 in July 1962. Other hits by big guns follow. Not bad for a kid from Queens.

What a photo! What a hairdo! The photo reminds me of the promotional trips that I took with RCA and then Guaranteed Records. Lots of towns, lots of hops, lots of BS. There was a deejay at WERE named Phil McLean who played a joke on Bill Randle, probably not appreciated. Bill got all the exclusives in Cleveland—he was the man. So Phil announced on-air that he had an exclusive on a new single by a seven-foot Watusi woman. Apparently, Bill called all the distributors around town looking for this non-existent Watusi. Wasn't AM radio fun!

—Paul Evans, New York, New York, November 2008

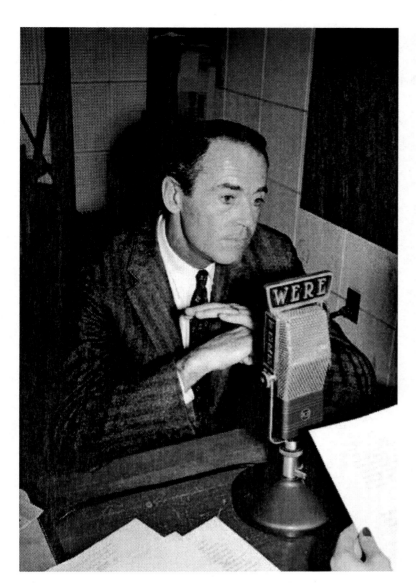

Henry Fonda

April 1957

The bored-looking guy with the everyman face is distinguished, fifty-one-year-old actor Henry Fonda. The person wearing nail polish on the other side of the RCA 44BX microphone is presumably the incorrigible Louise Winslow, on-air hostess.

The actor bides his time as the inept broadcaster reads off a United Artists cue sheet trumpeting the accolades for *Twelve Angry Men,* director Sidney Lumet's claustrophobic jury room drama. Fonda's performance is his usual sketch of understated beauty, but actor Lee J. Cobb steals the show as anguished Juror No. 3. "Kids! Ya work your heart out!"

Wanda Jackson

Saturday, April 27, 1957

Nineteen-year-old Capitol recording artist Wanda Jackson plays the hellcat poised to strike. It was the pretty Oklahoman's assertive July 1954 duet with Billy Gray on "You Can't Have My Love" that first caught the attention of Tommy Edwards. He's been in her camp ever since, straight through to her most recent release, the slinky ballad "Let Me Explain."

In just a few months, Jackson will unveil her masterpiece, the offensive, postwar-apocalyptic "Fujiyama Mama," which opens with one of the best rockabilly lyrical couplings of all time: "I've been to Nagasaki, Hiroshima too! The same I did to them baby, I can do to you!"

Wanda's aggressive, sexually charged music fails to connect with the teenage girls buying the records but will later serve to inspire countless others with its unprecedented female expression of individuality and freedom. When you hear rock music's first Queen growl "Fujiyama Mama's" "I'll blow your head off baby with nitroglycerine!" you better duck and cover.

Wanda Jackson comes in to the Circle Theater Jamboree tomorrow nite (27th) for her 4th appearance in the past three years.
 —"T.E. Newsletter," Vol. 4, No. 29, April 26, 1957

By April 1957, I had already established my look: Long hair, red, red lipstick, long Rhinestone earrings, high heels, tight-fitting dresses. My mother, Nellie, made the dress. It was rose-colored velvet, with silver beading.
 —Wanda Jackson, Oklahoma City, Oklahoma,
 July 2008

Dolores Hart

June 1957

Graceful nineteen-year-old actress Dolores Hart (Hicks) spreads the word about Elvis Presley's second movie, Paramount's *Loving You,* in which she plays his songbird love interest.

She'll soon be spreading an entirely different word: in 1962, Hart abandons her promising Hollywood career and becomes a Catholic nun. Quick to characterize her piousness as a spur-of-the-moment miracle, the starlet goes from memorizing scripts to chanting in Latin seemingly overnight.

Presley's RCA Victor wax from the movie's great soundtrack enters the *Cash Box* singles chart the week of June 29, on its way to No. 1.

Latest record to be banned by KYW is Elvis Presley's TEDDY BEAR SONG—we had it first here on WERE.
—"T.E. Newsletter," Vol. 4, No. 36, June 14, 1957

Elvis was just a sweetheart, he was having such fun. He had none of the worries that seemed to plague him later in life. I loved traveling and doing promo work for the film companies. I had a wonderful time doing it, the main reason being I would sit talking to the men and women on the circuit. I would get to know them. Most of the time, instead of people interviewing me I interviewed them. That was a lot more fun for me. I found out a lot about their families, what makes a family work. After we got the humdrum stuff of movies out of the way I'd find out what they were all about. I suppose I was being an operative Catholic before I even knew what a Catholic was. I made a lot of friends, relationships that continued even after I left the business and entered the monastery.
—Mother Dolores Hart, OSB, Abbey of Regina Laudis, Bethlehem, Connecticut, June 2009

Dale Hawkins

June 1957

The eerily fantastic sounds of "Suzie-Q," Dale Hawkins's (Delmar Allen Hawkins) hit single on the Checker label, conjure up our most primeval emotions.

This photograph intimately captures the exuberance twenty-one-year-old Hawkins feels as his deceptively simple song begins its influential journey. Written by Dale and a young Louisiana guitarist named James Burton, "Suzie-Q," one of the greatest rock 'n' roll recordings of all time, just sweats sex and obsession.

And this comes from a rather unremarkable artist who fails to repeat his initial success. The extraordinary James Burton will go on to inspire some of the most creative moments in the careers of Ricky Nelson and Elvis Presley, but Hawkins must remain content with his one moment, when the magic danced in his eyes.

Don Rondo

June 1957

While his robust vocal testifies what a thrill it is to "watch the gauchos ride the pintos out across the pampas trail," a pseudo–rock 'n' roll beat keeps our feet tapping. Throw in a stodgy organ solo, and you've got "White Silver Sands," Don Rondo's big-selling disc for Jubilee Records. When considering the mad success that's come his way, the hefty baritone looks just as surprised as the rest of us.

Somehow publicist Mario Trombone and Jubilee's Morty Palitz have positioned their star to be in exactly the right place at the right time. As the rock 'n' roll wolves circle hungrily, this former plumber out of Palmer, Massachusetts, is perched safely atop the charts.

I'm amazed; I've never seen this photo before! I was making the rounds promoting my recording of "White Silver Sands." I was twenty-seven years old at the time. It was strictly a promotional tour; I was not playing in the area. I remember the suit. I got it at Anderson-Little on State Street in Spring-field, Massachusetts, for a whopping $29!! I think I was wearing torn underwear at the time, due to some luggage issues.

—Don Rondo, Hooksett, New Hampshire, June 2009

Slim Whitman

July 1957

As a listener, it's a jarring experience. Things start off fine for thirty-three-year-old country star Slim Whitman (Ottis Dewey Whitman Jr.) on his new Imperial side, "I'll Take You Home Again, Kathleen." Lulled into a sleepy trance by the singer's plaintive tone and the song's melancholy lyrics, you're transported back to the fresh, green fields of home. Then it happens.

Suddenly Whitman breaks into his weird, signature yodel, and it's like someone's switched the TV station from *The Adventures of Ozzie and Harriet* over to *Science Fiction Theater*. It's a neat sort of gimmick, since there's no one else out there who sounds like a human theremin.

Twenty-year-old Elvis Presley soaked up a bit of the Whitman strange while the two toured together in 1955. Listen to the unearthly yodeling on his Sun recording of "Blue Moon" and get ready for those goose pimples to pop.

Bonnie Alden

August 1957

Is that a giant balloon dog? When jazz vocalist and actress Bonnie Alden drops by, it's all kicks and pranks, never a dull moment.

Her latest album is *Charleston,* a feisty nod to the 1920s, on which the impish Alden channels the party-hungry flapper girls and their rebellious lust for life. One of the Roulette LP's more accessible tracks has been released as a single, the cute novelty song "No Hu Hu."

Tommy Edwards hears some potential and says as much in the August 2, 1957, issue of his newsletter: yesteryear's exciting sounds dressed up fresh for a new generation's enjoyment.

Michael Landon

July 1957

A cool and relaxed twenty-one-year-old Michael Landon (Eugene Maurice Orowitz) doesn't seem all that concerned with the poor sales of his new single, the rockabilly-infused "Be Patient with Me / Gimme a Little Kiss (Will 'Ya' Huh)" on Candlelight Records. Maybe that's because he's been busy terrorizing drive-ins everywhere in the title role of American International Pictures' box-office smash *I Was a Teenage Werewolf.* The film's success puts Landon on the Tinsel Town map and the road to stardom. Meanwhile, his music career gets the silver bullet.

In September 1959, his popularity soars with his portrayal of Little Joe Cartwright on NBC-TV's *Bonanza.* Fono-Graf Records tries to cash in by reissuing the actor's 1957 Candlelight wax, but no one is interested.

Chris Connor

August 1957

Imperfections. They're the reason twenty-nine-year-old jazz singer Chris Connor's (Mary Loutsenhizer) voice is so engaging: a haphazard vibrato that threatens to veer off course, the undisguised copycatting of her influences, or a few sloppy notes at the end of a phrase. These are the price paid for performing risky vocal acrobatics without a net.

Connor's unpredictability makes for a grand listening experience, slipping in comfortably somewhere between the robotic precision of Ella Fitzgerald and the runaway train emotionality of Helen Merrill. Hear for yourself by picking up a copy of the new Atlantic two-LP set, *Chris Connor Sings the George Gershwin Almanac of Song*. The achingly sensitive pianistics of Ralph Sharon and the instant mood enhancer of Milt Jackson's vibes provide the perfect setting for some beautiful imperfections to occur.

"Miss Modern Music," as the *Cleveland Press* dubbed her in a July 19 ad, recently followed Dizzy Gillespie and his seventeen-piece band into the Modern Jazz Room down on East 4th in the Central Market area.

Steve Karmen

August 1957

Tommy Edwards's photograph of Steve Karmen captures the nineteen-year-old Mercury recording artist at the start of a successful career in pop music and a

new, advantageous friendship. WERE deejay Bill Randle seems to genuinely like the kid, taking the singer-songwriter under his wing and into his VIP world.

Backstage invitations to concerts, the never-ending soap opera of the Cleveland Indians, on-air high jinks, and flirting with pretty girls; the two men seem to share similar interests, tastes, and humor. But there's never any doubt about who's running the show. The sad thing is, young, starstruck Karmen is probably as close to Bill Randle as anyone ever gets. And that's a million miles away.

While in town, Steve headlines the Poodle Lounge, located at 13897 Cedar Road in Euclid Heights.

We hear a report from Philly to the effect that Dick Clark cancelled Steve Karmen's performance on the Bandstand Show yesterday (8th) 'cause he heard Steve talking about Cleveland being the No. 1 music city in the U.S.

—"T.E. Newsletter," Vol. 4, No. 44, August 9, 1957

It's outstanding to see this picture. A performer always dressed properly in those days, jacket, shirt, and tie, especially in the evening, quite different from what was to come in the music business. The hub of the record business then was Cleveland-Pittsburgh-Detroit. That's where every artist went to break their record. Radio stations were able to play new records by new artists, and programming was usually done by the deejay himself. Later, a record moving up could sell more copies in New York and Chicago, but those big-city station playlists were usually controlled by station program directors, making it difficult to get airtime unless you had action elsewhere first. WERE was the top station in the Midwest. I had appeared on the *Arthur Godfrey Talent Scout Show* (CBS-TV) in April 1957 as a Harry Belafonte–style calypso/folksinger and worked on Godfrey's daily morning TV-radio simulcast for another five weeks, as well as Godfrey's Wednesday-night network TV show. Godfrey was the king of the airwaves then. After Godfrey, Mercury Records bought my contract from Eldorado and tried turning me into a rock act. My first Mercury record was "She Had Wild Eyes and Tender Lips / We Belong Together." That's how I came to Cleveland, performing and doing record promotion. I was booked into the Cabin Club several times, which was only open on weekends; and later into the Poodle Lounge in Euclid Heights. I played each club two or three times a year, and that's how I met Bill Randle at WERE. Bill and I hit it off immediately. I liked him for a very basic reason: he was smart and inquisitive, and always ready to learn. That's the seed that breeds success in anything, the desire to learn. I can understand why people might have not liked him: when he played your records, you loved him; when he didn't, he was the worst bastard in the world. It's human nature 101. We always got along. Those were the fun days.

—Steve Karmen, Bedford Hills, New York, June 2009

Frank Pizani

August 1957

The teenage girls in the studio audience at Chicago's WGN-TV *Bandstand Matinee* think the new usher's pretty cute. And he even sings real nice, when the host lets him. The boys want to punch him in the mouth for the way their girlfriends make such a fuss—he better watch his back.

No need. Twenty-two-year-old Frank Pizani's (Pisani) a survivor. Street fights with jealous boyfriends are nothing compared to the cutthroat world of Chicago's music business. He strolls invincibly into WERE, complete with prerequisite teen-idol sweater and a fresh copy of his hot new single, "Angry," on Bally Records, an easy rocker with good vocals.

It's been a long time. I do remember that Tommy and I hit it off very well. We seemed to have a lot in common. I remember him saying that if I moved to Cleveland, he would see to it that I would get a lot of work. As far as the rumors about Eddie Cochran playing some guitar on "Angry," I doubt that he was on the session. Lou Douglas was the arranger, and he used Chicago-based musicians. I didn't know Eddie at the time and met him later on through Dick Clark. After "Angry," I recorded "Wanna Dance" with Leonard Chess. The arranger on that session was Harvey from Harvey and the Moonglows. They were great and did everything right off the cuff. My manager at the time helped the Chess Brothers from being taken over by some unsavory characters from Chicago. In return, Leonard helped my manager produce a session for us. We, in turn, sold the master to Joe Carlton from Carlton Records. This enabled me to buy my first brand-new 1963 Chevy Impala.

—Frank Pizani, Lincolnwood, Illinois, April 2009

Helen Merrill

August 5–11, 1957

Sam Firsten, owner of the Modern Jazz Room, could use some interior decorating tips. His small club on East 4th and Huron, which he touts as the "Jazz Corner of Cleveland," has all the charm of a prison cafeteria. Perhaps it's just as well: there's nothing to distract patrons from the beautiful music performed by the best jazz musicians in the world.

This week, a voice that shimmers with all the sadness of a Clifford Brown trumpet solo comes to the stage. Twenty-seven-year-old Helen Merrill (Hellen Ana Milcetic), an ambitious young jazz singer from Manhattan whose warm sound transforms a cold and impersonal nightspot into a safe haven for the brokenhearted.

Accompanied by the fine pianist Ronnell Bright and his trio, Helen's sure to sing at least one side of her new EmArcy single, "Blue Guitar / Listen."

This photo took me completely by surprise. My eyes look very sad in the photo, and I probably was. Of course I remember Tommy Edwards. I had to travel so much in those days that I often left memorabilia behind, including the pearls. You know, we were paid so little, as jazz artists, that I was grateful for the support, friendliness, and encouragement of the Cleveland audience and certainly of Tommy. Cleveland was a very important city for artists, as you know.

—Helen Merrill, New York, New York, July 2009

Paul Anka

August 1957

What were you doing with your life at sixteen? Stressing out over final exams? Nursing a puppy-love broken heart? Doing drugs? Ottawan singer-songwriter Paul Anka has been busy negotiating a record deal with big clout label ABC-Paramount, writing and recording a No. 1 pop song, "Diana," and laying the groundwork for a long and successful career.

He's also had his mind on other conquests, according to WERE deejay Bill Randle.

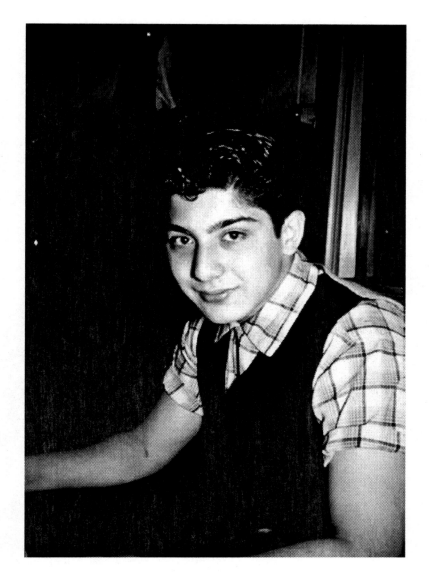

Paul was funny. Paul made an old man out of me. We're great friends. When Paul was sixteen, I was his guardian. He was a Canadian citizen. We brought him to this country to do a lot of shows with the Everly Brothers and Connie Francis. I had to be his guardian so he could work in the U.S. So I was his guardian, and in a minute I recognized that Paul was a very active young man. I mean, he was really looking for young women. Well-built young stewardesses were his forte. I knew that I really had to get some control over him. So I hired the Pinkertons around the clock and he never went anywhere for three days without the Pinkerton detectives. They slept in the room with him. So it hindered his action a little bit.
　　—Bill Randle, interviewed by Marty Conn on the
　　Marty Conn Show, WRMR, 2000

I remember spending some time with Bill Randle but I don't remember things ever getting too wild.
　　—Paul Anka, Beverly Hills, California, September
　　2009

The Poni-Tails

August 1957

The "new and improved" Poni-Tails prepare to sweat it out as "It's Just My Luck To Be Fifteen," their debut single on ABC-Paramount, misfires.

Nothing eighteen year-old Ohioans Toni Cistone (center) and Patti McCabe (right) can't handle. When pal Karen Topinka recently quit the group, it felt like the end of

roll history. In June 1958 the Poni-Tails release "Born Too Late," one of the best girl-group records of the fifties. Success, sales, and vindication follow. Don't mess with Cistone and McCabe.

Bill Randle flipped the 45 over and found "Born Too Late" and broke it, with Tommy Edwards following right behind. We did a lot of record hops with Tommy. To this day, I still think of him; he became a very good friend and he backed us up. Tommy was always right there for us. Whatever he asked us to do, we were more than happy. We'd go out to dinner with him. He pointed the camera at us and we'd smile. I did the high voice in the group. By the way, my poni-tail is fake!
—LaVerne Novak, Mentor, Ohio, August 2008

Tommy Edwards was a very nice person, one of the first deejays to play our songs and help us out. It was such an exciting time. We were just kids, after all, fresh out of high school playing to kids our own age at sock hops and at St. Michael's Hall with Bill Randle. I sang the melody and lead. My poni-tail was real. As soon as we got our record deal, I started growing my hair. LaVerne was late to join the group. She joined after we graduated, because Karen's father did not want her to continue. So LaVerne needed a poni-tail and quick, so we gave her a fake one to wear.
—Toni Cistone, Mayfield Heights, Ohio, April 2009

the world. She blamed her sudden departure on circumstances beyond her control, but the girls have their doubts. After two failed singles on local labels, they wonder if Karen just wanted off a sinking ship.

Whatever Topinka's motivations were, she'll be sorry. Refusing to let their dreams crash and burn, Toni and Patti waste no time recruiting eighteen year-old Ohioian LaVerne Novak (left) to make them whole again and the rest, as they say, is rock 'n'

Bob Jaxon

September 1957

Considering the paltry sum he's fanning out, maybe RCA recording artist Bob Jaxon (Robert Jackson) just cashed a royalty check. The twenty-seven-year-old New Yorker sounds eager to please on his second single for the label, the rockabilly-tinged "Gotta Have Something in the Bank, Frank."

Barclay, Cadence, RCA, Top Rank, ABC-Paramount, 20th Century Fox, and Big Name; Jaxon records for them all, with about the same results: earnest, yet commercially unsuccessful stabs at stardom.

Jeff Chandler

September 6–7, 1957

Thirty-eight-year-old actor Jeff Chandler must really like this "are you talkin' to me?" tough-guy face. There it is again on the cover of his just-released debut Mercury LP, *Jeff Chandler Sings to You,* a cigarette dangling from the Hollywood hunk's lips, the lighter's flame threatening to singe those bushy eyebrows.

Chandler's not much of a singer, and he knows it. But the unpretentious charm of his "Let's Get Lost" serves nicely as background noise to a romantic evening. While visiting WERE, he probably chats a bit about his role in Columbia Pictures' biopic *Jeanne Eagels,* starring Kim Novak as the self-destructive, heroin-addicted Broadway icon. The actor plays Sal Satori, a rough composite of all the cruelly opportunistic men who populated Eagels's career and bedroom.

The next four years bring more movies and music; a bitter divorce; and sudden death, when an operation to correct a slipped spinal disc goes very wrong.

Bobby Helms

September 1957

Decca recording artist Bobby Helms has just turned twenty-four years old and couldn't have asked for a better birthday present. The unassuming country singer from Indiana has himself a blockbuster with "My Special Angel," a perfectly schmaltzy ballad currently sitting at No. 1 in the "T.E. Newsletter" Top 10 Pop and Country poll.

Important-sounding *Billboard* awards and the soon to be unleashed perennial monster hit "Jingle Bell Rock" round out 1957 nicely for Helms, the year he wakes up to find the world at his feet, his only time spent in the limelight.

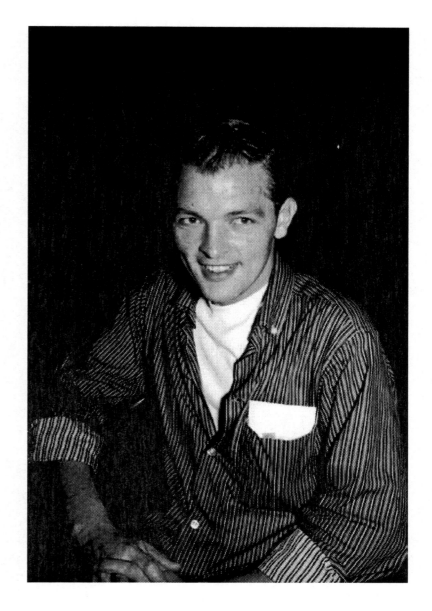

Kathy Barr

September 1957

If singer Kathy Barr (Marilyn Sultana Aboulafia) seems a bit tense, it's with good reason. The curvaceous soprano with the three-and-a-half-octave range seethes with frustration as her record company makes a shambles of her career. The sharp minds at RCA Victor are quick to dismiss Kathy's unique strengths as an exciting young opera star with sex appeal in favor of having her record silly songs aimed at the rock 'n' roll market.

The cold reception of her debut single, "A Slip of the Lip / Welcome Mat," motivates the talented singer to seek out more creative control. November sees the release of her LP *Follow Me,* a pretty collection of torchy standards that points in the right direction.

The Everly Brothers

Tuesday, October 1, 1957

Tommy Edwards and the Everly Brothers (from left: Phil, Tommy, and Don): Don is twenty and Phil just eighteen when they appear on the deejay's fledgling television show *Farm Bureau Jamboree,* broadcast live every Tuesday at 7 P.M., channel 5, WEWS-TV.

Edwards gives the Cadence recording artists a rousing introduction, and Cleveland reverberates with the Everlys' electrifying Kentuckian harmonies and slashing J-200 Gibson acoustic guitars, rock music's antidote for the repentant, gospel-tinged harmonizing featured on country music radio stations of the day.

The Everly Brothers guest on my TV show Tuesday, Oct. 1st—their record of WAKE UP LITTLE SUSIE is the biggest in town—and did you know that they recorded for Columbia a couple of years ago and they have some religious songs in the can over at Col.?

—"T.E. Newsletter," Vol. 4, No. 50, September 27, 1957

The Everly Brothers appearance on our last Tuesday evening TV show boosted our rating considerably.

—"T.E. Newsletter," Vol. 4, No. 51, October 4, 1957

Terri Stevens

October 1957

Sexy twenty-five-year-old Terri Stevens (Rose Theresa Caruso), caught fussing with her hair, must break Tommy Edwards's heart just for a second with her disarming smile. The pop singer's latest RCA Victor wax is "Pin-Up Girl / Untouched Heart."

If you don't mind relaxing with mobsters, drop by Morris Kleinman's Zephyr Room at 14737 Lorain Avenue between September 24 and October 8. Terri's in fine voice.

The bracelet was a magnificent charm bracelet from my husband. He gave me a new charm every birthday. Each charm represented a meaningful occasion. We were married in 1954, and the bracelet grew through the years, until we had a robbery in 1975 and my bracelet was gone. So much for that. My first label was AA. They had money troubles and couldn't get the records in the store. I had a hit with "Unsuspecting Heart" in '55, and no one could buy the record. I did a promo tour all on my own money. I was married to a South American who owned a club called The Boulevard on Long Island, so I had some funding. I made zero money from record sales, but the airplay got me on the *Perry Como Show*. Once you do things like that your price jumps from $250 to $1,000. My friend Morris Diamond, a national record promoter at the time, accompanied me on the road. My husband was in the business, so he didn't mind me being away. I signed with RCA, but then Elvis came on the scene, and that was the end of that.

—Terri Stevens, Bayside, New York, March 2009

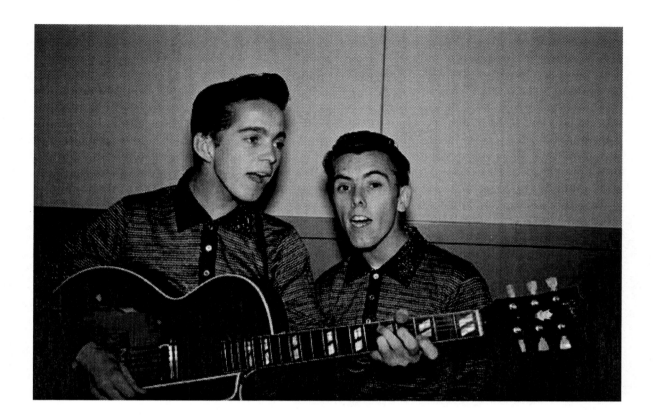

The Sprouts

Tuesday, October 8, 1957

The Nashville skyline must seem a million miles away to Tennessee rock 'n' roll duo Bobby Johnson and Billy Cosby. These boys in sparkly collars appear to be on the fast track to the big time. The Gibson ES-175 Electric Archtop sings out a G-major chord as the boys harmonize on "Teen Billy Baby," their peppy debut single out on Spangle.

As RCA Victor prepares to swoop down on the little Springfield, Ohio, label, they may think they've stumbled upon the new Everly Brothers—a rockabilly prelude to Alvin and the Chipmunks is more like it.

Future releases on Mercury, K-Ark, and Lucky Four confirm the obvious. Don and Phil Everly have nothing to worry about.

Ray Clark of RCA in town to try to sign the act we had on our TV show last Tuesday—THE SPROUTS—watch this group of 2, 17 year olders—much like the Everlys.
 —"T.E. Newsletter," Vol. 4, No. 52, October 11, 1957

The Sprouts were signed by RCA as we predicted 2 issues ago.
 —"T.E. Newsletter," Vol. 5, No. 2, October 25, 1957

Micki Marlo

October 1957

Not even the formidable talents of singer and actress Micki Marlo (Molly Moskovitz) can save the *Ziegfeld Follies of 1957*. Producer Florenz Ziegfeld's original titillating revues of the early 1900s broke all the rules,

sexing up respectable theaters with a flash of the thigh or a face full of frilly underwear.

But a recent run at Broadway's Winter Garden Theater closed up shop June 15th after just 123 performances, suggesting the *Follies* has overstayed its welcome. As the

touring edition of the show limps into the Hanna Theater at 2067 East 14th Street, a dejected Marlo puts on a brave face. It'll be a tough few weeks, but at least she's sure to get some soft, wet kisses from a four-legged friend.

Redd Evans writes that Clooney's song, MANGOS goes into the Ziegfeld Follies to be sung by Micki Marlo.
 —"T.E. Newsletter," Vol. 4, No. 25, March 29, 1957

Ziegfeld Follies did the week here with Micki Marlo and Clevelander Kay Ballard in the female top spots.
 —"T.E. Newsletter," Vol. 4, No. 51, October 4, 1957

I was a regular singing cast member on the original NBC *The Tonight Show* starring Steve Allen and a Capitol Records recording artist when this photo was taken. Gypsy was a family member and one of the first singing toy poodles on television. Gypsy sang on *The Tonight Show;* on the NBC game show *Charge Account,* where I costarred with Jan Murray; and on *Summertime on the Pier,* which I cohosted with Ed Hurst from Atlantic City's Steel Pier. It was much like the format of *American Bandstand.* I still have the dress I'm wearing in the photo and still love it as well as all of Gypsy's clothes that came from Saks Fifth Avenue's Dog Toggery. Fans would send in handmade clothes for Gypsy. After I did the Ziegfeld Follies of '57 on Broadway, we did a national tour. I costarred with Kaye Ballard and Paul Gilbert, and one of the best remembrances I have, and best Italian dinners I ever had, was at the Ballard family home. It was like family, and I say family because the entire cast was invited. We had a delicious and glorious evening, and I loved it, I loved it, I loved it! I remember it well. Thank you, Kaye.
 —Micki Marlo, Wellington, Florida, June 2009

Sam Cooke

October 1957

Ah, to be a fly on the studio wall! It's a safe bet that twenty-six-year-old Sam Cooke (Cook) has a few choice words for Tommy Edwards after this unglamorous shot. With a mouthful of pastry and the sweet melody of his No. 1 Keen single, "You Send Me," humming down the nation's high school halls, an already big year ends on a high note for the former gospel star.

On February 9, 1958, Sam headlines two big shows at Stambaugh Auditorium in Youngstown, Ohio, along with the Drifters and other top recording acts. Cleveland's *Call and Post* hypes the Sam Cooke Show as "one of the most exciting popular music concerts ever to tour America." Six years later, that same paper will carry the news of his fatal shooting by the manager of a Los Angeles fleabag motel, the final consequence of what had become a sordid and reckless life.

A soul singer before there was soul music; a sophisticated rock star in prime time; or a gritty blues man in the wee, wee hours of the morning: a flawed human being just like us all.

Kay Martin

October 1957

The LP cover to Roulette's *Kay Martin and Her Bodyguards* about says it all. A half-naked woman lays sprawled at the feet of two shadowed henchmen holding fencing foils. Deadpan comic Jess Hotchkiss and accordionist Bill Elliot look less like bodyguards and more like sadists as they hover over voluptuous entertainer Kay Martin. But that's because we're not in on the joke.

The album is a pretty faithful representation of the trio's naughty nightclub act, a perfect balance of double entendres and skin, just the right kind of sexed-up show for the horny high rollers and desperate suckers that Vegas breeds.

Anita Carter

November 1957

So uniquely American, so tragically beauti-
ful; try to imagine a voice able to express
all the weary pathos of John Steinbeck's
Grapes of Wrath, and you'll hear the chill-
ing soprano of (Ina) Anita Carter.

While the Carter family name evokes
the sights and sounds of country music
royalty dating back to the 1930s, Cadence
Records decides to package the pretty
twenty-four-year-old as the "Nashville
Patti Page." Several ill-suited forays into
country pop follow. She resists, and for the
remainder of her life is content to stay in
the shadow of her more gregarious sister
June Carter Cash, faithful to the folk songs
of her heritage.

One standout in a discography popu-
lated with unparalleled performances is
Anita's contribution to a 1963 Johnny Cash
album track, "Were You There When They
Crucified My Lord?" Listen as this lovely
girl from the Appalachian Mountains sings
"A-oooh-oooh, sometimes it causes me to
tremble" in the haunted and unpredictable
voice of what some consider country mu-
sic's finest female vocalist.

**Anita Carter is my TV guest on Oct. 15th—her
Blue Doll record is starting to show some action.**

—"T.E. Newsletter," Vol. 4, No. 52, October 11,
1957.

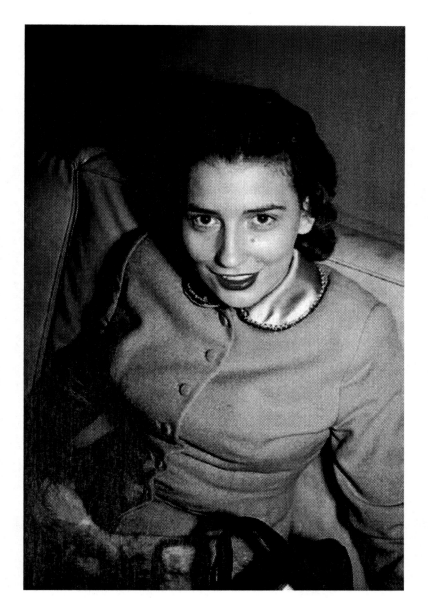

The "Original" Casuals

December 1957

Sometimes it's an innocent, spur-of-the-moment idea that winds up affecting one's life the most—like when eighteen-year-old singer-songwriter Gary Mears spies record-label impresario Don Robey's name on the back of a Clarence "Gatemouth" Brown album and decides to call him. With gumption to spare, Mears sings to Robey over the phone a few lines from a weird song he wrote: "She's so tough. That's why I love her." After a moment of silence that feels like an eternity comes the producer's excited shout: "Come on boys, we'll record it!"

Thanks for an opportunity to remember what our group, the Casuals, looked like almost a half century ago. The members of our group were Joe Adams (eighteen, baritone), Paul Kearney (seventeen, tenor) and myself (eighteen, lead). We were promoting our first record, "So Tough," which was recorded by Don Robey's Duke and Peacock Records. The Robey sound was obvious in "So Tough," a very un–rock 'n' roll sound because Robey used Junior Parker's band on it. That gives the song its rhythm and blues quality. I wrote the song as a tribute to Chuck Berry's driving beat in "Maybellene," but with more lyrical chord changes. The chord changes were common in old standards, but not so for R&B.

Mr. Robey's label and publishing company featured such seminal stars as Big Mama Thornton (the original "Hound Dog"), Bobby "Blue" Bland, Junior Parker, Johnny Otis, Clarence "Gatemouth" Brown, the Dixie Hummingbirds, et cetera. Robey's label was essentially African American artists at that time, except for the Casuals. We traveled with his groups, and it was an amazing time seeing racism from the inside out. How difficult it was to get food and a good place to sleep with a black or "mixed" band, as they called it. On many occasions, Joe, Paul, or me would have to get food in certain towns for our black music friends who couldn't get served. I do believe Chuck Berry did more to integrate the South than Martin Luther King. He was hired by thousands of white college party planners, and I watched him play to a vast gathering of whites in Dallas at the Sportatorium, Pappy's Showland, and other places. I never saw a racist moment in my observations, for the kids loved him. He could even drive around with white girls in his car and rarely got in trouble. He was an incredible entertainer, a phenomenal lyricist, and was much more popular with white audiences than black. He was a clear-headed businessman, and very personable. Indeed, the highlight of my musical experience was to have Chuck Berry take the time backstage in Oklahoma City (1958) to show me how he played a particular chord in one of his lesser known songs. This was the man I idolized, and he placed my fingers on the guitar neck in the position he used. He was humble, attentive, and, of course, made us all laugh with his duck walk.

When this photo was taken, we had just done some sock-hops for Dick Clark, a condition to get him to play the record, as I recall. We had been to almost every major radio station in the Midwest and East Coast. We were traveling with a singer who we frankly thought had no prayer of being a success, especially with a phony name like Johnny Cash. This very shy country singer said no more than three words in our five- or six-day trip with him into Canada. The road was not an easy life, and I knew then I could never make it my career. I tackled the job as an anthropologist would. Rock 'n' roll up close was a very foreign land to me. Paul Kearney died at about the same time Buddy Holly did, and I have not heard from or been able to track down Joe Adams since 1959. The beat goes on.

—Gary Mears, Emeritus Professor of Psychology, the University of Texas, Austin, Texas, July 2009

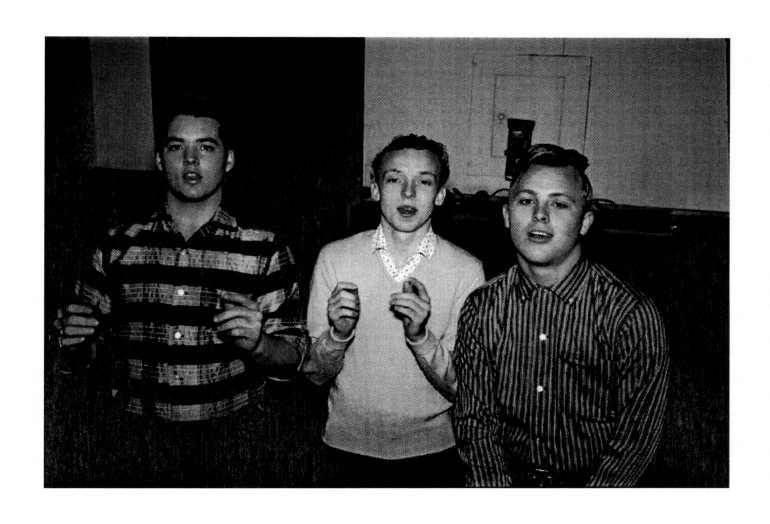

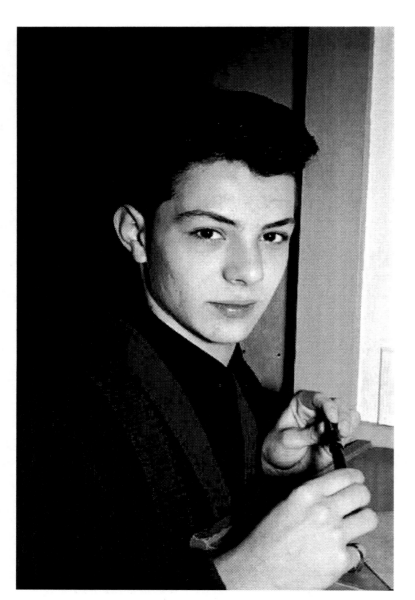

Frankie Avalon

December 1957

The bubble-gum charm of eighteen-year-old Frankie Avalon's (Avallone) music is rainy-day tears cried alone in our bedrooms; the comforting, sleepy pink blur of a spinning Chancellor 45 rpm; the all-consuming urgency of our next teenage crises.

Philadelphia's swoon-worthy hero has recently left his boyhood calling card, a battered trumpet, in a trunk back home, along with his anonymity. On "De De Dinah," his just-released second single, Avalon's pinched vocals sound like a broken kazoo, the band struggling to catch up with the singer as he madly trips through the arrangement. The record sells a quick million copies.

Blamed by community leaders, church groups, and a sensationalistic press for facilitating a rise in juvenile delinquency, record companies are forced to invent a soft and cuddly alternative to Elvis Presley and his dangerous ilk. Avalon is their solution, and the modern "teen idol" is born. Frankie Avalon's success and his non-threatening, squeaky-clean image sound the death knell for the 1950s rock 'n' roll star.

Though Frankie possesses neither a particularly interesting voice nor dynamic stage presence, there's just something about him that has taken root in our consciousness, mostly because of those utopian beach party films of the '60s but also the wonderful melodic craftsmanship of his biggest hits. Courtesy of songwriters such as Bob Marcucci and Peter De Angelis ("Why," 1959) and Ed Marshall ("Venus," 1959), Avalon's all-American boy image is a part of ourselves we don't want to lose.

The Casuals

December 1957

Wunderkinds of the Nashville music scene, Richard Williams (vocals and piano; left) and Buzz Cason (James E. Cason, vocals; right) of the Casuals. Two boys, just seventeen, dizzy with the realization that all their fantasies are coming true. This is actually happening. *We are rock stars.*

Richard and Buzz—along with their chums Billy Smith (drums), Johnny McCreery (guitar), Joe Watkins (sax), and Chester Powers (accordion and piano)—sign autographs and receive some nice hugs from pretty girls after an appearance at a Youngstown, Ohio, record hop, courtesy of host Tommy Edwards. Salad days indeed.

The best shot I've ever seen of me and Richard!! We were promoting "Hello Love" on Dot Records!! Rock onward!!
—Buzz Cason, Nashville, Tennessee, April 2009

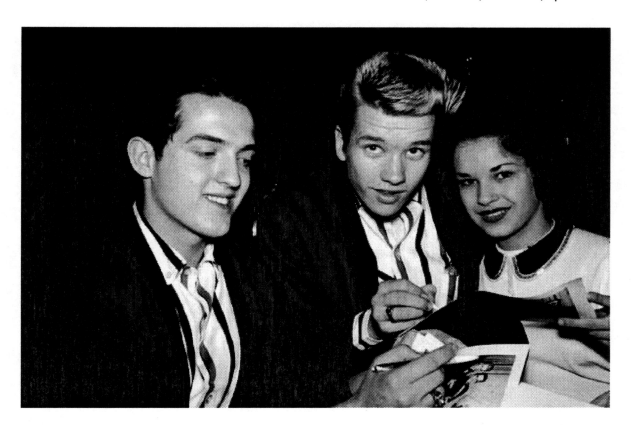

Johnny Jay

December 1957

The cat that swallowed the canary? Twenty-three-year-old rockabilly artist Johnny Jay (John Jerome Huhta) looks as if he's just stolen some poor baby's rattle—and won't give it back.

With edgy vocals reminiscent of Sun Records' great Billy Lee Riley and unusually high production values, Johnny's "Sugar Doll" sounds a bit different from the typical major-label rockabilly release. There's some integrity in the grooves.

Mercury Records sent me on an eastward jaunt to promote my single "Sugar Doll." Cleveland must have been our first or second stop. The record release was October 31, 1957, and I remember going home for a Christmas show from out east. I remember Tommy and Bill Randle. Our meeting stands out in my mind because of how much those guys loved rock 'n' roll and rockabilly and how nice they were to me. That was not the case further east.

—Johnny Jay, Pillager, Minnesota, May 2009

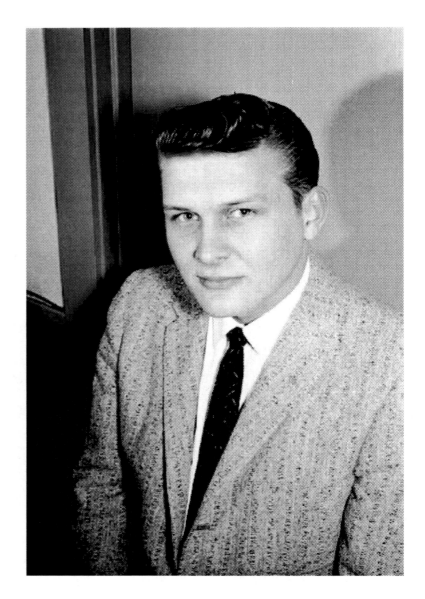

1958

Twilight Time

"Goodnight Rock and Roll"; Coral Records 9–61938

"Heavenly shades of night are falling, it's twilight time," sings the great Tony Williams on the Platters' No. 1 smash "Twilight Time" from April 1958. Unfortunately, the gathering shadows seem to extend precariously over the rock 'n' roll landscape as well. Under the guise of combating juvenile delinquency or fighting for the preservation of American musical standards, opponents of the music launch their attacks from the nation's church pulpits all the way to the halls of the Senate. Longhaired punks with flashy cars and loud guitars are the main targets, although the machines that feed the beast—radio and record companies—also come under heavy scrutiny. Duplicitous deejays brainwash stupid teenagers, who buy the records with money that lines the pockets of unscrupulous companies, who, in turn, bribe the deejays with payola. This vicious circle must end now!

But the rebels aren't going to just give up without a fight. It takes the U.S. Army to finally stop Elvis Presley, who's drafted in March. As a sulking Private Presley

wonders, "Was it all a dream?" the squares crash the party and commandeer the hi-fi, a sorry situation that more or less remains until 1964, when the Beatles cross an ocean to rock us back to our senses.

1958 makes its wintry entrance, and Tommy Edwards is raring to go, pitching a new service to the recipients of his newsletter. Every day he receives inquiries from all over the country asking about how to conduct record hops. As result, he's making himself available as a "record hop consultant": just fly him into town, and he'll show up at your event with his color slide show, employing all the gimmicks that have made his hops so successful in the Cleveland area.

"T.E. Goes Rock 'n' Roll!!" So screams the January 17 newsletter headline trumpeting the release of the deejay's third Coral single, "The Spirit of Seventeen / Goodnight Rock and Roll." Will Dick Clark's *American Bandstand* hurt *Perry Como Show* ratings on Saturday evenings? Why hasn't Columbia Records released any rock 'n' roll records? *Rebel without a Cause* actor Sal Mineo calls in to see how his new single, "Little Pigeon,"

is faring. Watch out for a hot rock number called "Tequila." And although Tommy dearly loves Keely Smith, he's getting tired of her deadpan act with Louis Prima.

February arrives, and the newest deejay contracted to buy Edwards's "Color Slide Show Service" is Dick Lawrence at WBNY in Buffalo, New York. Edwards now has fourteen jocks in the United States and one in Canada projecting his photographs at their record hops. The Platters' visit to the radio station goes unphotographed, and if Dean Martin's "Return to Me" isn't a hit, then Edwards doesn't know hits: he's been spinning it four times every show, and the audience response has been just terrific. Watch this one grow!!

The First Annual Pop Music Disc Jockey Convention ushers in March with Tommy in attendance. "White Silver Sands" singer Don Rondo couldn't make the Kansas City convention because of an ear infection. Watch the March 24 issue of *Billboard:* the country charts will show only country music. (It's been a hodgepodge of both rock 'n' roll and pop songs for the past year.) The Platters' recording of "Twilight Time" is getting sensational play in Cleveland, along with "How Will I Know My Love" by Mouseketeer Annette Funicello.

On Easter Sunday, April 6, Alan Freed brings his big rock 'n' roll show to town, featuring such artists as Jerry Lee Lewis, Buddy Holly, and Chuck Berry. According to the official Trendex list of the top 50 selling records in the Cleveland area, more than half the songs are not rock 'n' roll. A sign of the times? On the heels of their big hit "All I Have to Do Is Dream," the Everly Brothers are in town doing some personal appearances. Bill Randle will be hobbling around for most of April—he fractured a big toe while playing handball.

Because of local police trouble in May, WERE bans all Screamin' Jay Hawkins records. The Jerry Lee Lewis child-bride scandal has caused a big furor in town, sparking much public disapproval. Edwards notices a general cleaning up going on in rock 'n' roll. Radio stations and record labels seem to be getting away from the gutty, raunchy sound and promoting the ballad style more every day. In addition, he believes Top 40 programming is setting radio back twenty years; Top 40 stations are not alert, and they let others make the hits. This is a controversial stance that irks the WERE brass, triggering the cancellation of *The Biggest Show on Records,* a Top 40–type program Edwards hosts on Saturdays. Alan Freed resigns from WINS over trouble at a Boston rock 'n' roll riot, Tony Bennett vacations at his wife's folks' home near Mansfield, Ohio, and the talented Jimmie Rodgers sings at a local YMCA benefit. Frankie Avalon's protégé is announced, some kid named Fabian. Edwards's newest gadget is a tuner installed in his car—it receives all the local TV channels. In one weekend he gives away one thousand records at five record hops.

It's June, and all the raucous, discordant rock 'n' roll tunes have been banned from the air on WERE. Edwards reassures us that they're still playing rock, only the "quieter kinds." Bill Haley opens an art gallery just outside of Philly, and Tommy gives away Elvis Presley charm bracelets to twenty-five lucky listeners. As the month closes out, Edwards goes out on a limb and starts spinning an Italian song by Domenico Modugno, "Nel Blu Dipinto Di Blu." Better known as "Volare," the record is soon a worldwide smash, and the Cleveland deejay basks in the accolades for sending it soaring.

The July issue of *Hit Parader* features a nice spread on Cleveland's "Mr. Class," Tommy Edwards, who thinks the new religious EP by Pat Boone is marvelous. The hula-hoop craze gets started in Cleveland after its West Coast debut, and Billie

Holiday sings at the Modern Jazz Room in August. Tommy denies the rumors he's leaving WERE and gets busy banging the drum about his fourth single, "What Is a Boyfriend? / All about Girls and Women," on Dot Records. Come September, stereo disc equipment is installed at the station, and he previews a copy of the single "Little Bird" by Larry Fotine, supposedly the first stereo 45. It sounds good. The "T.E. Newsletter" has become one of the most widely read sheets of its kind in the nation. Chet Baker slays them at the Modern Jazz Room.

Adulterer Eddie Fisher's new record is not being played on WERE, as listeners rally behind his wife, poor little Debbie Reynolds. An October article in *Billboard* reporting on the "payola problem" compels Tommy to come clean. He's never asked for payola in his career, even refusing invitations from the boys to go grab a cup of java. Edwards receives some one thousand letters from Sydney, Australia, after a taped broadcast of his show airs Down Under. Following a brief hiatus, the *Farm Bureau Jamboree* returns to WEWS-TV in November as the *Landmark Jamboree*.

"The Chipmunk Song" by David Seville seems to be the big novelty record for the Christmas season, and "Little Drummer Boy" by the Harry Simeone Chorale is breaking for a hit, thanks to Edwards. By year's end, the cha-cha craze has just about had it and Coral Records releases Tommy's fifth and final single, two cute narrations entitled "Girls and Music / Dear Mom and Dad." This time the name on the label is "Talking" Tom Edwards, to differentiate between the deejay and MGM hitmaker Tommy Edwards.

As the rock 'n' roll playhouse burns to the ground, "Apache!" by the Chiefs, "Ten Commandments of Love" by Harvey and the Moonglows, and "Talk to Me" by Little Willie John still manage to radiate some sex and danger in 1958. For pop fans, "Gift of Love" by Vic Damone is just that, and "Maria" by Percy Faith is one of the most beautiful songs of the year. Hank Locklin's "Send Me the Pillow You Dream On" and Hank Thompson's "Squaws along the Yukon" are big coin in the honky-tonk juke joints.

The Emeralds

January 1958

Nothing comes easy, right? Try telling that to eighteen-year-old Bill Pazman (lower left), lead singer of Pittsburgh-spawned pop vocal group the Emeralds. He might have a different take.

So far, the pathway to stardom has had nary a pothole for Pazman and high school chums (from left, clockwise) Don Munhall,

seventeen (baritone), and George Grimes (bass) and Dom Slebrich (tenor), both nineteen. The boys' debut single, "You Belong to My Heart / The One I Adore," has just been released on ABC-Paramount.

The Emeralds' speedy ascension to the big leagues seems to have spared them the hard lessons of developing artists: the endless, sleepless nights spent finding oneself, or the learning to live with the soul-sucking drain of constant rejection. There's something to be said for having to pay some dues, however; if anything, it gives a humbled appreciation for any shred of good luck that happens to fall in your lap.

Inexperience and indifference will dissolve the group before the year is out.

I never had anything to do with singing. One day, when I was in the ninth grade, I was leaving my house and I heard the Hilltoppers singing "Till Then" on the *Patti Page Show*. I ran back inside to watch. I was so impressed by the lead singer, Jimmy Sacca, I thought, "Wow, I really like that, I want to do that." It was a strange way to get into the business. I had never sung before. I had a good ear for pitch and arranging, but I had never sung a song in front of anyone before. A local deejay named Jay Michael helped get us a recording contract with ABC-Paramount. It was unusual to have a major-label deal like that right out of the gate. We went to New York City to sign the contract, and I met with Don Costa, who was one of the head honchos there. It was exciting and interesting, for sure. The arrangement I came up with for "You Belong to My Heart" was patterned after "Little Darlin'" by the Diamonds. I was a songwriter, too. I wrote the flipside, "The One I Adore," in study hall in high school. We wore sweaters with an "E" on them, patterned after the Hilltoppers. They had a "W" for Western Kentucky State College on their sweaters. We broke up after our second single because we weren't making any money. We were just four teenage guys with no knowledge about the business, no idea about how to succeed. One of the guys wanted to get married, I think. We needed someone older, a manager to help direct us. At that age you think you're really cool, but you really don't know anything.

—Bill Pazman, Chester, Pennsylvania, September 2009

Jimmy Edwards

January 1958

Somebody better call an exterminator, twenty-five-year-old rockabilly singer-songwriter Jimmy Edwards (Jim Bullington) could stand a little fumigation.

Handwritten on the plastic ladybug's left wing is "Love Bug 'Crawl'" and on her right "Jimmy Edwards—Mercury," a silly promotions gimmick that assists the Missourian's new single in just denting the lower reaches of the Top 100.

"Love Bug Crawl" features a rollicking boogie-woogie piano, some exciting guitar work, and Edwards's uninspired mimicry of Buddy Holly–type hiccups and Jerry Lee Lewis–style whoops of delight. He also throws in a couple of real sour low notes that would make Sun Records' Malcolm Yelvington very proud.

Johnny Cash

January 1958

Twenty-five-year-old country music super-
star Johnny Cash appears quite comfortable
on a WERE couch, dropping by the studios
to support the release of his new Sun single,
the soon-to-be country and pop crossover
smash "Ballad of a Teenage Queen."

Less than comfortable must be Sun
Records owner Sam Phillips, walking the
floor back in Memphis, justifiably paranoid
about the clandestine deal Cash has struck
with Columbia Records to leave Sun as
soon as contractually possible.

Two years earlier, Cash had been a
depressed door-to-door appliance salesman
begging Phillips for a chance.

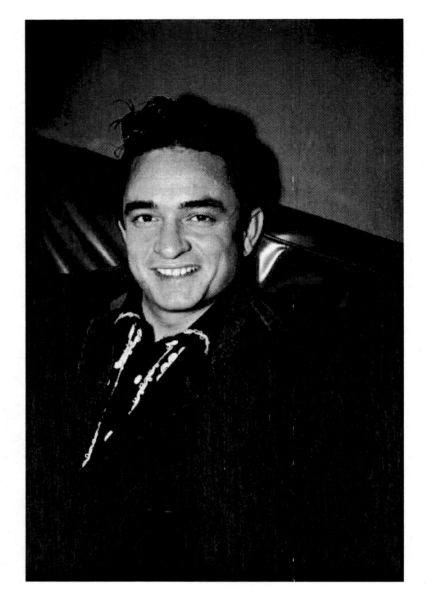

Earl Holliman

January 1958

Depending on what kind of shape you were in on New Year's Day, you may recall hearing a handsome young actor sing a melancholy ballad on NBC's Kraft Television Theatre production of *The Battle for Wednesday Night.* Or not.

Twenty-nine-year-old Earl Holliman's passion for music has not parlayed into the recording career he desperately wants. The Louisianan keeps releasing records, and the public keeps ignoring them.

At least all those years of rejection from practically every Hollywood casting agency are behind him. Holliman's "tough guy with a heart of gold" image is currently in demand for live television theater, thanks to his portrayal of Katharine Hepburn's guileless brother in Paramount Pictures' *The Rainmaker,* for which he won the 1957 Golden Globe for Best Performance by an Actor in a Supporting Role in a Motion Picture. This plum role was originally intended for Elvis Presley until manager Colonel Parker nixed the deal.

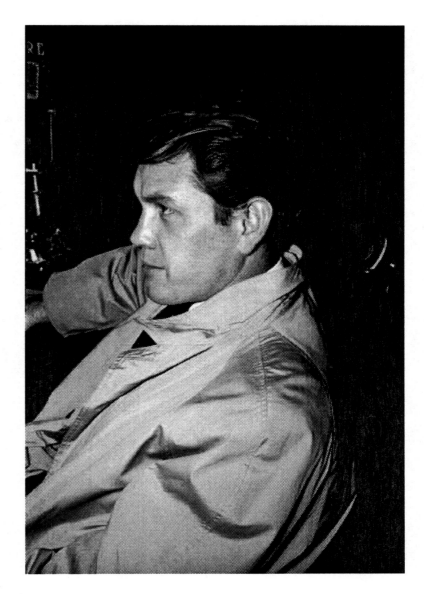

I remember being in Cleveland pushing a record on Prep called "Sittin' and a Gabbin' and Nobody Knows How I Feel."
　　—Earl Holliman, North Hollywood, California,
　　　December 2008

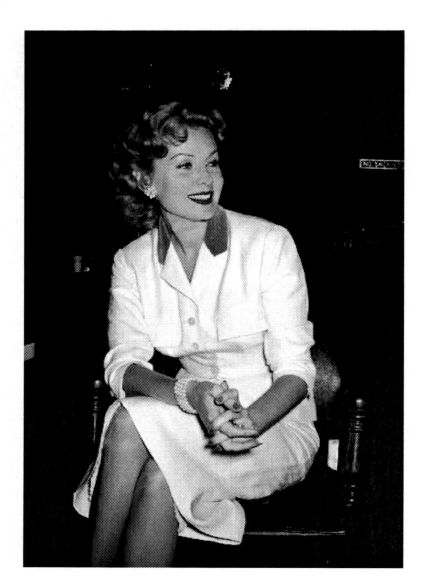

Rhonda Fleming

January 1958

She's a Gil Elvgren pin-up come to life. She just may be the most beautiful movie star to ever step in front of a camera. And she's a damned good singer, too.

Thirty-five-year-old actress Rhonda Fleming (Marilyn Lane), the current reigning Queen of Technicolor, also moonlights as a Columbia recording artist with a debut album to support. *Rhonda* is a well-produced and -arranged collection of standards, the incendiary cover shot worth the price of admission alone.

I have to catch myself from time to time from playing too many Columbia records on my show—the lack of R & R on that label makes it perfect programming for me.
 —"T.E. Newsletter," Vol. 5, No. 15, January 24, 1958

Tommy Edwards certainly was a good-looking man. I surely wish someone had a copy of my interview with him. Doing the album was very enjoyable, and the album cover even won an award. My original name was Marilyn Lane. I was named after Marilyn Miller of New York stage fame. The Lane Sisters were under contract with Fox at that time, and I was told that the name "Marilyn" was not commercial enough. After losing my name, you know who came along two years later . . . Marilyn Monroe. So my agent came up with the name Rhonda Fleming, since there wasn't another Rhonda at that time. David Selznick added the "h" to Rhonda.
 —Rhonda Fleming, Los Angeles, California, April 2009

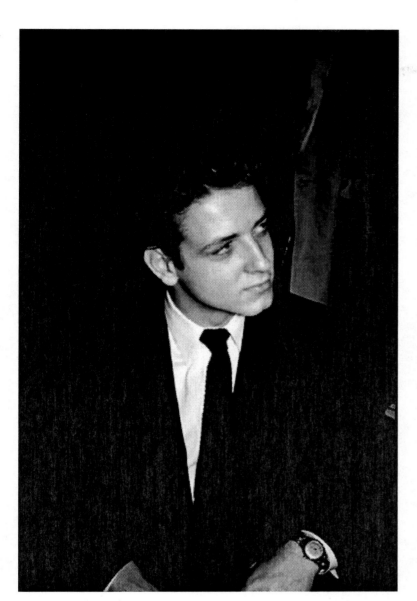

Eddie Cochran

January 1958

With Elvis Presley about to begin a two-year exile in the U.S. Army, the King's crown is up for grabs. And Liberty recording artist Eddie Cochran might just be the one to take it.

His blistering new single, "Jeanie, Jeanie, Jeanie," features one of the best electric guitar riffs of the 1950s. A rock 'n' roll star with smoldering sex appeal; an innovative guitarist, songwriter, and music producer; international touring act and budding movie star—the kid's got it all. Except time.

On the night of April 16, 1960, Eddie Cochran sings his last song in the backseat of a speeding taxi. After completing a successful tour in the United Kingdom, Cochran, fiancée Sharon Sheeley, tour manager Patrick Thompkins, and Gene Vincent are on their way to London's Heathrow Airport when their driver misses a turn and skids out of control, slamming into a streetlight. Eddie dies the next day in hospital, and the others escape with minor injuries.

143

Laura Lee Perkins

January 1958

Why waste words describing the allure of Laura Lee Perkins (Alice Faye Perkins), when Big Joe Turner's 1956 masterpiece shouts it best:

> Now she digs that music with a beat
> Rock 'n' rollin' is her need
> My boogie woogie, boogie woogie, boogie
> woogie country girl
> Well I mean what I mean, my boogie
> woogie country girl.

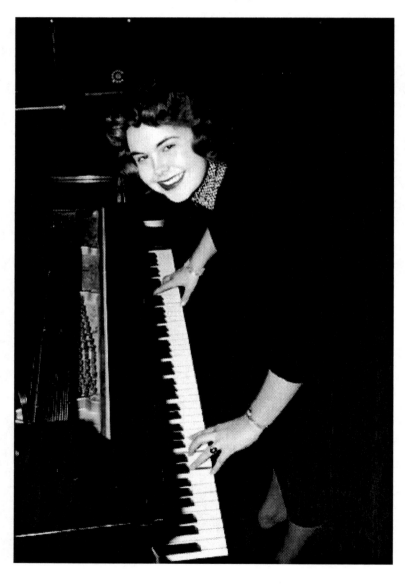

Just a few months before, an eighteen-year-old coal miner's daughter boards a sad and fusty Greyhound in her hometown of Killarney, West Virginia. She wakes up in foggy Elyria, Ohio, her only aspiration to become some faceless factory girl.

What she finds instead is a far cry from playing boogie-woogie piano before Sunday church services in sleepy Killarney: a deal with Imperial Records as the female Jerry Lee Lewis and rockabilly immortality. The slam-bam "Kiss Me Baby" kicks off her debut single.

I played a lot of record hops in Cleveland with Paul Anka, Fabian, the Everly Brothers, Connie Francis, and Frankie Avalon, and that's where I met Tommy Edwards. In fact, Frankie Avalon and I were hired to perform at some rich kid's birthday party in Shaker Heights, and it was scary because the band didn't show up. So I just went over to the piano in the corner and starting playing, and Frankie and I sang all our songs and anything we could think of all by ourselves. The kids loved it anyways.

> —Laura Lee Perkins, Farmington, Michigan,
> September 2008

Tina Robin

January 1958

For sweet little Tina Robin from Newark, New Jersey, it's all going according to plan. Back in March 1957, the ambitious singer landed a contestant spot on NBC's short-lived Tuesday night game show *Hold That Note,* hosted by Bert Parks. Hearing just a few notes, Tina wows viewers by correctly guessing song titles and winning big prize money.

Serendipitously, her snippets of singing on the show attract the attention of Coral Records, and a recording contract is quickly drawn up. Her records do well, and she hits the road, achieving overwhelming success in nightclubs and hotels around the country, such as Miami Beach's Eden Roc and the Shamrock Hilton in Dallas.

But the bloom is off the rose. Her latest single, "Everyday / Believe Me," sounds like a million other records. The pretty vocalist struggles with her weight. Just when a career breakthrough seems imminent, Tina Robin starts a slow and irreversible descent into obscurity that leaves supporters like Tommy Edwards wondering what the hell happened.

Tina Robin appears at the local Zephyr Room starting Monday at a considerable hike in pay since her last stop here—she does the Sullivan TVer on Feb. 23—she's on her way but definitely.

 —"T.E. Newsletter," Vol. 5, No. 16, January 31, 1958

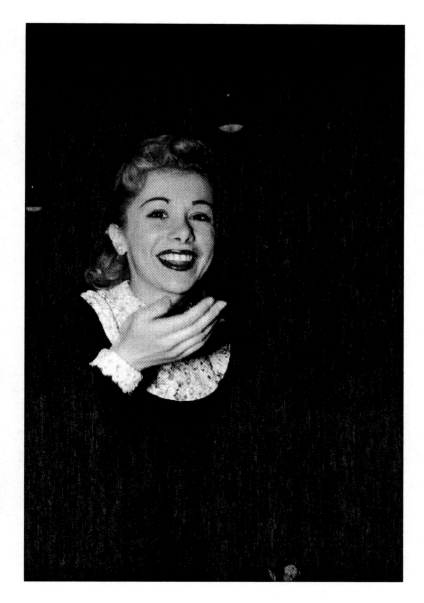

Toni Arden

February 1958

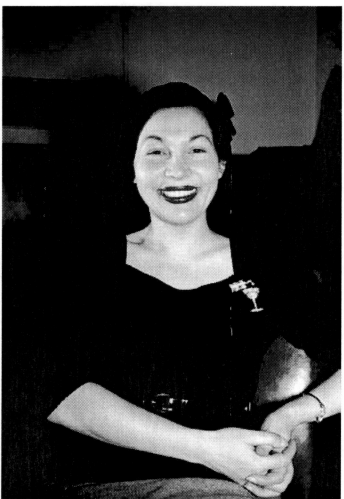

Lovely thirty-year-old songstress Toni Arden (Antoinette Ardizzone) seems the picture of contentment as she visits with her friend Tommy Edwards, a copy of her new Decca album in hand. *Miss Toni Arden* is a multilingual sonic love letter, a grand showcase for her formidable skills.

Diminutive in size, gigantic with talent, the New York City native has come a long way from the wartime ballrooms of the 1940s, where as a teenager she honed her operatic vocal stylings on lovesick servicemen.

In just a few weeks, Edwards will spearhead the momentum on Arden's million-selling single, "Padre." The recording is an epic, no-holds-barred performance, the singer at times quite literally growling out the lyrics, emotionally vesting the listener in the plight of a jilted lover who's destined to count her rosary beads alone.

The newest tune to cause quite a stir here is Padre. The Toni Arden version seems to have the edge over the Valerie Carr wax—this could be one of the important songs of the year—and the first big hit for Toni Arden—the one she has waited for.
—"T.E. Newsletter," Vol. 5, No. 25, April 4, 1958

We told you about the record of Padre by Toni Arden last week—and this week it is Cleveland's number 1 selling record. It's the Arden record all the way. We called Toni at the Latin Casino in Philly and she was thrilled with the news. It'll go all the way.
—"T.E. Newsletter," Vol. 5, No. 26, April 11, 1958

Basic black. My favorite. I still have the pin set and wear it quite often. It was a diamond set, a champagne bottle and glass. It was a gift to me from the owners of the Desert Inn in Las Vegas on my closing night. I did some shows with Tommy Edwards. The Cleveland audiences were fantastic—I loved how they would yell out the names of my recordings. I did four shows a day at the Cleveland Theater. It was Tommy, a fine dresser with his sandy blonde hair who said I reminded him of a master painter, with my beret on, and I'll never forget that. Tommy was very warm and very nice, very complimentary and very sweet to talk to. My recording of "Padre" was Elvis Presley's most favorite recording. I wish I could have met him to say thanks. Yes, wonderful memories of when I was a young girl starting to share my talent with the world.
—Toni Arden, Lake Worth, Florida, September 2008

Kathy Linden

February 1958

Take a voice that sounds like a precocious little girl who's forgotten she should never take candy from a stranger, throw a bit of slap-back echo on innuendo-ridden lyrics, and you'll have a pretty good idea what pop singer Kathy Linden's (Marion Simonton) shtick is all about.

Just a few months ago, nineteen-year-old Marion was a bored to death secretary at the RCA Missile and Surface Radar plant in Moorestown, New Jersey. Some genius at Felsted Records falls in love with her unsettlingly childlike delivery of a creaky old song and rushes the record out. Before listeners can catch their breath, "Billy" goes top 10, and it's goodbye radar plant.

The truth is, most fans of the record believe the singer is in fact a prepubescent girl. Kathy Linden's March 19th appearance on *American Bandstand* sets them straight.

Ralph Marterie and Ann Mull

February 1958

It's a glamorous life, exciting and sexy, filled with stars, parties, and handsome men. Thirty-six-year-old Ann Mull (Ann Marie Lengle), eleven years the wife of Tommy Edwards, hopes the roller coaster never stops.

Her husband complains about her excessive drinking and constant flirting. Ann has no trouble finding sympathetic shoulders to cry on, a welcome escape from Tommy's irrational jealousies and rumored infidelity. There's trouble brewing in paradise, as their marriage slowly starts to unravel.

Forty-four-year-old trumpeter and Chicagoan big band leader Ralph Marterie looks pleased as punch to have Tommy's attractive wife sitting on his lap, while his Mercury recording of "College Man" is busy climbing the charts. One can't help but wonder what Edwards sees through his viewfinder: likely not a popular recording artist enjoying success but his brazen wife slipping away from him.

Ann was a bitch. She was very jealous of Tommy and accused him of screwing around. She once found a pack of condoms in Tommy's van and flipped out. She had no trust in Tommy; she didn't trust anybody. Ann was an alcoholic, a closet drinker. She couldn't have kids—her tubes were tied. I think she had an abortion before she met Tommy. She was a loving person, but such a pain in the ass. She had some kind of a breakdown after they split up, then got remarried and died a few years ago in a Cleveland nursing home. Ann had Alzheimer's pretty bad at the end. I got along great with Tommy, I loved the guy. We were former army guys and hit it off. He didn't like to talk about his private life too much. I remember him broadcasting from his basement in Parma.

—James Lengle, Ann's brother, Palm Bay, Florida, April 2008

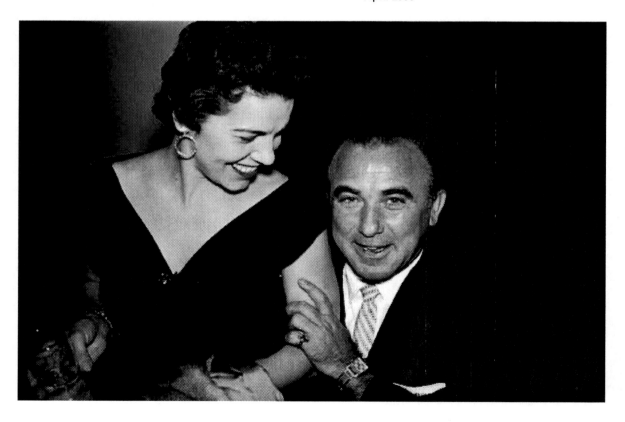

Mitch Miller

March 7–9, 1958

Have camera, will travel. Tommy Edwards attends the First Annual Pop Music Disc Jockey Convention at the Muehlebach Hotel in Kansas City, Missouri, and keeps an artistic eye out for subjects to photograph.

He finds one in the annoyed fellow behind the Vandyke beard. It's Columbia Records' forty-seven-year-old head of Artists and Repertoire, the mighty Mitch Miller. A controversial figure within the industry and an unpopular taskmaster with recording artists, his fingerprints can be found all over the label's biggest hits. Consequently, his musical tastes and idiosyncrasies largely define the soundscape of the nation.

Miller causes quite a furor and receives plenty of publicity when he delivers a passionate speech at the convention admonishing program directors and deejays for their "lazy programming" and for not providing enough balance between that "cacophony" the kids like and adult-oriented music.

At next weekend's Kansas City Deejay Convention I'll be part of a 3 man panel discussing INCREASING PRESTIGE AND INCOME THROUGH RELATED OUTSIDE ACTIVITIES—2:30 Saturday afternoon——My wife and I will both be happy to see you there.

 —"T.E. Newsletter," Vol. 5, No. 20, February 28, 1958

Marty Robbins

March 7–9, 1958

It's no wonder that thirty-two-year-old country music heavyweight Marty Robbins (Martin David Robinson) is smiling. On March 1, following a particularly nasty little flare-up between himself and WSM station manager Robert Cooper in Nashville, "the boy with a tear-drop in his voice" was unceremoniously booted off of the Grand Ole Opry. WSM president Jack J. DeWitt Jr. steps in to arbitrate, and by March 6 the star is back in the saddle again, all apologies accepted. Just in time for the Columbia recording artist to attend the First Annual Pop Music Disc Jockey Convention in Kansas City, Missouri, where he'll hobnob with deejay tastemakers like Tommy Edwards.

"Stairway of Love / Just Married" is Robbins's latest, his spooky 1959 smash "El Paso" and its Grammy for best country and western song still to come.

CONVENTION NOTES: The general consensus of everyone to whom I talked about the convention was that it was an overwhelming success——If I didn't see too much of you please forgive me— I've never talked so much in my life before—— The most outstanding performers that I saw were Tony Bennett, Eileen Rodgers and Pat Suzuki. —— My wife, Ann, was one of the few wives to attend the convention and she acted as part time hostess for Max Callison in the Capitol suite— —I will definitely attend next year.
 —"T.E. Newsletter," Vol. 5, No. 22, March 14, 1958

Ed Townsend

March 7–9, 1958

This weekend Kansas City, Missouri, hosts the First Annual Pop Music Disc Jockey Convention, and attendee Tommy Edwards has experienced something quite special—the depthless beauty of Ed Townsend's voice.

The twenty-eight-year-old songwriter has penned what just may be the greatest make-out record of the fifties, "For Your Love." Improbably, Ed will team up with soul singer Marvin Gaye and cowrite the greatest make-out record of the seventies, Gaye's 1973 smash "Let's Get It On."

CONVENTION NOTES: On the strength of meeting and hearing Ed Townsend I am on his record like crazy—watch out for—FOR YOUR LOVE on Capitol—this is another RETURN TO ME.

 —"T.E. Newsletter," Vol. 5, No. 22, March 14, 1958

Clark Gable

Thursday, April 3, 1958

The King of Hollywood comes home. Fifty-seven-year-old actor Clark Gable (William Clark Gable) probably won't have time to drop in on the old neighborhood of Cadiz, Ohio, his birthplace, about two hours south of Cleveland. He's too busy looking distinguished at the premier party for *Teacher's Pet,* Paramount's sexy romp through the hectic world of journalism, costarring a perky Doris Day.

Next up for Gable is traversing the murky depths with Burt Lancaster in United Artists' submarine warfare movie, *Run Silent, Run Deep.*

Clark Gable had the feminine hearts aflutter here yesterday.
—"T.E. Newsletter," Vol. 5, No. 25, April 4, 1958

The Fraternity Brothers

April 1958

These guys must be great at parties. No one will ever accuse Verve recording act the Fraternity Brothers of lacking enthusiasm. Twenty-five-year-old Perry Botkin Jr. and twenty-six-year-old Pat Murtagh (filling in for Gil Garfield) have brought their own special brand of high-octane showmanship to town, commandeered the piano, and are ready to entertain anyone who cares to listen.

The latest wax of "Study Hall / Bulldozer" sinks stateside, but Europe falls in love with the boys' Ivy League smoothness and jacked-up cosmopolitan sound.

If appearances can be deceiving, then the Fraternity Brothers have us duped. Neither brothers nor college students, they'll carve a career out of their overseas success and sustain it by adapting to pop music's latest trends.

Talk about a surprise . . . this is amazing. This is a photo of Pat Murtagh and me. Pat was a cowriter of "Passion Flower," a Fraternity Brothers recording that was a bomb in the U.S. but a huge hit in Italy, No. 2 record of the year in 1958. Also did well in France. The Fraternity Brothers were Gil Garfield and me. The photo was taken on a brief promotion tour that Verve Records sent us on in 1958. Gil couldn't make it because he was in the real estate business with his father and was busy on a house renovation, so Pat took his place.

—Perry Botkin Jr., Studio City, California, April 2009

Valerie Carr

April 1958

Don't be fooled by twenty-two-year-old Roulette recording artist Valerie Carr's kittenish charm or schoolgirl giggles. Just beneath the surface lurks a rhythm and blues giantess waiting to be reawakened.

Just take a listen to the New Yorker's thick and meaty, no-holds-barred performance of 1955's "Rockin' Bed" on Harlem's Atlas Records, and you'll hear that her present-day crystalline voice has a bit of a tawdry past.

While the slinky "When the Boys Talk about the Girls" climbs the charts, those lucky few who flip the disc over find Carr's subtle interpretation of "Padre," a challenger to Toni Arden's signature smash recording.

Valerie Carr in town for 2 weeks at the Theatrical Lounge.

—"T.E. Newsletter," Vol. 5, No. 26, April 11, 1958

Link Wray

April 1958

Absolute rock 'n' roll gangster. The steely blue eyes and sardonic grin seem to suggest twenty-nine-year-old guitarist Link Wray (Frederick Lincoln Wray Jr.) is about to put the mark of the "squealer" on some unsuspecting deejay.

You can just about hear the subversive chords of "Rumble" slithering from the studio speakers as the secretaries strain their necks to catch a glimpse of the scary fella dressed like a mob hit man.

The big instrumental hit on Cadence Records finds its way onto the turntables of a few impressionable young musicians you may have heard of, namely Pete Townshend, Jimi Hendrix, and Ray Davies.

Ruth Shapiro working on RUMBLE—big request number at hops here.
—"T.E. Newsletter," Vol. 5, No. 28, April 25, 1958

Glenn and Jerry

April 1958

The music emanates from two beautiful blond 1954 Epiphone Century electric guitars with Brazilian rosewood fingerboards, Tone Spectrum "New York" single-coil pickups, and tortoiseshell pick guards. The solid, high harmonies belong to teenagers Glenn Disbro and Jerry Williams, friends whose self-penned debut single is a nice rocker with a cool, stuttering guitar break.

The scene? Some school gymnasium or church hall filled with hundreds of excited kids ready to dance, listen, and have fun. It's just another weekend record hop hosted by Tommy Edwards. That lady in red clapping along in the background is an expert at coaxing the boys into dancing and playing peacemaker, should any problems arise. Ann Mull, the deejay's thirty-six-year-old wife, thrives on the interaction.

Glen & Jerry, who have a new record on the local Whirl label, HELLO, A NEW LOVE, guest on my TV show this Saturday night.
—"T.E. Newsletter," Vol. 5, No. 27, April 18, 1958

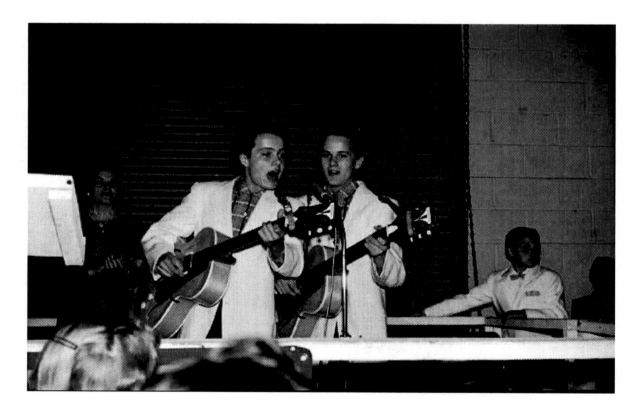

156

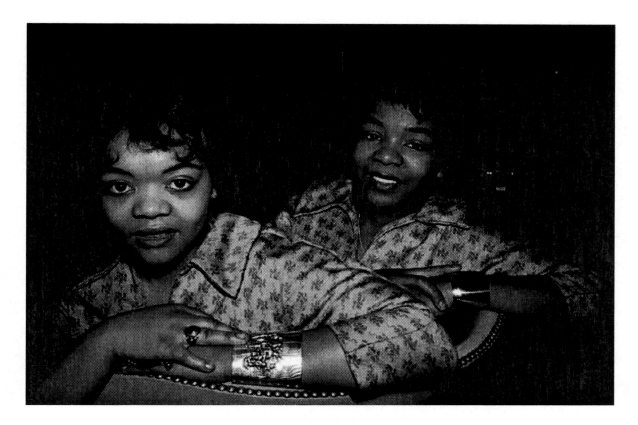

The Storey Sisters

April 1958

"And I knew by the way he smoked, He was a bad motorcycle." Imagine the 1940s Andrews Sisters, of "Boogie Woogie Bugle Boy" fame, fronting a kick-ass 1958 rock 'n' roll band. The attitude, sexual assertiveness, and dangerous fun of "Bad Motorcycle" by Cameo recording duo Ann and Lillian Storey make it by far the coolest record of the year and the prototype for the explosive girl-group sound of the 1960s.

The gals from Philly have brought their taut harmonies and funky jewelry to town for the Biggest Show of Stars of '58 extravaganza, set for Sunday, April 27 at Memorial Hall. The rainy weather won't stop the kids from coming out in droves to hear Sam Cooke, Paul Anka, Clyde McPhatter, and a whole host of other acts.

Marlene Cord

May 1958

When you're an aspiring singer looking to make inroads, it's nice to have married well. Marlene Cord (Mary Fabiano), an attractive, stylish twenty-year-old with a pleasant trailing tremolo to her voice, hit the jackpot when she fell in love with and married Nick Fabiano, a Wisconsin nightclub owner. Nick thinks his girl is the living end so he pays the big bucks for some recording time at Universal Studios in Chicago. The Fabianos soon emerge with an entire LP's worth of standards, which pricks up the ears of Dot Records' head honcho, Randy Wood.

Instead of testing the waters with a few singles, Wood decides to issue Cord's eponymous debut album straightaway, an expensive and risky proposition with an untried performer. Perhaps he hopes the public will hear what he hears. When Cord sings "Mad about the Boy," it's like having the pretty girl next door coo at you from her window on a warm summer's night.

The clothes I'm wearing are all from Bonwit Teller in Chicago. My husband, Nick, loved to take me shopping there. The pendant is a single marquise diamond that he gave me. I had it made into a pinky ring. I don't know why I did that. I hardly wear it now. Back then I wore it all the time. I should've left it alone. I played Cleveland many times prior to my album's release, usually at the Theatrical Grill over on Vincent Ave. I worked with the Barbara Carroll Trio a lot and the Theatrical's house band, the Ellie Frankel Trio. I started as a piano player in my hometown of Springboro, Pennsylvania, and by the time I was a senior in high school I was singing too. At seventeen I was the guest piano player on the Ollie Brown TV show out of Erie. I'd play boogie-woogie piano. An agent from Pittsburgh approached me when I was performing at Conneaut Lake Park and asked if he could book me into nightclubs around the country. I said sure. My dad had taken me to hear Cab Calloway and the big bands, swing bands at Conneaut Lake Park. I was thrilled with the performers. I wanted to be one of them. My first agent came up with the name Marlene Chord. I was booked into a club in Kenosha, Wisconsin, where I met my husband. He owned the club. He got rid of the "h," and I was Cord from then on. My album on Dot was my only record. It was a thrilling experience. We made a few more recordings for Randy Wood, but for some reason he never released them. I would've liked to have had another album. Maybe it's not too late.

—Marlene Cord, Tampa, Florida, August 2009

Frankie Sardo

May 1958

It's always risky business when the deejay opens the phone lines and invites listeners to call in with their questions or comments for a new, unknown artist. Sometimes no one calls. If anyone does call, they're looking for free tickets or prize money. And then there's always the joker who rings in to say how much he thinks your new record sucks eggs. But maybe this is twenty-one-year-old singer Frankie Sardo's lucky day. An excited fan is on the line, someone who loves his latest record, some stranger who makes him feel like a million bucks.

Before the year is out, Sardo jumps to ABC-Paramount and nabs a spot as an extra attraction on the Winter Dance Party tour of 1959, a doomed jaunt through the midwestern states that spells the end of the line for Buddy Holly, The Big Bopper, and Ritchie Valens.

I do, very fondly, remember Tommy and recall we laughed and joked a lot. I was promoting my MGM single "May I / The Story of Love."
—Frank Sardo, Toronto, Canada, November 2008

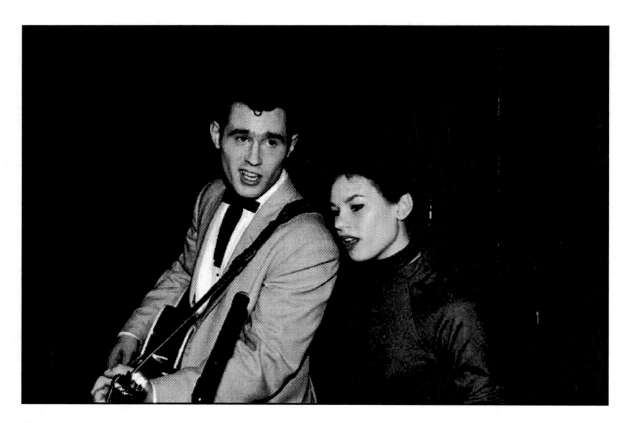

Gino and Gina

May 3, 1958

Warm up the sets and turn the dial to channel 5! It's Saturday night, and here comes another fun half-hour of live music as Tommy Edwards's WEWS-TV show *Farm Bureau Jamboree* flickers to life on the screen. A minor adjustment to the aerial, and a handsome duo materializes out of the black-and-white waves, harmonizing into a sleek Electro-Voice Model 654 microphone.

The loving chemistry that crackles between Gino and Gina prompts some viewers to jump to hasty conclusions. Actually, songwriter Harry Giosasi and his sister Irene are just two lucky kids from Brooklyn caught up in the whirlwind that overnight success brings, one-hit wonders riding a shooting star that has already kissed the horizon.

Cleveland was a big record town. If you made it big in Cleveland, you were big elsewheres. I was nineteen years old when "(It's Been a Long Time) Pretty Baby" hit the top 20, Gina five years younger. It was a crazy time; the road was murder.
—Harry Giosasi, Long Island, New York, August 2008

We played high schools. The frenzied reaction of the kids was different for us. We were onstage in Cleveland, and a guy wanted to shake my hand. Well, he tried to pull me into the crowd and I thought my brother was going to crack him on the head with the guitar. It was a scary time and not scary. I knew my brother would protect me. I had my own chaperone. Mercury Records made my sister come on the road with us. I guess they thought my brother would make a bad chaperone.
—Irene Giosasi, Long Island, New York, August 2008

Tina Louise

Monday, May 19, 1958

Most of us will never experience the kind of problems this twenty-four-year-old actress and model endures every day. When you're one of the beautiful people, so desirable, so sexy, sometimes that's all people see.

Tina Louise (Tatiana Josivovna Chernova Blacker) is a no-nonsense gal from Brooklyn who has little patience for the Hollywood system. Let her read for a part wearing a potato sack and a shopping bag over her head—then maybe these flesh-ogling producers and directors will know there's a serious actress in the room, not just a pretty face.

Some leering executive at United Artists likes what he sees and instructs the newly formed records division to release her jazzy pop single "I'll Be Yours / In the Evening." Given the choice of material and quality of production, it seems no one at the film studio has considered that Tina can actually sing. Her talents deserve more respect.

In 1964 the actress embarks on the S.S. *Minnow* for a "three-hour tour" and winds up shipwrecked with some idiot named Gilligan for three seasons on CBS-TV.

Tina Louise comes to town next Monday (19th) on record promotion—the song, I'LL BE YOURS—ye aa ah.
 —"T.E. Newsletter," Vol. 5, No. 31, May 16, 1958

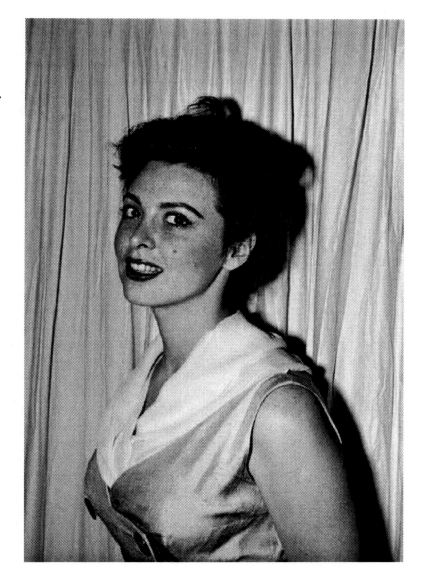

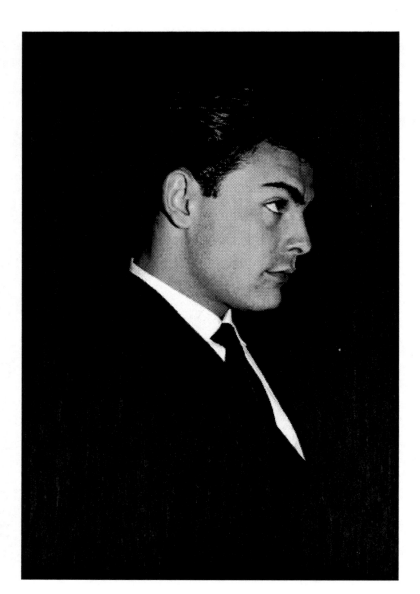

John Saxon

May 1958

A serious young actor in profile or a pretty-boy heartthrob who thinks he's Marlon Brando? The Hollywood press can't seem to make up its mind about twenty-two-year-old John Saxon (Carmine Orrico).

New in theaters this summer is *This Happy Feeling*, a light romantic romp starring a saucy Debbie Reynolds, whose fumbling sexcapades find her sandwiched between Saxon and the always stoic Curt Jurgens.

I did a couple of promos in Cleveland for *This Happy Feeling*. I was accompanied by a studio publicist. Promos at the time were a blend of radio, newspaper, a little TV and once in awhile a record store where we signed 33⅓ recordings of the score of the movie we were promoting.

—John Saxon, Studio City, California, November 2008

Arlene Fontana

May 1958

Cabaret singer, actress, dancer, recording artist. Twenty-three-year-old Arlene Fontana's natural talents and striking good looks all but guarantee her success. But sometimes the stars refuse to align, even for the most enviable among us. Fontana's latest wax on the Paris label, "I Can't Believe That You're in Love with Me," fails to click with listeners and quickly disappears from Tommy Edwards's playlist.

Roles in acclaimed Broadway productions such as *No, No Nanette* and *The Ritz* will soon allow Arlene to shine her brightest, until a star dedicated to show business succumbs to cancer at age fifty-four.

I love the photo. I met Arlene in Las Vegas while she was starring in *Flower Drum Song* in 1962. We moved to New York and were married in 1964 and stayed married until she died in 1990. They coined the phrase "Show Business Is My Life" after Arlene.

—Carmen La Via, New York, New York, April 2009

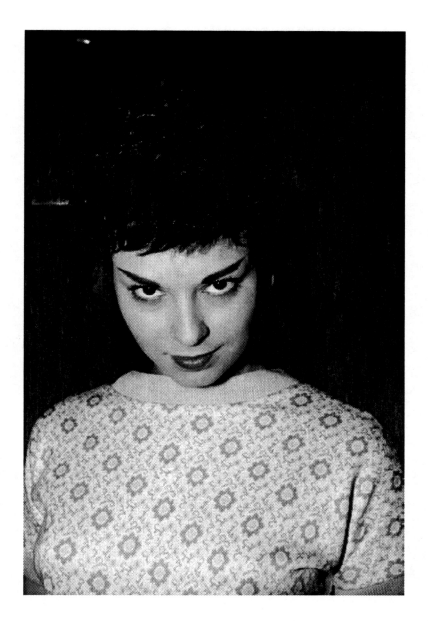

Ann Weldon

June 1958

She's taller than you expect. That's the second thing you notice when meeting twenty-four-year-old balladeer Ann Weldon for the first time. Of course the first is how beautiful she is. Such an easy, natural sexiness, you almost forget to remember she also sings with the lyrical beauty of a storyteller who's as comfortable exploring the magical heights of new love as wallowing in the despair of heartache.

Up to pitch Weldon's new pairing of "You're Hurting Me / Old Man River" is Universal International Records' promotions man Art Fried. Quite familiar with his artist's shyness, Fried presumably does most of the talking.

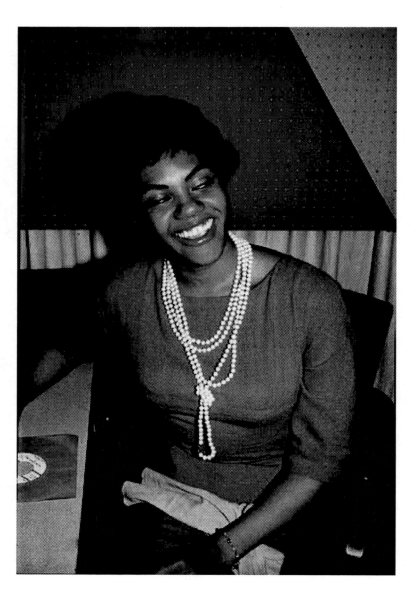

I was influenced by Diana Washington, Rosemary Clooney, and Johnny Ray. Music was part of the family. My father sang in church. I did not; I did not like church. I started by singing in a high school talent show. When I heard the stadium of fifteen hundred students scream and applaud with delight, I was hooked! From looking at the necklace I'm wearing, it seems I did not take the time to put the clasp behind my neck. The bracelet was made of black pearls. I did not mind doing interviews, but I was very shy. I can remember playing Las Vegas around the time this photo was taken. Nevada was the West Coast Mississippi; we were to come in through the back door of the Riviera, even when we were packing the house. I refused. It was in Texas the first time I saw whites sit on one side and blacks on the other, in a BLACK nightclub. It made me laugh that white laws were so racist and stupid. Race was hardly discussed in my home, sometimes to my dismay. My dad was a true Christian. I was really upset when the KKK killed Emmett Till, and my father said that God would take care of it. So I wondered why God hadn't saved Emmett! Why did God allow these evil psychos, with the tacit approval of our government, get away with murder? I didn't feel it so much in Bakersfield, California, maybe because I was popular and came from a good family. My passion is for all America to know how much blacks have contributed to the wealth of this country.

—Ann Weldon, Van Nuys, California, June 2009

The Big Bopper

August 1958

Bigger than life and in your face, multitalented deejay, singer-songwriter the Big Bopper (Jiles Perry "J.P." Richardson Jr.) hams it up for the camera. With his new Mercury single, "Chantilly Lace," just starting to heat up in Cleveland, J.P. lets go with one of his great booming laughs full of Texas swagger and warmly thanks Tommy Edwards for the spins.

In a few weeks that laugh will be ringing from every radio in the nation when "Chantilly" climbs into the top 10 and stays there. A Winter Dance Party tour is in the works, featuring Buddy Holly and the Crickets, Dion and the Belmonts, Ritchie Valens, and Frankie Sardo. The future seems limitless.

But in a cold Iowa cornfield on February 3, 1959, first light reveals the wreckage of a small chartered plane and the lifeless bodies of Holly, Valens, pilot Roger Peterson, and twenty-eight-year-old Richardson. Rock 'n' roll's never-ending vicious cycle of tragedies begins here.

Two of the newest and biggest R&R type tunes on WERE are Old Mac Donald by the Chargers (started by our Ernie Simon) and "Chantilly Lace" by The Bopper.

—"T.E. Newsletter," Vol. 5, No. 42, August 1, 1958

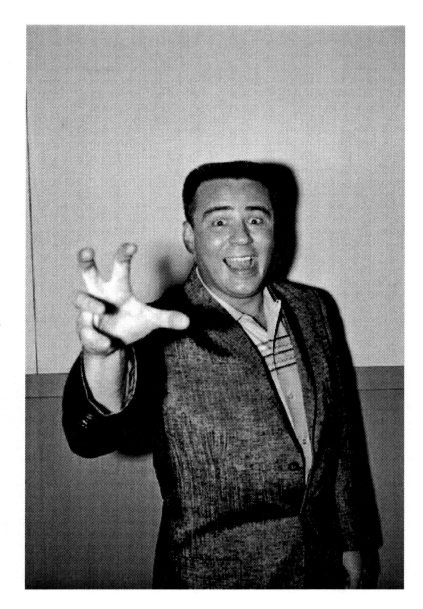

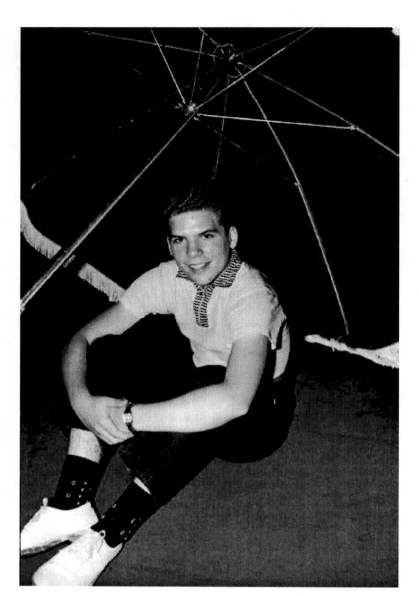

Ronn Cummins

August 1958

Dubbed by his handlers "Mr. Personality Jr., Stylist of Song and Dance," little Ronn Cummins smiles bravely and prays one of the indifferent, gum-snapping teenage girls in the record-hop audience will join him under his umbrella.

Sid Prosen, the local Felsted Records rep, has supplied the hokey prop for Ronn's appearance as they try to breathe life into the stillborn single "Cinderella 'Neath a Beach Umbrella."

A few more unwelcome releases on obscure labels, and Cummins calls it quits, scampering back to a promising television and Broadway career, which never regains its momentum.

Betty Madigan

Saturday, August 16, 1958

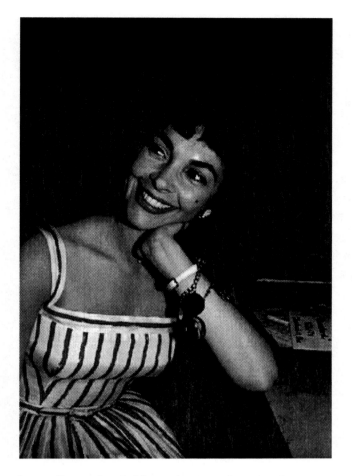

Hailing from Washington, D.C., twenty-six-year-old pop singer and actress Betty Madigan brightens up the set of WERE deejay Phil McLean's bandstand show, seen locally on WJW-TV, channel 15. While McLean is busy gallivanting around Europe for the United Service Organizations (USO), his friend Tommy Edwards has kindly volunteered to take over host duties.

Ever since her well-received April 1954 recording debut for MGM, the Irish beauty's been no stranger to Cleveland, periodically returning for lengthy engagements at the Hollenden Hotel's Vogue Room and the Zephyr Room. But Betty's grown bored with the game. She feels artistically stifled singing the same old arrangements with the same old hack bands. Whether it's some dump in the Catskills or the Fontainebleau in Miami Beach, the song remains the same. She wants out.

But as she soon learns, the consequences of the young, impatient decisions we make can haunt us forever.

I'm doing Phil McLean's Bandstand TV Show again tomorrow (16) and in person we'll have Betty Madigan, Del Vikings, The Olympics, The Dappers and Dale Wright.
　　—"T.E. Newsletter," Vol. 5, No. 44, August 15, 1958

Gee whiz, I wasn't too bad looking in those days. I remember visiting Cleveland, going to all the radio stations. It was fun. In August 1958 I was promoting my single for Coral Records called "Dance Everyone Dance," which was an English version of the Jewish folk song "Hava Nagila." I remember teaching all the kids how to do the Hora at record hops. A boyfriend I had at the time bought me the charm bracelet. The bracelet's long gone, but I saved all the charms. One charm was given to me by NBC for the role I played in *Scrooge.* It

has a diamond on it. My mother was the one who enthusiastically pushed me into the music business. She had me in every amateur kiddie show. She had stars in her eyes. I did not. But when you hear that applause, it's captivating. You love it. In my late teens I was going to school during the day and singing on Les Sand's WTTG-TV show at night. I soon left D.C., went to New York, and auditioned for every record company. MGM signed me, and my first record, "Joey," happened to be a hit. It was exciting at first, but after five years I was upset that my career wasn't progressing musically the way I wanted it to. I wanted my own combo backing me up. I wanted some space to try out new ideas vocally. My manager at the time just didn't understand and kept booking me in the same old places. I was tired of hotel rooms and living out of a suitcase. After a few years I just decided to stop. It's hard to keep going that way. It was a disappointing and heartbreaking thing that I couldn't come up with another hit. I should've stayed in there, been more tenacious.
　　—Betty Madigan, Miami, Florida, September 2009

Dion

August 1958

The euphoric rush of heroin's heavy sweetness has long passed for nineteen-year-old addict Dion DiMucci. Soon he will slip away into some dark place, the stab of the needle chasing away all his demons.

Out of the Bronx has come rock 'n' roll's unlikely savior. An insecure pretty-boy who sings tougher than all the rest. A troubled punk whose bold voice will singlehandedly keep rock music alive from Elvis Presley's 1958 disappearance into the U.S. Army until the Beatles arrival stateside in 1964.

"No One Knows" is Dion and the Belmonts' achingly beautiful ballad on the Laurie label, its hypnotic tempo the perfect soundtrack for awkward backseat passion.

ALAN NELSON who puts out YOUR NATIONAL HITS OF THE WEEK is responsible for a surprisingly accurate, up to date top hits list—all staffed by teen agers—plugging Dion's NO ONE KNOWS.
　—"T.E. Newsletter," Vol. 5, No. 45, August 22, 1958

Scott Engel

August 1958

Seen here autographing a copy of his Orbit single "Charley Bop / All I Do Is Dream," fifteen-year-old native Ohioan Scott Engel wants so very desperately to be a pop star. With a few clunkers under his belt and several more to come, he will soon reinvent himself for a new generation. Changing his name to Scott Walker, he, along with two other American compatriots, launch a blue-eyed soul attack on 1965 London as the Walker Brothers; mass hysteria and adulation will ensue.

But be careful what you wish for: success proves to be the monster under Scott's bed. Throughout the '70s he resists, retreats, and ultimately shrinks into an esoteric press darling, a reclusive Ingmar Bergman–esque character issuing non-commercial solo albums so ridiculous they must be considered high art.

Ray Meinburg brought around a record by Scotty Engel WHEN IS A BOY A MAN on RKO which sounds like a comer.

—"T.E. Newsletter," Vol. 4, No. 19, February 15, 1957

Conway Twitty

August 1958

Twenty-five-year-old Harold Jenkins knows he'll never be as dangerously beautiful as his fellow Mississippian hero Elvis Presley. So he invents someone called Conway Twitty and does the one thing Elvis could never do. He writes a hit song.

"It's Only Make Believe," cowritten with drummer Jack Nance, will soon be a worldwide smash on MGM. Nearly obscuring the song's greatness is Jenkins's forced imitation of Presley's vocal mannerisms, an embarrassing distraction that will continue for another decade. It's only when Harold leaves his idol behind and finds his own voice in country music that the remarkably successful journey of Conway Twitty truly begins.

Tommy Edwards would be well aware that "Doctor Bop" (Hoyt Locke), the manic jock over at WCOL-AM in Columbus, deserves the credit for breaking "It's Only Make Believe." Hoyt also runs the Bop Shop on East Main Street, Columbus's hippest record store, his tastes and recommendations turning on local teens to the newest and best sounds in rhythm and blues, country, and rock 'n' roll.

Paul Hampton

September 1958

It's so easy for Paul Schwartz. All he has to do is just flutter those long blond lashes and good things seem to happen. But the name "Paul Schwartz" sounds too Jewish. Change it—something more wholesome sounding. Yes, "Paul Hampton" works. Can he act? Who cares? The kid looks like a movie star, so let's just say he is one. Give him a lead role in Columbia Pictures' latest piece of teen drivel, *Senior Prom*. Throw him up on the screen, and tell him to smile. The girls will melt, and that's money in the bank. Wait, he sings? That's even better. Give him something to sing in the movie. "The Longer I Love You" is innocuous enough. Columbia can press some 45s and . . .

There's just one small wrinkle. Twenty-one-year-old Schwartz couldn't care less. All this fuss means nothing to him. Record companies and Hollywood executives falling over themselves? Just distractions. It's a swingin' night in Cleveland, and Paul's main concern is eight o'clock Donna finding out about eleven-thirty Carol.

It's so damned easy for Paul Hampton.

When I first started, I kept thinking, "What am I doing here? How did all this happen?" My clean, all-American look has taken me a long way. I never had to audition for anything. For instance, I'd be standing under a canopy waiting for a cab, and someone would approach me and ask if I wanted to model. And I'd say sure, why not? I've never considered myself a songwriter or an artist. Things just kept falling into my lap. Most of all, I remember the girls, the girls.

—Paul Hampton, New York, New York, May 2009

Jo Ann Campbell

October 1958

With trademark vinegar and sass, twenty-year-old Jo Ann Campbell shimmies up to the lipstick microphone (Altec-Lansing Model 21) and encourages the kids to clap along to the rockabilly beat of "Tall Boy," her latest offering on Gone Records. Looming book report deadlines and the constant threat of pop math quizzes are forgotten as another fun weekend record hop hosted by Tommy Edwards gets underway.

Dubbed "our little blond bombshell" by disc jockey Alan Freed, Jo Ann is still a few years away from the release of her biggest hit, "I'm the Girl from Wolverton Mountain" (1962) and her red-hot appearance in the 1961 Paramount film *Hey Let's Twist*.

Campbell's 1964 disappearance from the music scene and her absolute embrace of anonymity continues to baffle and frustrate fans. The abandonment of her talents and audience at the height of a promising career makes her one of rock 'n' roll's more intriguing enigmas.

Bobby Pedrick Jr.

October 1958

These young record hop attendees must be wondering just who this skinny kid with the big head thinks he is, stepping onstage and positioning himself behind the microphone. He's gonna get in big trouble any second when that deejay guy looks over—

Jaws drop and eyes pop as Tommy Edwards introduces twelve-year-old rock 'n' roll singer Bobby Pedrick Jr. (Robert John Pedrick Jr.) to sing "White Bucks and Saddle Shoes," his debut single on Big Top Records out of New York City. A clear and powerful voice dipped in Brooklynese rings out and confirms this isn't some class clown who's snuck onstage. Pedrick's good, and so is the song, another winning collaboration from the venerable songwriting team of Doc Pomus and Morty Shuman.

Nearly twenty-one years later, a chubby, bearded, and bald Robert John scores a No. 1 single with his ballad "Sad Eyes."

Fran Warren

October 1958

There's poise and elegance on the surface, but thirty-two-year-old sultry-voiced torch singer Fran Warren (Frances Wolfe) leads a secret life, one rife with shady dealings and seedy characters.

The former chorus-line dancer from the Bronx has come full circle with MGM's release of "A Sunday Kind of Love," a re-recording of the song that put her on the map back in 1947. It's a good record, and Tommy Edwards gets on it like gangbusters, spinning it to No. 10 on his Top Pop 20 chart. It's a bittersweet moment. Warren's wave, a very successful one, has certainly crested; it's time to quit while she's ahead and go out on a high note.

If only. Reckless lifestyles have a way of catching up with you, and in fall 1964 Fran's career suffers a direct hit from which it never fully recovers. Possession charges for the half pound of marijuana hidden in her bedroom closet are the least of Fran's troubles. She, her boyfriend, and her brother are arrested in what's called the biggest check swindle in New York City's history. Bookings are canceled; phone calls to her agent go unreturned. It's a swift, messy fall from grace.

Within these pages, though, all is forgiven. We prefer to remember an artist at the height of her powers, onstage in some tucked-away nightclub singing an achingly poignant "You Don't Know What Love Is" that rivals Chet Baker's definitive 1955 recording of the song.

Dolores Dale

October 1958

Aspiring pop singer Dolores Dale—the research says she's a New Yorker in her early twenties. Intuition says she's a fun, sexy young woman destined to do something else with her life.

"Love Me as I Am / One Made of Two" doesn't sell, and she's soon brusquely cast aside by her label, S&S, to make room for the next roll of the dice. Let's hope she has a shoulder to cry on, someone who loves the way her nose crinkles up when she laughs, someone who lives for the mystery of that perfect beauty mark.

Jimmy Crain

October 1958

The urchin grin of a jack-o'-lantern looms in the background as eighteen-year-old Spangle Records artist Jimmy Crain serenades a pretty fan from the crowd. There's sure to be a couple of Halloween record hops on Tommy Edwards's busy schedule this fall, with the kids just back to school, ready to have fun, flirt, and dance. Tonight's venue is the gymnasium of Shaker Heights High School.

The A-side of Crain's debut release is a rockabilly train wreck called "Shig-A-Shag," a song that seems to be making some noise regionally and is poised to be an unlikely hit. But it's the record's flipside, "Will You Tell (Tell Me)," that hints at Crain's range and potential. Jimmy is the real deal, a developing singer with sweetness and heartbreak in his voice, unlike many of the talentless hacks who've come crawling out of the rock 'n' roll woodwork desperate for fame.

On the pinky finger of the hand holding the Calrad Model 400C Crystal microphone is a Siamese ring, a token of love given to Crain by his sweetheart.

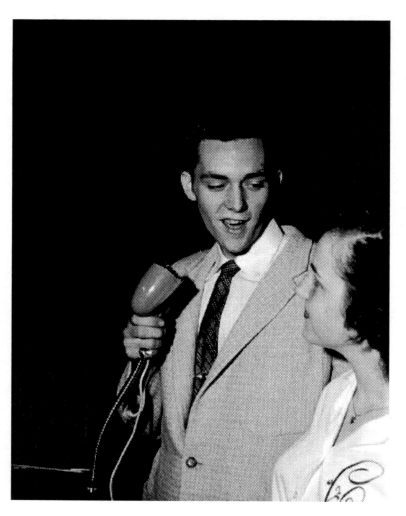

Yes, I do remember Tommy Edwards as a really pleasant guy who treated all the artists that he came into contact with the same, whether a well-known longtime star or just a young person trying their wings. It's funny, but I remember the girl in the photo and the evening that the pic was taken. I was there in Cleveland with my manager, who also was the owner of Spangle Records, promoting "Shig-A-Shag." When the photo was taken, I was singing the flipside, which was a ballad called "Will You Tell (Tell Me)." It was a love song. Tommy played the record quite a bit and helped me a lot. I remember he interviewed me on the air. I only made it to No. 26 in the top 100. I got out of the business in the early sixties and became a family man. I had enough. I can tell you a funny story about Dion and the Belmonts. We were in Baltimore doing a TV appearance together. The dressing room was the bathroom, a long narrow room with urinals on one wall and a big mirror on the other. I was putting makeup on—you had to wear makeup on TV or you looked like a ghost—and Dion and the boys were going through their routine and dance moves in front of the mirror, all in their underwear. I laughed because they looked so funny, but they got real pissed off at me because they thought I was laughing at their singing.

—Jimmy Crain, Springfield, Ohio, March 2009

Sam Hawkins

October 1958

"Busted Wide Open" is how Gone Records describes the status of rock 'n' roll chanter Sam Hawkins's new single in the November 3, 1958, issue of *Billboard*.

While "busted" might be too strong of a word, "King of Fools / The Whatchamacallit" appears to be selling a few copies, which is a bit surprising because the New Yorker's pitch isn't the greatest, his unnerving falsetto-tenor likes to spread itself too thin, and the song is mediocre at best.

But teen-idol looks and sharkskin suits go a long way in obscuring a singer's technical shortcomings. By the end of tonight's record hop at Shaker Heights High School, Hawkins's impeccable sense of style will have made quite an impression on the kids listening and on host Tommy Edwards.

Sid Mills reports good action on the Sam Hawkins record KING OF FOOLS—this looks like a record that could make it big—the boy is a great performer.

—"T.E. Newsletter," Vol. 7, No. 5, November 14, 1958

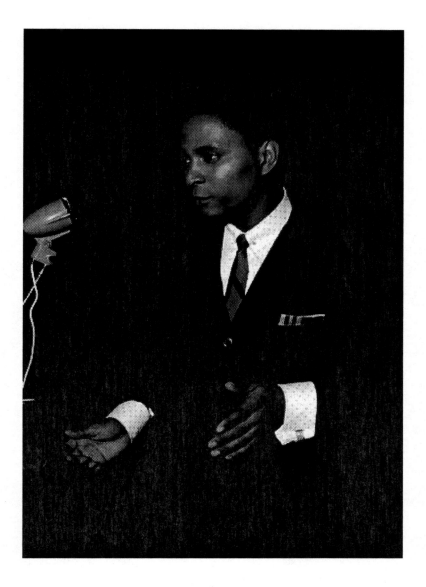

Beverly Ross

Saturday, November 8, 1958

Self-conscious about her weight, the girl who's always thought herself unpretty wears black for camouflage. Her nerves are rattled by the live television cameras of

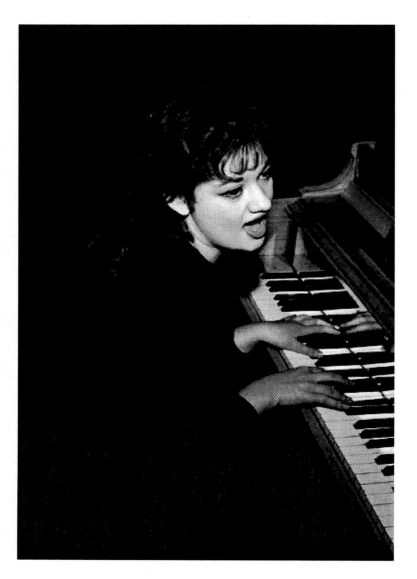

WEWS-TV's *Landmark Jamboree,* and her hands feel stiff and heavy as she fumbles for familiar chords, her throat dry and closing fast. Cut her a break. She's just a girl who grew up on a New Jersey chicken farm.

She also happens to be one of the premiere architects of rock 'n' roll. Rebel and songwriter extraordinaire, twenty-two-year-old Beverly Ross really shook up the status quo a few years ago as a white girl cowriting hit songs with a black man. Her taboo creative partnership with Julius Dixson birthed such gems as 1954's anthemic "Dim, Dim the Lights," a groundbreaking interracial crossover hit for Bill Haley and the Comets, and this year's worldwide smash by the Chordettes, "Lollipop."

But with Columbia's release of "Stop Laughing at Me / Headlights," Ross has emerged from behind her writer's curtain of safe anonymity to try on the role of pop star. Unfortunately, the fit sucks.

It's probably the best picture ever taken of me. I never wanted to be a performer. I was a painter and a writer. Performing has always been difficult for me. I can't do it without having a nervous breakdown. At the time, being a female songwriter in such a male-dominated field, I had to put up with a lot of sarcasm and men making passes at me. They thought I was going to be some kind of idiot, but I could out-talk anyone, even then. Elvis's publisher, Jean Aberbach, told me how much Elvis loved the song I cowrote with Sam Bobrick, "The Girl of My Best Friend," how much he had worked on it in the studio to get it just right. The song was on his first album after he got back from the army in 1960. Jean invited me to a charity show Presley was doing in Memphis in 1961, and I met him backstage. Elvis seemed so sad. Jean introduced us, telling Elvis I was the one who wrote the song he liked so much. He didn't look me in the eye, mumbled hello and that was it. Here was a guy who everyone made such a fuss over, and he just looked so lonely and depressed.

—Beverly Ross, New York, New York, September 2009

Ethel Ennis

November 1958

When trying to describe the sound of
twenty-five-year-old jazz singer Ethel En-
nis, it's tempting to take the easy way out
with comparisons to her contemporaries.
The control of Ella Fitzgerald, the wistful-
ness of Peggy Lee, the desperation of Billie
Holiday, blah, blah, blah. To capture the
essence of Ennis, you'll just have to listen.

The new Capitol LP *Have You Forgot-
ten?* does an adequate job showcasing her
gifts, but it's on the live stage that the
musician in Ethel truly thrives. As demon-
strated in May when she wowed them at
the Brussels World's Fair alongside Benny
Goodman, this daughter of a Baltimore
baker is a supreme communicator, one of
the best since Sinatra, sensitive to the lyric
and utterly believable.

But with great artistry comes unpre-
dictability. In the coming months, Ennis
retreats from the glare of the international
spotlight, taking long hiatuses from perfor-
mance, only to suddenly reemerge when we
need her the most with brilliant bursts of
creativity and beautiful singing.

My goodness, I look like my daughter or grand-
daughter. This is great to see. I remember the
watch! In those days of recording, I didn't have
much say in what material I recorded. An A&R
man would choose the songs, and I'd just read
them off. It was usually a fight over the kind of
songs they wanted me to sing and those I wanted
to sing. But there were some nice things on *Have
You Forgotten?* such as "There's No Fool Like An
Old Fool" and "Serenade In Blue," which I enjoy
listening to today. When appearing live I hardly
ever performed the songs off my latest album, and
the record company didn't like that too much! I'm
happy those days are over.

—Ethel Ennis, Baltimore, Maryland, August 2009

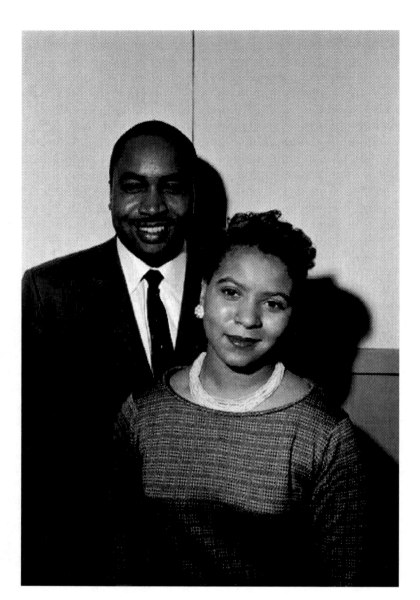

Billy and Lillie

November 1958

Thirty-three-year-old Billy Ford and seventeen-year-old Lillie Bryant. A pop duo on top of the world, but the top of the world is a very lonely place.

I started singing in New York City clubs and one day heard Billy Ford and the Thunderbirds were holding auditions for backup singers. When I arrived for the audition, Billy was auditioning himself for producers Bob Crewe and Frank Slay, who had a deal with Swan Records. In the middle of Billy's audition, Bob and Frank asked me to do a few songs. Now remember that Billy had never even heard me sing before! Bob and Frank liked my sound and said they were looking for a duo. They pulled the sheet music for a song they had out of their briefcase. It was "La Dee Dah." Billy and I sang it together, and they said they liked our sound and wanted to record us. That was it. "La Dee Dah" came out, and it was a big top 10 hit. I thought all my dreams had come true. I was a star. We were all over the radio; we played the Apollo Theater, what a thrill that was. But Billy's resentment made it so difficult. I looked at this photo and thought wow, I really look sad. We had just released "Lucky Ladybug," a big record for us. He was in the business for fifteen years and resented a seventeen-year-old girl coming along and stealing his thunder. I was not treated fairly by him. It was always turmoil with Billy. I ended up leaving. I couldn't take the stress of it. The sad thing is Billy and I had reconciled and were talking about reuniting for some shows just before he died in 1984.

—Lillie Bryant, Newburgh, New York, September 2008

Gene Mumford

December 1958

It's a bird; it's a plane. The unassuming gentleman behind the Clark Kent glasses just happens to be thirty-three-year-old Eugene Mumford, considered one of the great Supermen of 1950s rhythm and blues music by the genre's hardcore fans.

Gene's powerful tenor and slow motion phrasing grace his latest Columbia sides, "Street of Dreams / If You Were the Only Girl in the World," smooth vocal performances reminiscent of his revered recordings with the Larks ("My Reverie," Apollo 1951) and Billy Ward and the Dominoes ("Star Dust," Liberty 1957).

It's wintertime in Cleveland, and Gene's looking to warm up backstage after an appearance. Every Superman must have his kryptonite, and for Mumford it's the booze, a thirst he pays for with his life in 1977 at age fifty-one.

Connie Freed

December 1958

Pretty and petite, pop singer Connie Freed tells the kids how it really is. "Things They Don't Teach You in School" has just been released on Challenge Records and one of the more enjoyable stops on her promo tour schedule is a record hop hosted by Tommy Edwards.

An appearance on *American Bandstand,* two more singles, and Connie Freed slips through the cracks, another casualty of an unforgiving business.

In 1956, Elvis Presley's notorious manager, Colonel Tom Parker, orchestrated a lucrative merchandising deal on behalf of his star, producing products such as the "I Like Elvis" button Connie is wearing. Ever the shrewd carny, Parker makes sure "I Hate Elvis" buttons are available as well.

1959
to 1960

Life after Radio

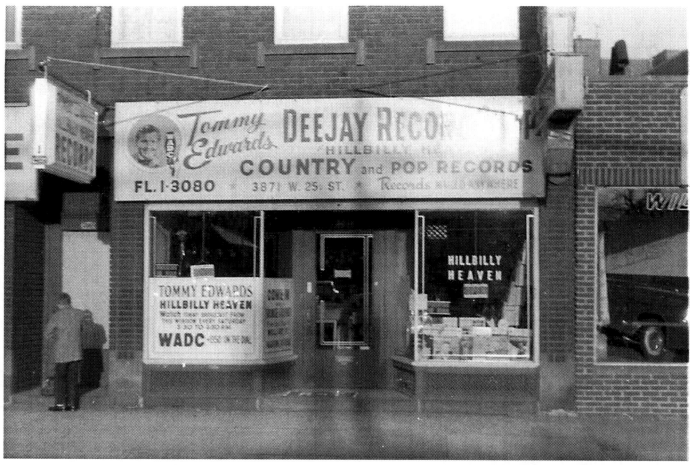

Tommy Edwards's Hillbilly Heaven record store, 3871 West 25th Street, September 1962

Can it be that Cleveland is not the record town it once was? The personality deejay is no longer with us. He's been snowed under with the creeping nemesis of the Top 40 type shows. Deejays have no control over what is going to be played. A plugger must make his overtures to the program director. Robot-like deejays are taking over and the next step is to eliminate the human error altogether and go to actual machine operation. As for myself, I don't want to work in a station which expects me to be an automaton.

—"T.E. Newsletter," Vol. 8, No. 3, October 28, 1959

*O*n Thursday, July 2, 1959, Tommy Edwards is fired from WERE, with the excuse that he won't fit in with the station's new programming formula. Outwardly, Tommy wears a brave face and writes of having "a few irons in the fire," but the sudden dismissal breaks his heart into a million pieces, a breach of loyalty from which he never truly recovers.

Unfortunately, Edwards's predictions regarding radio's cold and impersonal future were spot-on. For the next fifty years, terrestrial radio will commit slow suicide by disrespecting the music and abusing listeners with unentertaining programming. Under siege by competing mediums, "free" radio must either reinvent itself or face extinction. Today, in the early twenty-first century, it may already be too late. The freedom of choice that satellite and Internet technology now offers the consumer has triggered a radio renaissance, a welcome return to a time when the connection between deejay and audience was one of friendship through music and opinion. If Tommy Edwards were alive today, he'd

surely be spinning wax on satellite radio, blogging every day, and scoping out the next big wave.

1959 starts off on the wrong foot when Dean Martin has failed to send a Christmas card. The singer's disc of "Return to Me" was last year's smash, all thanks to Tommy. Rumors begin to circulate about the deejay's job dissatisfaction. Hula-hoop contests are all the rage at the record hops, and Tommy's newest gimmick is taking Polaroid pictures of the kids and handing them out as souvenirs. To his delight, the Polaroids have appeared in various trade magazines and papers. It's official: The cha-cha is out; the conga is in. By January's end Tommy is sans mustache, having shaved it off for a stunt on his TV show.

He is back to plugging his "Color Slide Show Service" in February, pitching that it's almost like having the big stars at your record hop in person. Another one bites the dust: WHK in Cleveland has gone to a Top 50 format, with rumored deejay firings in the works. On a Hawaii-bound flight, pop star Andy Williams sings his

185

hit "The Hawaiian Wedding Song" while a minister marries a couple in midair. Local newspapermen ask Edwards if he's ever been pressured by gangsters to play certain records—he laughingly tells them that not even his best friends can pressure him to play records he doesn't believe in.

The *Landmark Jamboree* is now seen over an Ohio network of five TV stations: WEWS Cleveland, WSPD Toledo, WTVN Columbus, WHIO Dayton, and WHIZ Zanesville. Pee Wee King, Homer and Jethro, and Conway Twitty are scheduled for March appearances. Schools and churches in the area are becoming wary of inviting deejays to their record hops because of a few bad apples. Edwards signs a personal management contract with a New York City firm covering radio, TV, and records. WERE has been without a program director for the past three months, a sign of the tenuous climate within the radio industry. A few Detroit deejays resign in protest against the format-type radio they were forced to follow.

In April, Quincy Jones stops by with his "Tuxedo Junction" platter but doesn't stick around long enough to have his photo taken. Sonny James passes through town on some personal appearances. Tommy wonders how many parents have actually listened to the lyrics of "Stagger Lee," which seem to cheerlead murder and gambling. It's going to be a swinging deejay convention in Miami at the end of May, and wives are welcome. Mitch Miller calls in to plug his new single, "This Here Goat." Singers Steve Lawrence and Eydie Gorme call to say "howdy." Edwards complains about all the junk records he's been hearing in the past few weeks. Where are the records with real style and quality? Less than 10 percent of all the records he receives ever get on the air.

May's newsletter opens with a few observations about the approaching Miami deejay convention. Tommy is prepared to get some work done; the convention is a real one, not an excuse to get away. Surprisingly, there was very little "balling it up" in Kansas City last year. On May 7 Edwards's briefcase and four cameras, worth $400, are stolen from his car. Luckily, he's insured. Actor Dennis Weaver of TV's *Gunsmoke* calls in to thank him for the spins he's giving "Girls Wuz Made to Be Loved," his new Cascade single. The deejay's new "Picture Pac" features black-and-white shots of Fabian, Connie Francis, Edward Byrnes, and Dion.

When Tommy returns from the circus that was Miami's Second International Radio Programming Seminar and Pop Music Disk Jockey Convention, he finds a stack of 350 records waiting to be auditioned. In June he gives away 2,500 records to churches for their carnivals and festivals. Local deejay firings and hirings continue unabated, and "Old Black Magic" by the Clovers is selling like mad, another hit Edwards started. The *Landmark Jamboree* goes off the air for the summer, set to return on September 19. Country music crooner Eddy Arnold phones about his "Tennessee Stud," and Tommy fields inquiries regarding his One-Stop Deejay Service, a record distribution setup designed to help tertiary radio stations compete with the big dogs.

What a difference a day makes. Tommy Edwards's world turns upside down when he loses his job at WERE. In July, the station imports two very young formula deejays to replace him and puts a seventeen-year-old boy in charge of music programming. Only two issues of the "T.E. Newsletter" are mailed out this month. Tommy implores his business associates not to drop him like a hot potato just because he can't help them right now. Claiming he was prepared for the firing both mentally and financially, Edwards says that he's neither desperate nor destitute, but his words betray him. In what

must be a bitter pill to swallow, the "temporarily unemployed deejay" starts doing TV commercials on a late-night wrestling show to make ends meet.

The August 5 newsletter is "An Open Letter to the Trade," in which Tommy addresses the possibility that he may have overpromoted himself at WERE, thus limiting his chances of connecting with another radio station. He passes on an attractive job offer from KWK in St. Louis, blaming the city's terribly hot summers. He refuses to take a subpar job just for the sake of appearances. All said, it's a depressing glimpse into the rationalizations of a man who's clearly lost the passion to stay in the hunt.

After a lapse of nine weeks, October marks the return of the "T.E. Newsletter" and an embittered Tommy Edwards. Deserted by his so-called friends, the national record pluggers and label executives, he's kept a careful list of the rats leaving the sinking ship and plans to deal with them when he's back on top again. A few radio stations express interest in hiring him, but he's unwilling to work for the peanuts they're offering. In an attempt to win back disgruntled school and church officials, Edwards buys a weekly ad in the *Cleveland Plain Dealer* touting his record hop service, headlined "Are You Afraid of Disc Jockies?" The deejay finds some vindication in a *Cleveland Press* report that the two Top 40 kids hired by WERE to replace him will be leaving shortly.

The word on the street echoes Edwards's sentiments on the deterioration of radio. It's almost impossible to get a new record off the ground unless it's done by an established artist. In these payola-phobic times, the jocks are sealed off from the rest of the world to avoid contamination. Busy hosting dances at Eastlake Teen Town, St. Ignatius Parish, and other venues, in the November 12, 1959, "T.E. Newsletter," Tommy reflects

on the main reason his record hops are so successful: "I genuinely like the kids and I'm not there to make a fast buck and blow the scene." But the empty weekdays, between weekend hops and the *Landmark Jamboree* TV show, spent contemplating his fate are increasingly harder to reconcile.

November slips away with a warning. If you can't do the time, don't do the crime: the U.S. government boys are coming to Cleveland to investigate payola abuses. Perhaps in response to this news, Edwards sets up free record hops for orphanages and children's hospitals. To occupy his mind, he painstakingly constructs a crystal reflecting ball for the record hops, just like the ones in ballrooms, to give that starlight, glittering effect. At the same time, he begins to play with the idea of starting up a country and western deejay show in Cleveland.

Proud of his clean reputation in the business, Tommy takes issue with being lumped in with the minority of the nation's ten thousand deejays accused of taking payola. His personal estimate is that there were, on the average, at least six jocks, program directors, and music librarians on the take in each major market. In December Edwards auditions for a weather show on KYW and doesn't get it. It's getting harder to book record hops, and Internal Revenue men have been checking the returns of Cleveland deejays.

On February 15, 1960, Tommy Edwards issues his second and last "Open Letter to the Trade." This final issue of the "T.E. Newsletter" speaks to the payola scandal rocking the nation and is laced with emphatic denials of any personal wrongdoing. The lament ends with the deejay's offer to testify on the behalf of his profession before the investigative committee in Washington.

By June Edwards has parlayed a short-lived stint on WADC out of Akron into emceeing a few live country shows at Cleveland's Denison Square Theater on

West 25th Street. Despite having always referred to himself as Tom Edwards on air and in his newsletters, he begins to promote himself as Tommy Edwards. This is done most likely with the intent of circumventing a termination clause in his WERE contract that precludes him from working within 150 miles of Cleveland for two years. The nickname sticks, forever dubbing him Tommy in the public consciousness. To fill the retail void for country music in town, Edwards opens the Hillbilly Heaven record store across the street from the Denison in December 1961. Tommy and Ann divorce in June 1963.

Pop songs we're caught humming in 1959–1960 include "Blah Blah Blah" by the Italian troubadour Nicola Paone, "Only You" by Frank Purcel, and "I've Waited So Long" by Anthony Newley. Frank Sinatra's lovely "The Last Dance" gets lots of exposure, off his *Come Dance with Me* LP. "Detour" by Duane Eddy and "Goodbye Baby" by Jack Scott satisfy the kids, while "Baby Talk" by Jan and Dean sounds the beginnings of garage-band rock. Country music's Don Gibson scores with his "Who Cares," and "Tell Him No" by Travis and Bob bops along with one of the best melodies of the year.

Ricki Pal

January 1959

When you're on tour, the holidays often prove to be the loneliest time of year. Just when you should be curled up cozy at home with loved ones, you're risking your life on wintry all-night drives to the next city, nursing an annoying head cold and sleeping in cheap hotel rooms with cockroaches for bedmates.

Welcome to the world of pop singer and songwriter Ricki Pal, the Arwin recording artist seen here halfheartedly decking the halls. Fresh from a December 30, 1958, appearance on *American Bandstand,* she's come to Cleveland to promote a pretty enough ballad called "Just Outside of Love," her own composition. The flipside, "No Need for Crying," is a collaboration between Pal, orchestra leader Adam Ross, and Joe Lubin—an opportunistic British tunesmith who holds the dubious honor of being the guy hired to sanitize the lyrics to Little Richard's "Tutti Frutti" for Pat Boone.

The Short Twins

January 1959

Twenty-nine-year-old identical twins Ray (left) and Bob Labnon credit the naming of their energetic nightclub act to a Boston deejay with an ironic sense of humor. The 6-foot 3-inch, 190-pound pop singers and comedians from New Hampshire are riding the crest of "Take a Look," a potential hit on Eagle Records, a real cornball tune punctuated by some nice harmonies.

Just a few days before we got to Cleveland, we were in a car accident in Manchester, New Hampshire. The car slid off the road and hit a tree. My head hit the windshield. The car was demolished. So I got patched up and we continued on the thirty-one-day promotional tour for Eagle. "Take a Look" was a good song, and we sold a few hundred thousand records. Those were excit-

ing, exciting days, a terrific time of life. We had a great sound, harmony-wise. We won the Arthur Godfrey Talent Show, and that started the adventure. We played everywhere, Buffalo, the Desert Inn in Las Vegas, the Hawaiian Cottage in Merchantville, New Jersey. Everywhere, you name it. My brother Ray and I were inseparable. We never exchanged a harsh word. Ray died about twenty years ago of a heart attack. I had a real tough time with his death; it really shook me up, still does. We were just a couple of guys looking for the right breaks. People think you're an overnight success but that sort of thing just doesn't happen. I never got married. I love the bachelor life. I've got a girlfriend. As far as I'm concerned, there are three rings in every marriage. The engagement ring, the wedding ring, and suffering.

—Bob Labnon, Berlin, New Hampshire, September 2009

Tommy Edwards

Friday, January 16, 1959

"Love me, love me," pop singer Tommy Edwards repeatedly implores on his latest MGM wax, "Love Is All We Need." Well, Happy New Year to him because all the incessant begging has paid off, giving the thirty-six-year-old a substantial follow-up hit to his beautiful 1958 smash, "It's All in the Game."

Starting tonight, Edwards takes over the Modern Jazz Room on East 4th and Huron and will also make an appearance on tomorrow night's *Landmark Jamboree* TV show. That the singing star shares his name with the *Landmark*'s mustached host, our man Tommy Edwards, makes for just a little confusion amongst fans.

By the way, more people think that the record IT'S ALL IN THE GAME by Tommy Edwards on MGM is mine—wish it were—it's a remake of his original hit of 5 or 6 years ago.

—"T.E. Newsletter," Vol. 5, No. 42, August 1, 1958

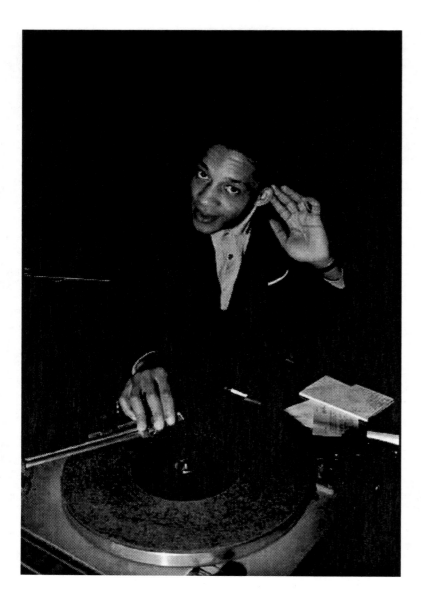

Malcolm Dodds

January 1959

Best described as the missing link between Sam Cooke's gospel pop fusion of the late 1950s and the soulful sixties sophistication of Marvin Gaye, the music of Malcolm Dodds (Williams) amazes those fortunate enough to hear it. His voice is one of those sweet discoveries; the kind where you stumble upon greatness and it feels like your own little secret.

An appreciation of the artist should start with 1959's rock-solid pairing of "Tremble / Deep Inside" (Decca) and the obscure "Every Time I Fall In Love," featuring sensational backing vocals by the Curls (Sue Singleton and Sue Terry). Listen as Malcolm's intricately beautiful vocal arrangements paint new colors onto the pop music soundscape.

Ready to go on the dusty WERE Rek-O-Kut B16H turntable is a copy of the singer's latest Decca single, "This Is Real (This Is Love)."

The Arena Twins

January 1959

Clap along with Floridian heroes Sammy and Andy Arena (from left), as the twenty-eight-year-old identical twins do their best to keep the kids up and dancing at a Tommy Edwards record hop.

It's been a heady few months for the brothers, crisscrossing the country in support of their debut Kapp Records release, "Mama, Cara Mama / Little Pig." Sure, they'd experienced some success back home in Tampa, but this was something else entirely. Performing for such enthusiastic young audiences, selling records, meeting pretty girls—this is the stuff of dreams, and if they're lucky, Sammy and Andy won't be waking up anytime soon. Between the twins stands a lipstick microphone (Altec-Lansing Model 21).

I pulled my favorite gimmick yesterday—played the Arena Twins' Kapp wax of Mama Cara Mama 6 times on the air without introducing it or mentioning it. Phone calls started coming in asking what it was and the record is on its way!!!
—"T.E. Newsletter," Vol. 7, No. 15, January 23, 1959

I remember Tommy Edwards just as clear as I'm talking to you, it's unbelievable. I remember like it was yesterday. We were coming into Cleveland, my brother and I were driving a '47 Cadillac, and I heard Edwards say, "Here are the Arena Twins with their hit, 'Mama, Cara Mama!'" and I just went crazy, here we are two guys from Florida and they're playing us in Cleveland! It was a beautiful time.
—Andy Arena, Tampa, Florida, August 2008

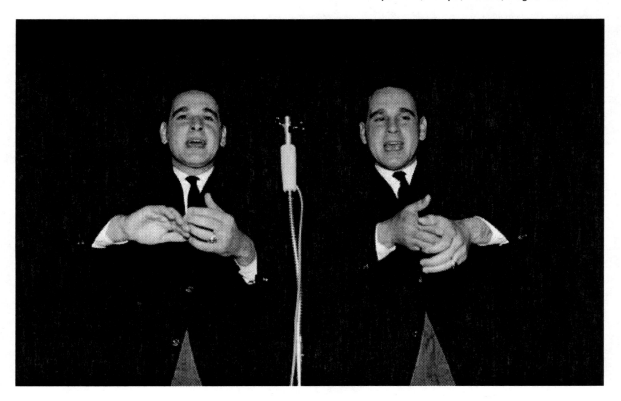

Bobby Colt

January 1959

Why me? That's what nightclub singer Bobby Colt (Robert Bonaccolta) appears to be asking the big guy upstairs. It's just the kind of silly rhetorical question many of us ask when the hole we've dug for ourselves is too deep and too dark to climb out of.

Let's disregard the Brooklyn baritone's fine wax of "Before It's Too Late / Guilty," now out on Hope Records. The real story lurks between the sheets. Very soon a lurid soap opera begins to unfold publicly, culminating in the singer abandoning his burlesque stripper wife and newborn son for the waiting arms of a Turkish belly dancer who seems to enjoy frequently overdosing on tranquilizers.

Vernon Taylor

January 1959

So it's come to this. The great Sam Phillips of Sun Records, the visionary genius who heard God in the thunderous growl of Howlin' Wolf and a revolution in Elvis Presley's out-of-tune guitar, suddenly finds he's become inconsequential and, what's worse, expendable.

Phillips knows it was inevitable, that he'd be unable to compete with the deep pockets of the major labels, but still, it hurts. His Memphis sound has awakened the sleeping giants, and they've come for his babies. Elvis and Howlin' Wolf are long gone, and Carl Perkins was lured away in January 1958 followed by Johnny Cash in July. Now instead of sifting for diamonds, he's saddled with Dot Records reject Vernon Taylor (Alderton), a twenty-one-year-old rockabilly singer from Washington, D.C., whose cool hair and chiseled cheekbones distract us from his musical shortcomings.

Taylor lacks the stomach for a business that will very soon chew him up and spit him out. Here he signs a copy of his debut Sun single, "Today Is a Blue Day / Breeze."

Would suggest that some movie company screen test Dot's Vernon Taylor—one of the handsomest kids I've ever seen.

—"T.E. Newsletter," Vol. 5, No. 2, October 25, 1957

I remember Tommy. I did his live country music TV show on my second trip to Cleveland in 1959. I wanted to lip-synch to the record, but Edwards insisted we do it live. Tommy said he liked my Sun single of "Mystery Train" very much. He told me, "It's not a hit record but if you keep at it, you're bound for success." That's a quote I remember. He was a nice guy. I was shy, not very talkative. Recording at Sun, in the original studio at 706 Union Avenue was awesome. I was amazed by it. It had a real aura. I felt like I was walking on hallowed ground.

—Vernon Taylor, Hagerstown, Maryland, May 2009

Tab Hunter

January 1959

That dreamy blond cut with the tousled top frames the face of Adonis; eyes the color of blue ice; firm, yet pliant lips; and a perfectly cleft chin that just begs to be kissed. Underneath that sharp houndstooth and adorable bowtie waits the muscular body of a former figure skater, the chiseled work of a master sculptor.

Ok, ok. So twenty-seven-year-old movie star Tab Hunter (Arthur Kelm) is one of the best-looking actors in Hollywood. But he still can't sing. "Apple Blossom Time" on Warner Brothers Records is a flat, boring affair that burns up the charts anyway, another huge record for Hunter.

Just turn off the sound and admire the scenery when he makes his January 31 appearance on the *Perry Como Show.*

I had no aspirations to be a singing star. While Natalie Wood and I were promoting a film in Chicago, Howard Miller, a big DJ there, saw the crowds that I drew and suggested I cash in on my popularity by trying my hand at recording. Howard called Randy Wood at Dot Records, and within several weeks I was in the recording studio recording "Young Love," cut December 15, 1956. It hit the Billboard chart the first week of January 1957, rose to No. 1, knocking Elvis out of the top spot, and remained on the charts for months. Because of this, Jack Warner formed Warner Brothers Records for me, and I was their first recording artist. I liked to record in the studio but hated performing live. I was shy about my singing. I ended up recording six albums and sang in *Hans Brinker* for Hallmark Hall of Fame in 1958 and also in *Damn*

Yankees that same year. I did do a live concert in Australia with the Everly Brothers in 1959. "Apple Blossom Time" was my last chart hit, and I think it peaked at No. 31 on the Billboard charts in 1959. I do remember going to Cleveland on a publicity tour promoting my record. I bought one of my best horses in Ohio that I named Holy Toledo. My favorite thing to wear in the 1950s was bowties. So this is a typical outfit of the day for me. In January of 1959, I had bought out my contract at Warner Brothers. I wanted better movie roles, and they wanted me to star in *77 Sunset Strip.* I didn't want to do a series, so I left the studio and my career quickly faltered thereafter. I continued to record for Warner Brothers Records for several more years, however. But when this photo was taken, my life was in turmoil.

—Tab Hunter, Montecito, California, August 2009

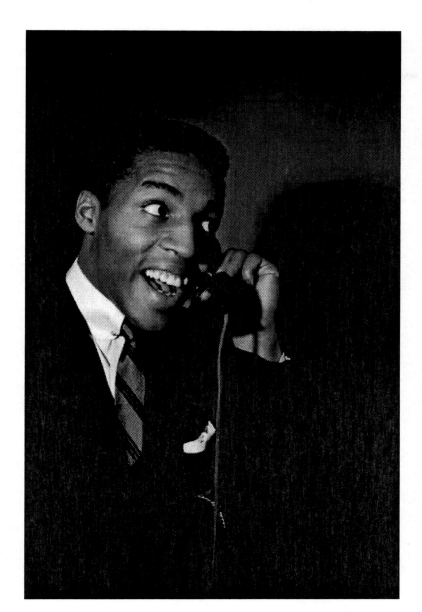

Billy Barnes

February 1959

Judging by his reaction in this photo, rhythm and blues singer Billy "Willie" Barnes hears some nice words of encouragement from a call-in listener.

The sound of the slamming drums drenched in reverb makes for an ominous intro to a lover's ultimatum. Barnes threatens "I'm Coming to See You" on his brand new United Artists single, and the man means business.

The Nebraskan's confidence behind the microphone stems from time served as the soaring tenor in such respected vocal groups as the Five Echoes, the Sultans, and the Admirals, where he often shared lead vocal duties with the impressive Gene McDaniels. The two fine singers have decided to engage in a little harmless competition by seeing which one can score the first hit as a solo artist. McDaniels ultimately bests his former bandmate with the release of "One Hundred Pounds of Clay," a No. 3 single in May 1961.

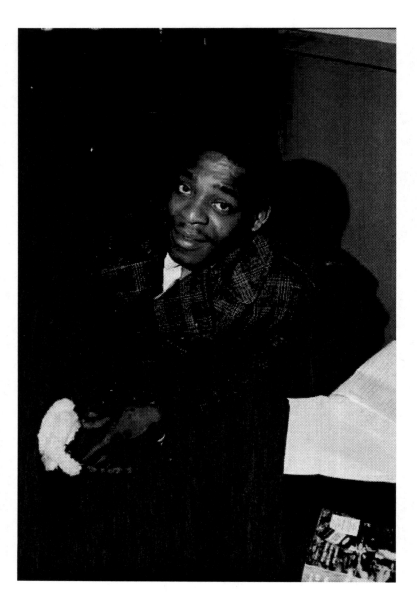

Brook Benton

February 1959

Twenty-eight-year-old Brook Benton (Benjamin Franklin Peay) makes no effort to hide his exasperation about the hassles of record promotion. Not even bothering to hang up his coat and stay awhile, he wears a chilly demeanor in the studio that nicely complements the damp winds whipping the streets outside.

Benton's breakout hit "It's Just a Matter of Time" showcases the vocal acrobatics of his satiny, bottomless baritone, a signature gimmick that rumbles many a car radio speaker. The song eventually peaks at No. 3 on the Top Pop 20 chart of the "T.E. Newsletter" in March.

It's as a songwriter that Brook Benton is most at peace, free from the stressful expectations record labels and fans place upon an artist. A keen pop sensibility pervades his beautiful melodies, evident in his 1959 hit recording of "Endlessly" and "A Lover's Question," the 1958 smash for the extraordinary Clyde McPhatter.

Tony Bellus

February 1959

Jerry Lee Lewis is one cocky son of a bitch. But that's ok. That's exactly how the greatest rock 'n' roll star should behave. Who else but "The Killer" could possibly think he'd come out unscathed after marrying his thirteen-year-old cousin? In May of 1958, the scandal breaks. Twenty-two-year-old Lewis, once considered Elvis's heir apparent, suddenly finds himself a social pariah, his career in ruins, forced to earn a living playing piano for drunks and prostitutes in the backwoods bars of the South.

What does all this have to do with NRC recording artist Tony Bellus (Anthony Bellusci)? Not much. Contrary to popular belief, the twenty-three-year-old singer and songwriter's hit record "Robbin' the Cradle" was not inspired by the Lewis disaster. Not that Bellus much minds the publicity generated by the rumor.

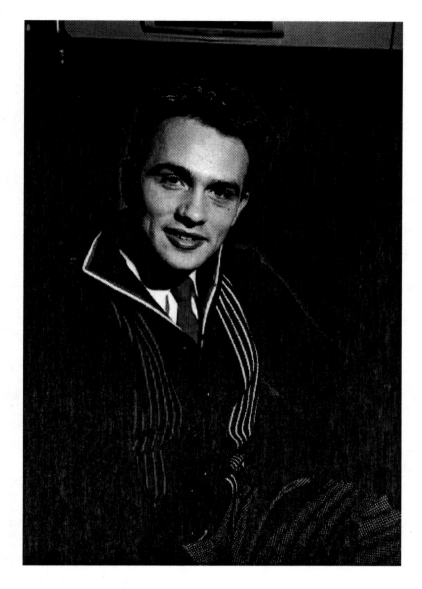

I met Tommy Edwards when I went through Cleveland on a promotional tour for "Robbin' the Cradle" on NRC. Those were the days when an artist could drive the USA and visit all the radio stations along the way. You could walk in with your new record, meet the deejay who was on the air at that particular time of day, do a spontaneous on the air interview, and get your 45 rpm played on the spot. Especially if you had it in hand and you were neat, presentable, polite, and humble. Being grateful of the interruption that you were creating by your unscheduled visit was also most important. If the deejay liked you, and your visit provided him and his listeners with some new and exclusive information, he more than not would put it on his and the station's playlist and refer you to other radio people while you were in his town.

Tommy was one of those special radio personalities. "Robbin' the Cradle" had nothing to do with Jerry Lee Lewis's child-bride scandal. I was twenty-two years old when I wrote the song, and I had a girlfriend, a senior in high school. It was a forbidden romance, and that was inspiration enough for the song. About the photo, she gave me that sweater for a birthday gift, April 17th. She got a going-steady ring in exchange. I was drafted right at the peak of my success. It didn't seem to hurt Elvis none, but it killed my career.

—Tony Bellus, Dunedin, Florida, December 2008

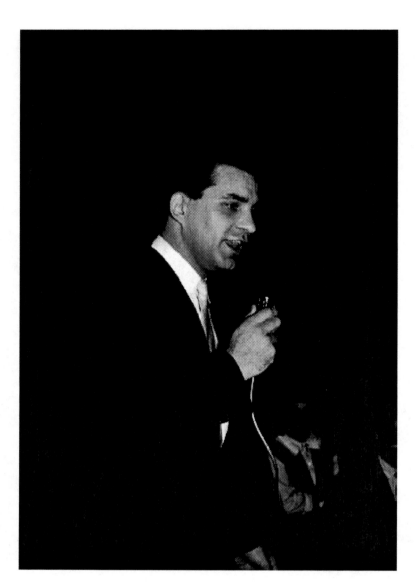

Vince Wayne

February 1959

Local Cleveland boy and Roulette recording artist Vince Wayne really hits those high notes, thrilling the kids at this weekend record hop.

Deejay Tommy Edwards is all gung-ho over the twenty-nine-year-old baritone's pop wax of "I'm All Alone Tonight," calling it "great" in the February 13 issue of his newsletter.

Things are looking rosy for this up-and-coming artist, supposedly a shoo-in to be the new male singer in Sammy Kaye's band.

But when your number's up, your number's up.

We here in Cleveland were shocked to learn of the death of Vince Wayne last weekend—he collapsed while singing at a record hop, fell off the stage and sustained a fatal head injury—he was buried on Thursday—his new record on Roulette was just released this week—the title, FARE THEE WELL MY LOVER.
—"T.E. Newsletter," Vol. 7, No. 28, April 24, 1959

Connie Francis and Jimmie Rodgers headline that benefit show for Vince Wayne's family on May 22nd—there will be more than 15 record acts.
—"T.E. Newsletter," Vol. 7, No. 31, May 15, 1959

It was one of the most unbelievable things that ever happened. I still can remember every single moment. I have a pretty good recall of most things. We were at Benedictine High School. The stage was up high, about ten feet high. A big, beautiful stage. We had a dance there for those kids, and Vince Wayne came to sing. He'd hit high notes. Big-voiced top notes. He was singing "I'm All Alone Tonight," and he reached that peak. I was standing down below and off to the left. The place is packed, and all of a sudden he hits the

high note. As he reached the peak of it, he went straight forward just like a log. He went headfirst onto that concrete floor, and you could hear that whack, and that place got so still. And that was an incredible, incredible event. He was a fine singer. I mean a really good singer.

—Bill Randle, interviewed by Marty Conn on the *Marty Conn Show,* WRMR, 2000

My dad died on April 19, 1959, exactly one week before my eighth birthday. I remember sitting on the steps at the house the day he died and listening to the crying and family members talking about him. My mother, Edna, never remarried. I believe he was the love of her life. I remember her listening to his records and twirling her wedding band in her fingers while she cried. She passed in 1985. My grandmother Clara was devastated. He was her only child. If it hadn't been for us four grandkids, I don't think she would have survived. He was her life. I remember on the day of her funeral, I took the last fan club picture of my dad and put it in her hands. She is buried next to him.

Music was my dad's life. He had a fan club based in Cleveland. I remember playing outside and my maternal grandmother calling us in to watch dad perform on the *One O'Clock Club,* a local TV show on channel 5. Dad was a regular on the show. He also performed at the Riviera nightclub on 12th and Chester on a regular basis. He was performing at a radio hop at Benedictine High School the night he fell off a four-foot stage. He was taken to the hospital and released some time after midnight. He went home and began throwing up in the middle of the night, and was rushed back to the hospital. I think they operated but he went into a coma and never came out. He died of a brain aneurysm. I don't know if it was the fall that caused his death or something else that had been going on for a while. I do remember him suffering from headaches a lot, though.

The benefit show was sponsored by KYW radio and was held downtown at the Cleveland Arena. Connie Francis, Jimmie Rodgers, and the Poni-Tails performed. The Poni-Tails were extremely close to my father. They were at the hospital and sat with my grandmother through the whole ordeal. KYW said they raised $3,000 that night. The deejays at the station donated the proceeds from their next two record hops to the family fund as well. He was a good dad, the little bit I remember. I remember one day the twins got into trouble. He spanked them and then came into the kitchen and cried. I also remember always going on family picnics in the park.

—Sharon Duche, Olmsted Township, Ohio, August 2, 2010

May 2, 1959
Dear Mrs. [Clara] Holan [Vince Wayne's mother], I am sending along the slides that I took that night at the funeral parlor. I have taken one of the slides and sent it away to be enlarged for you and it should be back in about 2 weeks. I want to thank you, too, for the words you wrote about my wife, Ann, in your letter to the editor the other night. I hope that you have recovered from your great shock by now.

Kindest regards,
Tommy Edwards

Toni Carroll

February 1959

How sweet it is! The good life seems to suit this photogenic soprano from St. Louis, twenty-seven-year-old singer and dancer Toni Carroll (Lorraine Antoinette Caroline Iaderschi).

Toni's earned her furs with a successful career born from the gritty placards of Manhattan's famed Copacabana and Latin Quarter nightclubs. Her new MGM LP of jazz standards, *This One Is the Toni,* sports the sexiest gatefold album cover ever released.

I wore furs everywhere. I was in love with furs. In my act I did a song called "Little Girl Mink." I got to parade out all my furs during the song. I've always been a jewelry and coin collector. I hung out on 47th Street in Manhattan, where all the jewelry and coins are. I had the pendant I'm wearing designed. I thought wearing money around my neck would make me a magnet for all great things.
—Toni Carroll, New York, New York, April 2009

The Teardrops

February 1959

Twenty-three-year-old Tony Ciaurella (left) has some fun with his brother Paul, twenty-five. The Teardrops arrived in Cleveland late last night, wised off to some cops, then charmed their way out of a potential jam. If their luck holds, today the boys will convince Tommy Edwards to step up the spins on "We Won't Tell / Al Chiar Di Luna (Porto Fortuna)." Also present is hardworking Josie Records rep Danny Kessler, who chimes in with some airplay statistics and promising sales numbers.

Tony and Paul have channeled the passion and humor of an Italian upbringing into a successful stage and recording act. The duo endures until February 1980, when backstage at a New York City nightclub Tony dies of an aneurism, in his brother's arms.

I was so surprised when I saw these photos, I cried. I remember Tommy and Cleveland well because my brother Tony and I were on our way to Vegas, and the record company said it'd be a good idea if we go up to see Edwards. We got into Cleveland late and were arrested at 2 A.M. We made an illegal U-turn or something, and we got dragged into the station. We were laughing about it. We said, "Officer, we're from New York, and we got lost!" so they let us go with a warning. Tony had an unbelievable mind. He did the bookings, the arranging, everything. He looked like Brando in *On the Waterfront*. He was a lot bigger than me, and he'd break my chops. He'd pick me up and say, "Anybody want this trophy I just won?" Stuff like that. We got along unbelievably well, like bread and butter or whatever. He was very protective of me. We had an unbelievable relationship. No one could get in between us, no way. Not even a girl. Even when he was wrong, he was right as far as I was concerned, and vice versa.

—Paul Ciaurella, Pleasantville, New Jersey, June 2009

Al Martino

March 1959

Finally back in the States after a 1953 run-in with the Mafia sent him scampering off to the United Kingdom, thirty-one-year-old Italian American pop singer Al Martino (Alfred Cini) is ready to make up for lost time.

The promotion blitz for his new single has paid off. The former bricklayer from Philly returns to the U.S. charts in style, his classy voice welcomed home with open arms. In 1972, Martino acts like a man and accepts an offer he can't refuse, the role of Johnny Fontane in Francis Ford Coppola's *The Godfather*.

HOUSEWIVE'S RECORD OF THE WEEK: Al Martino was in for the show to read the ballots on air concerning his new 20th Fox record of I CAN'T GET YOU OUT OF MY HEART—luckily, all six jurors voted that the song would become a hit—watch this one—it's great.

—"T.E. Newsletter," Vol. 7, No. 21, March 6, 1959

Jimmy Isle

March 1959

A few months ago, eighteen-year-old rocka-
billy singer Jimmy Isle must have stopped
and pinched himself before entering 706
Union Avenue in Memphis. After all, this
is where it all went down. Elvis, Jerry Lee,
Johnny, Carl Perkins; all his idols had
found their footing at Sun Records. And now
it was his turn.

So it stands to reason that the freckle-
faced kid from Decatur, Illinois, was a bit
nervous about his first recording session
for the label. We can imagine him standing
shyly off to the side as the great Sun rocker
Billy Lee Riley fiddles with a guitar amp,
searching for the right tone. Producer Jack
Clement smiles conspiratorially as piano
player Charlie Rich tries to intimidate Isle,
asking no one in particular about the river.
Is she running muddy or is she all peace-
ful-like? Some Memphians believe that the
mood swings of the Mississippi River hold
sway over the city's creative energy.

Well, the river must have been a cranky
bitch that day, because the just-released
single "Without a Love / Time Will Tell" is
a depressingly limp coupling typically over-
produced by Clement. The record sinks like
a stone, and Jimmy never recovers from
the disappointment. By the early 1960s,
he's out of the business, a bitter young man
lost to the years.

Jim and I were married in 1959. I was married to
him for twelve years, we had two sons. He was
very jealous and made me miserable. You know,
that's not love. I met him at a dance in Nashville. I
was from South Dakota, so all the bright lights of
Nashville really bowled me over. When his music
career died out, he had to go to work and he didn't
like that. He started drinking. He was just a drum-
mer that I met, no big rock 'n' roller.

—Beverly Isle, Hendersonville, Tennessee, May
2009

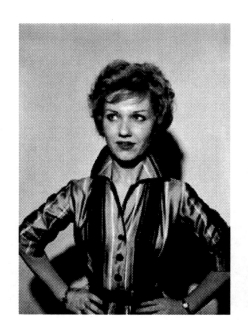 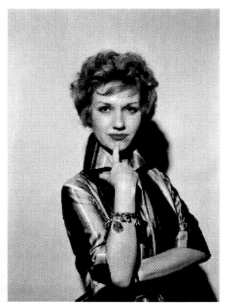 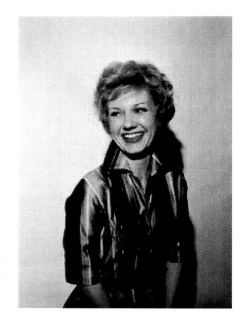

Jo Ann Campbell

March 1959

The curtain swings back as a Bo Diddley–esque guitar starts to squawk and maracas call the beat. Out struts sexy twenty-year-old rock 'n' roll singer/songwriter Jo Ann Campbell, snapping her fingers and swinging her hips to the rhythm.

If you're a guy, you'll find her performance of "Mama (Can I Go Out Tonite)" from the Alan Freed film *Go, Johnny, Go!* riveting. She's full of schoolgirl innocence,

coy winks, and lip-curling growls as she prances around a stage set consisting of a jukebox, LP record, and musical staff—all oversized. If you're a girl, you're probably jealous.

Wearing the same fabulous dress she'll don in the movie slotted for June release, Jo Ann strikes some flirty modeling poses for Tommy in support of "Nervous / Mama (Can I Go Out Tonite)" on Gone Records.

Bobby Darin

March 1959

Walden Robert Cassotto cocks an eyebrow at the camera and perpetuates the image that is Bobby Darin. Rock 'n' roll million-sellers and pop signature anthems may be part of his résumé, but Darin never sets the trends, only follows the leaders.

The twenty-two-year-old hotshot from Italian Harlem is in the midst of his latest musical identity crisis. On his new Atco LP, Walden wants us to believe that he's Frank Sinatra, even though his performances are mostly devoid of the thing that makes Sinatra the best: sincerity.

Bobby Darin finally has some songs I can play on my shows in his new LP, THAT'S ALL——By the way, both Bobby and Jo Ann Campbell denied they are secretly married this past week—they recently returned from an Australian tour with Chuck Berry as headliner.
—"T.E. Newsletter," Vol. 7, No. 23, March 20, 1959

Claire Hogan

March 1959

The Irish Billie Holiday, thirty-two-year-old Monocle recording artist Claire "Shanty" Hogan.

Claire cut her teeth as a big-band vocalist in the 1940s, so it was probably some joker in Boyd Raeburn's orchestra or Jimmy Dorsey's band who stuck her with the tongue-in-cheek nickname. This sexy gal with the voice like a hangover is quick with the barbs and way tougher than she looks, more the poor "shanty Irish" than haughty, upper-class "lace curtain." The moniker's humorous connotations suit Hogan's underdog persona just fine.

A volatile love affair with alto saxophonist Johnny Bothwell, complete with "pretend marriage," will haunt her for the rest of her life, but today it's all about her fantastic new single, "Hold Me, Thrill Me, Kiss Me / Kiss Me."

The Heart Breakers

March 1959

It's easy to picture the scene: Four sixteen-year-old girls, hearts pounding and palms sweaty. Their faces say "bored," but the nervous fidgeting of fingers and feet gives them away. Inevitably, the charade collapses into fits of excited giggling and jumping in place, as the overwhelming thrills of the lights, cameras, and action take over.

This is the glitz and glamour of showbiz, a land of make-believe where everything seems possible and nothing is as it seems. There's one last chance to check ribbons and makeup. Watch for your cue. And you're on!

From left, Arlene Bucci, Sally Heiser, Sally Gesner, and Kitty Semple, collectively known as the Heart Breakers, sing for Cleveland on Edwards's *Landmark Jamboree*.

Last week we pulled a boo boo by calling an attractive quartet of Cleveland young ladies "the Heartbeats" instead of THE HEARTBREAKERS—their record is BOODELY BUMP and it's a good one for the R & R set.

—"T.E. Newsletter," Vol. 7, No. 24, March 27, 1959

What good memories you have brought back! I remember appearing on Tommy's *Farm Bureau Jamboree* show. I was also one of the square dancers on the show. We were promoting "Boodely Bump" and "Hum-Be-Doo-Be," which were on the Cos-De record label. We had good memories working with Bob Hope at Cain Park in Cleveland, 1959, along with Elaine Dunn; she was a good entertainer (dancer). We had a lot of fun with him, and my biggest moment was when Gene Carroll brought Bob and his manager to our home, while they were still in town. I remember feeling so important because he was at my house. Ha! My parents enjoyed them.

—Arlene Bucci, Los Angeles, California, July 2009

Glenn and Jerry

March 1959

A snapshot study of a 1959 record hop, Tommy Edwards style. Recording artists often drop by to sing or lip-synch their latest and greatest. Tonight it's rock 'n' roll teen duo Jerry Williams and Glenn Disbro with "Hello, a New Love" on Kapp Records. It's a fun song the boys originally released in April 1958 on the Whirl label without much success, and this second attempt fares no better.

The deejay doesn't sponsor the event or organize it himself. He appears strictly as a guest at different schools and churches each hop night. Dances are held Friday and Saturday nights during the school year. Most dances are organized to raise money, with an average admission fee of 35¢. Attendance usually hovers around 250.

The deejay furnishes the PA system, the records, and the record player. Just in case an amplifier tube blows, he brings along double equipment—double microphones, double amplifiers, double turntables, every-

thing is duplicated just to forestall any emergencies.

Bill Carey's Coral wax "Record Hop" serves as theme song. There are dance, hula-hoop, and Elvis bubble-gum-blowing contests; gimmicks galore; record give-aways, Polaroids of dance couples, and wallet-size photos of the smiling deejay for anyone who wants one. And don't forget the big slide show. Electrifying color photographs of the top stars, taken by the deejay, are projected twelve feet high on a screen or blank wall. It's a showstopper!

After about three hours, the deejay spins "Goodnight Sweetheart" by Jimmie Haskell, cueing the kids to moan their disappointment as a night to remember comes to a close. His fee? Fifty bucks a hop.

Along with this week's sheet you'll find my newest gimmick for my record hops—a page from my autograph pad—my wife, Ann, and I autograph the page and give them to the kids at our record hops—they can either put them in their wallet or paste them in their scrapbooks as a souvenir of the hop.
—"T.E. Newsletter," Vol. 7, No. 22, March 13, 1959

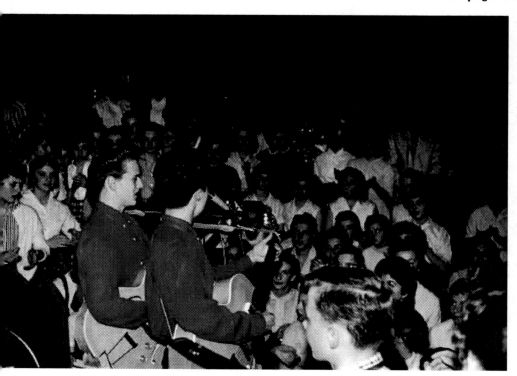

Kenny Rankin

April 1959

Late night partying with Dion, writing songs for Peggy Lee, recording with Bob Dylan—all this looms in the near future for Kenny Rankin, a freshly scrubbed nineteen-year-old who's stepped off the teen-idol conveyor belt straight onto the set of Tommy Edwards's *Landmark Jamboree* TV show.

A well-accoladed career will be hard earned, so it's a good thing this talented kid's a lot tougher than he looks. An ambitious musician from Washington Heights, New York, Rankin's laid-back tenor on his new Decca single, "Cindy Loo (My Cinderella)," sounds like Bobby Rydell on quaaludes. And that's a compliment.

Chuck and Betty

May 1959

Pop singers Betty Chotas and Chuck Simmons like the odds on their new composition, the gimmicky "Walking in My Dreams." With cleverly strung together lyrics and good harmonies set to a solid beat, the record sounds like a surefire hit.

The duo's winning May 11 performance on *American Bandstand* comes and goes, their label unable or unwilling to capitalize on the song's catchy appeal. The missed opportunity evaporates as a creative partnership heads for the rocks.

Chuck and I counted them up once, and there are thirty-two titles of hit songs in "Walking in My Dreams." Practically every word is a title of a hit song that was on the charts at that time. The record was unique and very, very commercial. I don't think Decca knew or cared. That's why we didn't get many spins. I wore a pink sequined dress on *Bandstand* that glittered like mad. I looked like a movie star. Dick Clark gave the record a high rating and said I wasn't the prettiest girl he's seen, but I sure was pretty. That sounded just fine to me! Chuck and I were pals, we grew up together in Atlanta and just got to a-hangin' out and singin'. I met him on the school bus and taught him to sing. Later, when I was married and had kids, Chuck would come over, I'd play guitar, and we'd rehearse while the kids played in the room. We worked hard. Every morning he'd come over. He was a good guy, never made a pass at me. He called my husband "Lucky." Chuck's wife was very jealous. Not of me, but of him. She was the reason we stopped singing together. She didn't like all the attention he was getting. Chuck didn't take care of himself, got very heavy, and passed away some time ago. This is a nice picture. I usually wore my hair long. I had it cut short and I hated it. I always dressed nice. I was real sophisticated-like. I wrote some songs for Brenda Lee and Patsy Cline. If I didn't have two kids I wouldn't have quit. I would've been on top of the world.

—Betty Chotas, Austell, Georgia, August 2009

Carmel Quinn

May 1959

The Dublin Thrush, in all her beautiful Irish glory. In 1954, Carmel Quinn left a blossoming career in Ireland to try her luck in America. The ambitious risk paid off in spades, landing her a regular spot on the *Arthur Godfrey Show*. With her charming brogue, winning personality, and unwitting sex appeal, it's no wonder American audiences have a bit of a crush on the thirty-three-year-old soprano.

My first thought when I saw the picture was, "Gee, I wish I looked like that again!" I remember how great Tommy Edwards treated me. It was lovely, I was treated like royalty. I was promoting "I'm Just a Country Girl (Boy)" on Headline Records. It was a lovely song with lyrics I identified with. Headline was a small New York label started up by my late husband, God rest his soul. It was always a joy to go to Cleveland. I always had an attraction for Cleveland, because before I was born, my mother left Dublin when she was twenty and went to Cleveland. Back then in Ireland all the girls were sent away to become nuns. Some made good nuns, some made cranky nuns. She was a rebel. I have a photograph of her taken in Cleveland in a man's suit, lighting up a cigarette. When she sent this photo back home to Dublin, it caused quite a stir. My uncles left Ireland and went to work in Cleveland, and they would send us kids back home comics and clothes. They would send backless evening gowns and high-heeled shoes, and I loved it so. I would take the clothes they sent and put on little shows with the neighborhood kids. In Ireland, Cleveland was IT as far as America was concerned. We knew everything about Cleveland.

My uncles would send us the *Cleveland Plain Dealer* newspaper. Cleveland is a big thing in my life. As far as my recording career, Cleveland was much bigger than New York or LA. Arthur Godfrey was like *American Idol,* only quieter. I won, and he asked me to stay on. I told him I had to think about it because I wasn't sure it was what I wanted to do. I'm the type of singer who likes to sing a song then go out for a long walk.

—Carmel Quinn, Leonia, New Jersey, September 2008

Connie Stevens

May 1959

This pensive starlet might look familiar to you if you're a fan of ABC-TV's 1959 Friday night hit detective drama, *77 Sunset Strip*. The April 10 episode, "Honey from the Bee," starred twenty-year-old actress and singer Connie Stevens (Concetta Rosalie Ann Ingolia) as Cleo Mason, the sympathetic date for Gerald Lloyd "Kookie" Kookson III. Twenty-five-year-old teen heartthrob Edd Byrnes plays the compulsively hair-combing hipster, parking lot attendant, and amateur sleuth Kookie.

Some bright bulb at Warner Brothers pairs these two beautiful people up to record a single. "Kookie, Kookie, Lend Me Your Comb" is a smash, just another victory in what turns out to be quite a year for Connie. In October, she'll start her tenure as photographer Cricket Blake on the quasi–*77 Sunset Strip* spin-off, *Hawaiian Eye*.

Johnny Horton

May 1959

Turn the dial, and it's hard to escape the boot-stomping beat of Johnny Horton's Columbia recording, "The Battle of New Orleans."

Instead of sitting in a stuffy Cleveland radio station, the thirty-four-year-old *Louisiana Hayride* star, once billed as the "Singing Fisherman," would probably prefer to be casting a line on some sleepy East Texas lake. Maybe he promises himself an expensive new rod and a quiet sportsman's retreat as soon as he's fulfilled all the TV and personal appearance commitments, as soon as all this showbiz raucous subsides.

After "Battle" wins Best Country and Western Performance at the second Grammy Awards in November 1959, Horton rehashes the winning storyteller formula for a few more hits. But he never does get back to his secret sweet spot, the one where the catfish almost jump right into the frying pan. A drunk driver swerves into oncoming traffic on a Texas railroad overpass, killing Johnny Horton on November 5, 1960.

Connie Francis

May 1959

A defiant flip of chiffon, a sassy hand on the hip—twenty-one-year-old MGM recording artist Connie Francis (Concetta Rosa Maria Franconero), the tough Italian girl who escaped the backstreets of Newark, New Jersey, has scored another top 10 hit with "Lipstick on Your Collar," and she's damn proud of it.

Her sustained chart success following last year's breakthrough smash, "Who's Sorry Now," makes her father's suffocating, yet intuitive guidance seem tolerable. Even her heart aches less. The memory of a recent tumultuous affair with songwriter Bobby Darin is numbed by a hectic schedule of recording dates and live appearances.

Connie was first up to chat with Tommy Edwards back in December 1955 when she was just a blip on the pop-music radar. Tommy took note of the charismatic teen, tracking her progress in his "T.E. Newsletter." This visit marks her eighth and last, these lowly deejay meet-and-greets no longer a necessity for a star of her magnitude.

At odds with her safe and accessible stage persona is Connie's sensually powerful voice and its emotional transparency. Not unlike those of Patsy Cline, her best performances transport fans to an intensely vulnerable space, and they, in turn, love her for it, rewarding her with unparalleled success throughout the world. Our first pop diva.

Connie Francis is lending her name to teenage items like dresses, bobby sox, charm bracelets, etc. etc.

—"T.E. Newsletter," Vol. 7, No. 32, May 22, 1959

Melvin Smith

May 1959

Well, at least we know who he isn't. This strapping young man with the bedroom eyes is not the well-accounted-for Atlantan rhythm and blues singer Melvin Smith who recorded unsucessfully for RCA in the early 1950s and who later raised some hell as frontman of the Nite Riders.

This Melvin cut just one obscure pop 45 for Metro Records, a short-lived singles label under the MGM umbrella. The May 4 issue of *Billboard* cheerleads "A Tree and a Love Will Grow" as a "teen-appeal rocka-ballad sung with sincerity and heart" that "merits exposure." Sadly, no one else agrees.

So all we're left with are Tommy Edwards's few photographs of a mystery man sporting a conk hairstyle and a sly smile. Hey, Melvin, if you're out there, drop us a line. We'd love to hear from you.

John Gary

May 1959

Still sporting his Marine corps buzz cut, twenty-six-year-old Fraternity Records artist John Gary flashes his charming smile and chills out for a change. Always regarded as a monster talent by his contemporaries, this boy next door just happens to sing his ass off. The heroic balladry of "Let Them Talk" is the latest single. Singer, songwriter, inventor, sculptor, athlete, artist; the handsome pop crooner seems to do it all, and he does it all very well. A true renaissance man.

John's self-described "lyric baritone with a freakish range" voice won't truly hit its stride for another couple of years. In the midst of 1964's Beatlemania's maelstrom he unexpectedly, albeit briefly, becomes relevant with the release of *Catch a Rising Star,* his smash debut LP on RCA Records.

I know John was very fond of Tommy Edwards.
 —Lee Gary, John Gary's widow, Richardson, Texas, November 2008

Al Kasha

May 1959

Tender melodies are always in his head, beautiful songs that seem to materialize out of thin air, embracing him like old familiar friends. The music fills him with a private joy, a special kind of contentment. Twenty-two-year-old songwriter and singer Al Kasha struggles with rest.

Brunswick Records would like to paint him as a sunshiny pop teen idol, but the company soon realizes it's backed the wrong horse. The introverted kid from Brooklyn who grew up in a family of dysfunction and alcoholism is too busy running from his demons.

Tommy Edwards must have had a gift of prophecy because he saw in me, as a kid back in '59, an artist that would have great success as a writer, a two-time Academy Award–winning songwriter and composer. I was promoting my record "Good Things Come to Those Who Wait."
 —Al Kasha, Beverly Hills, California, December 2008

Jan Tober

May 1959

Such wild sounds, such excitement. It's 1955, and the record spins; a pretty teenager falls deeply in love with the music that changes her forever.

Hail, hail, rock 'n' roll, right? So wrong. It's the stratospheric excursions of the great Art Pepper's alto sax, the gorgeousness of trombonist Milt Bernhart's choices, and the pure class of singer June Christy that inspire Jan Tober. It's jazz, and it means everything to her. She makes bandleader and pianist Stan Kenton's 1950 LP, *Innovations in Modern Music,* her sonic

bible and studies it fanatically. When she has a chance run-in with Kenton at Thearle's Music Store in San Diego, Jan's ready. Following a successful audition, the 1958 incarnation of the Stan Kenton Band introduces an eighteen-year-old vocalist whose dreams have all come true.

By the time Tober makes her springtime sojourn to Cleveland, she's singing with Les Elgart's band and reluctantly promoting a solo pop single. The jazz devotee agrees to sing fluff like "Just Married" only after her label, Golden Crest, placates her by promising an Ella Fitzgerald song for the flip side, "You Turned the Tables on Me."

Whoa, it feels like ten lifetimes ago, seeing this photo. I remember Tommy: he was a very nice man. I forgot all about that dress. It's black linen with orangey red poppies embossed and embroidered. I was always into color, design, and textures. It was absolute bliss getting the job with Stan Kenton, really mind-boggling. Les Elgart's cousin in New Jersey wanted me to do a pop record. I wasn't a pop singer; I didn't like it. I never recorded another. Singing jazz was what I always wanted to do. When I was three, my father would make recordings of me on acetates. By five, I was singing songs well. I was always a bit different from the other kids. I wasn't your typical teenager, I hated rock 'n' roll, couldn't stand it. My brush with rock 'n' roll happened when I was asked to open for Elvis Presley when he played the San Diego Arena in June 1956. I told my agent I didn't want to do it, I couldn't stand his music, and plus, it would be an all-female crowd—I'd bomb. My agent said I was crazy but I didn't care.

—Jan Tober, Olivenhain, California, June 2009

Jayne Mansfield

May 29–31, 1959

Twenty-six-year-old Hollywood sex queen Jayne Mansfield is just an innocent by-stander. The accomplished actress who plays stupid well (but isn't) enjoys a night out in Miami, taking in a show and a few laughs at the Americana Hotel's Carioca Lounge.

But unbeknownst to her, she's stumbled headfirst into the seedy underworld of the Second International Radio Programming Seminar and Pop Music Disk Jockey Convention. These unscrupulous deejays act like "little tin gods" according to the *Miami News,* peacocking around on unchecked power trips with their wallets open, slaves to an unquenchable greed.

Well, drink up because come the fall, the party's over. The House Legislative Oversight Subcommittee, chaired by Representative Oren Harris, is gearing up for their congressional witch hunt into the payola pandemic.

I think it is time for someone in the deejay trade to voice a few comments concerning the payola situation. The whole deejay profession has been given a black eye ever since the disclosures about payola broke into the news several months ago. I would be willing to go to Washington myself to be questioned by the committee investigating payola to give the other side of the story. Someone should be given a voice to remove the stigma placed on all deejays because of the actions of a few.
 —"T.E. Newsletter," February 15, 1960

Connie Russell

May 29–31, 1959

If we are to believe *Time* magazine's scathing June 8, 1959, article entitled "Disk Jockeys: The Big Payola," then the Americana Hotel on the oceanfront at 97th Street, Bal Harbour, Miami Beach has just been transformed into a decadent playpen by over two thousand corrupt deejays.

The infamous Second International Radio Programming Seminar and Pop Music Disk Jockey Convention and its scandalous fallout hasten the demise of the autonomous deejay, whose disappearance from the scene marks the end of an era.

All-night parties in the Americana's Bal Masque Supper Club and Carioca Lounge also serve as showcases for recording artists selling their wares. Thirty-six-year-old jazz singer and actress Connie Russell has braved the savage humidity to promote her United Artists LP, *Don't Smoke in Bed*. Besides sporting an incendiary album cover, the record contains beautiful renditions of such standards as "The Thrill Is Gone" and "Angel Eyes."

There are and were thousands of other deejays like myself who felt a feeling of satisfaction in trying to make hit records strictly on our own and without taking considerations in the form of money and gifts. Will someone bring out the fact that there were deejays, like myself, who sent money back that was scotch-taped to a new record—who refused offers of simple lunches and cups of coffee—who paid all their own expenses at the deejay convention in Miami last year? In regards to the convention, there were only a handful of us who attended all the business meetings and seminars. I made up my mind at that time that I would never again attend a deejay convention, because it was a convention in name only—it was, in reality, only a BALL.

—"T.E. Newsletter," February 15, 1960

I was a William Morris agent at the time Connie and I met. In 1953, I got her a picture at Columbia, called *Cruisin' Down the River,* starring Dick Haymes. She came to LA and we met face to face for the first time. I told her I thought we should get to know each other. We had dinner at the Brown Derby, and that was that. We met in January of 1953 and we were married in July 1953. She died thirty-seven years later in 1990. I never wanted another woman before or after Connie. She was a terrific gal, a really great singer. She was born in New York City and was kind of thrust into show business by her vaudeville parents because she was so talented. The Dave Garroway radio show made her a young star, and at fifteen years old she was under contract with MGM. They hired her to sing for the stars in the movies, overdub their voices. She played the big nightclubs, headlined at the Coconut Grove. She was close friends with Sinatra; he was a big fan of hers. Everybody loved Connie. She had this great laugh, the most unusual laugh. It was such a warm thing. Carl Reiner said he could always tell when Connie was in the audience by her laugh. I think she looked more beautiful in person than she does in this photo. Her personality was part of her looks. She loved singing but not the business. One day she turned to me and said, "You know something? I think I've had it" and she quit. Never looked back. She was a passionate performer and passionate in her private life too. She had a wonderful smile and was a great mother. Connie really loved life. I'd do anything for her.

—Mike Zimring, Los Angeles, California, June 2009

The George Shearing Quintet

May 29–31, 1959

The percussive, block chord pianistics of thirty-nine-year-old arranger and composer George Shearing blend effortlessly with the scratch of drummer Ray Mosca's brushes and the staggered walk of Carl Pruitt's bass lines. Colorful congas sans Armando Peraza stand by, while out of frame but locked in step are Ray Alexander on vibes and Toots Thielmans on guitar. A conspicuously lonely microphone awaits the honey-dipped tones of platinum-topped jazz singer Peggy Lee.

The scene is the Americana Hotel, Miami Beach, where the smell of drying sweat mixes with the metallic, artificially cooled air, courtesy of the Carioca Lounge. The event is a live recording session featuring two Capitol artists at the height of their creative powers; the Afro-Cuban influenced "Shearing Sound" lovingly nestled about Lee's always evocative vocals. The result is the stunning, albeit studio doctored, *Beauty and the Beat!* LP.

Spiraling out of control around them is the Second International Radio Programming Seminar and Pop Music Disk Jockey Convention, a supposed hotbed of payola-induced mayhem.

The Shortcuts

June 1959

Mary Ellen Keegan (left) is an artistic rebel way ahead of her time and frequently an obsessive-compulsive recluse; a beautiful dreamer and often a cold practicalist.

In other words, she's a poet.

Carlton picked up a great record by two young Cleveland girls—the Keegan Sisters (The Shortcuts)—Bill Randle started the song a week ago to great response—watch this one.
—"T.E. Newsletter," Vol. 7, No. 30, May 8, 1959

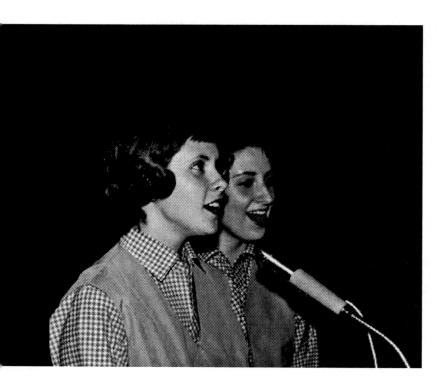

These photos are very important to us because for some reason no one took very many! Was I ever that young?? I'm on the left, age eighteen, and my sister Margy is seventeen, on the right. Bill Randle set up shows for us in and around Cleveland. There was one show where we opened for Connie Francis. She was nervous as hell and couldn't wait to get back to her mom! Bill also set us up to open for the Everly Brothers, and that was at the Rollerdrome. Don and Phil had us running back and forth to the concession stand for stuff! Margy and I spent a lot of time at WERE and have fond memories of Tommy Edwards and especially Bill Randle!! The record we were promoting in '59 was "I'll Hide My Love" (A-side) and "Don't Say He's Gone" (B-side). Songwriting is something I have always done, including poetry. Back then I would stay up to 4 A.M. if I got a good melody in my head. Margy and I would rent studio time and record our songs for fun, then send them around to different contacts. I can't think of any other group from that time that wrote the songs they recorded. Looking back, I have no idea why this was not made out to be a big deal. I wish I knew then what I know now! What a great time Margy and I had. We met so many cool people. Any regrets??? Oh yeah!! I've got a big one. During the time we were hanging out at Audio Recording, one of the engineers offered to send my song called "Was I Wrong?" to Paul Anka's manager. He felt the material would work great for Paul. And I said NO! Margy and I felt only we should record our own material!! What big dummies!! Of course, one will never know what might have happened. I wish I could take that one back!! Oh-oh there goes the doorbell. Probably a bunch of our fans wanting autographs!! Will it never end?
—Mary Ellen Keegan, Lyndhurst, Ohio, May 2009

Jimmy Ford

June 1959

So you want to be a rock 'n' roll star? Rockabilly singer-songwriter Jimmy Ford assumes the position and does his best James Dean, that smoldering, tortured soul look having been perfected in the bathroom mirror back home in Arkansas.

Someone or something breaks his concentration because in the next few frames there's a smiling, laughing kid with big dreams written all over his face.

Luckless music entrepreneur Foster Johnson sees summertime dollar signs and rushes out back-to-back Jimmy Ford singles on his Stylo label, a division of Dub Records headquartered in Little Rock, Arkansas. Foster's betting on "We Belong Together," but the best of the bunch is "Don't Hang around Me Anymore," a minor key threat with a cool, repeating guitar riff and a lead vocal straight out of the Jerry Lee Lewis playbook.

Gordon Young

June 1959

Despite such awesome hair, rocker Gordon Young's (Galbraith) latest single, "Fills Her Skirt / Who's Fooling Who," stiffs in the racks, and Felsted Records shows him the door. Soon enough Strand, ABC-Paramount, and 20th Century Fox Records follow suit, leaving the prolific songwriter with wounded pride, messed-up mojo, and boxes upon boxes of useless "Gordon Young National Fan Club" membership cards.

Elaine Dunn

June 1959

Beauty is timeless. And so it goes for twenty-five-year-old singer and dancer Elaine Dunn (Dombcik), her loveliness paid tribute in this wonderful candid.

Returning home to Ohio, Elaine joins fellow Clevelander Bob Hope and his variety show for a two-week run at the Cain Park Theater, a three-thousand-seat amphitheater in Cleveland Heights, starting June 15. Along with a swingin' jazz version of "Buckle Down, Winsocki," Elaine's well-honed nightclub act features her latest RCA Victor single, "Far Away Places." But the magic truly sparkles in the summer night air when she joins Mr. Hope for a bit of soft shoe.

The gold watch on my left hand was given to me by my then boyfriend and future husband. I had a high fashion look for the 1950s. People always thought I was Italian or French, with my short hair. I was a little bit of a hippie living in the Village back in New York, but then I got high fashion!
—Elaine Dunn, Las Vegas, Nevada, April 2008

Bob McFadden

July 1959

"I belong to the beat generation. . . . I don't let anything trouble my mind." So claims Brunswick Records novelty artist Bob Mc-Fadden on his slinky ode to the Kerouacian lifestyle, entitled "The Beat Generation."

As the thirty-six-year-old lazily talk-floats his way through the lyrics, his enigmatic partner "Dor," or "Rod" spelled backwards—as in twenty-six-year-old mad-poet Rod McKuen—provides hip interjections.

At year's end, the boys release the LP *Songs Our Mummy Taught Us,* whose cover features a bandaged, curvy female about to crash a teenage party. "Weirdsville, yeah!"

George Darro

October 1959

George Darro (Horchak) wants to save the world. From a proselytizing shout to a weepy, righteous whisper, the twenty-two-year-old rockabilly artist delivers his message of rock 'n' roll salvation at a Shaker Heights High School record hop, hosted by Tommy Edwards.

Darro straps on the Jörgenson electric guitar, a faithful companion handmade in Germany, and bangs out the opening chords to "Eye'n' You Up," his single on Nationwide Records. Monday morning back at the school, it won't be George's singing the kids remember. Instead the gossip will revolve around his intensely passionate in-between song sermons on the healing powers of music, the wonders of the cosmos, and the mysteries of love and sex. They'll understand that rock 'n' roll is more than a rebellious sound, it's an attitude, a way of life—the only one they want to know.

George Darro wants to save the world, and he's just the man to do it.

Other songs I'm hearing a great deal in town— Honestly and Truly, Tommy Edwards—Eyin' You Up, George Darro—High School U.S.A., T. Facenda.

> —"T.E. Newsletter," Vol. 8, No. 4, November 4, 1959

I got goose pimples when I looked at this photo, it's miraculous! I was the greatest car salesman in Pennsylvania and makin' tons of money at age eighteen. I went up to Cleveland for a car auction and sang a few songs, to sell cars. The guys at Nationwide Auto Sales loved me so much, they put out the record. I don't sing songs, I live 'em, you

follow me? You know what I love about me? I wrote songs I never heard before. I entertain the hell out of me! I love me! When you love yourself, all that love will spread across the earth. Something come over me I call Friendly Force. Friendly Force is the power of good deeds that's gonna save the world. I'm a No. 1 dancer. In high school I'd ask the girls to dance, and they'd be shakin', you follow? If I was ever voted President of the World, the first law I'd pass is no more walkin' . . . you gotta dance!

> —George Darro, Ambridge, Pennsylvania, April 2009

Maureen Cannon

October 1959

Singer, dancer, actress, mystery. Tommy Edwards seems to enjoy photographing Maureen Cannon. The deejay's archives contain several photos of her exuberant smile on the set of his WEWS-TV show *Landmark Jamboree.* The pair might share a few cups of coffee and some flirtatious small talk in a cramped dressing room.

What little we know about thirty-three-year-old Maureen Cannon is discerned from such treasures as a faded 1941 theater program announcing the debut of Broadway's latest and greatest ingénue; the good reviews following her USO–Camp Show tours during World War II; sporadic record releases on Bartone, Derby, and her latest, "I Double Dare You," for Jubilee; a torn ticket stub to a 1955 Alan Freed tour alongside Frankie Lymon and the Teenagers; and finally, a few intimate photographs of a seasoned performer taken by a smitten Cleveland deejay.

The pretty Irish girl from Chicago remains one of those forgotten artists who exist only on the shadowy fringes of American popular culture.

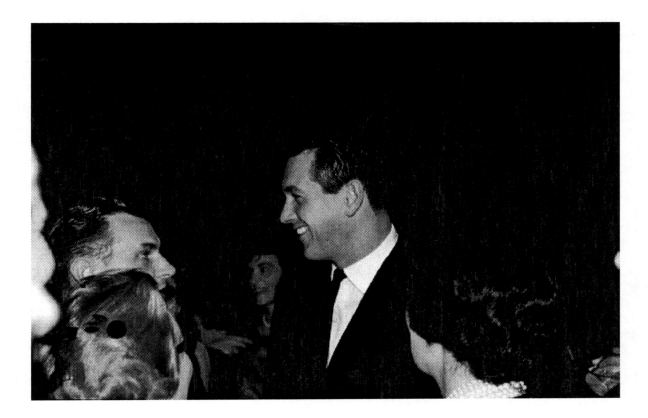

Rock Hudson

October 1959

The Rock acts. The Rock dances (sort of). The Rock sings?! Yes, thirty-three-year-old heartthrob thespian Rock Hudson (Roy Harold Scherer Jr.) warbles through two songs featured in his new hit film, *Pillow Talk,* Universal International Pictures' sex comedy costarring Doris Day. To promote the movie's single, "Roly Poly / Pillow Talk," Decca sends the beautiful one out on a cross-country deejay tour, to the great pleasure of record dealers and fans alike.

With the ink still wet on his divorce from secretary Phyllis Gates, Rock looks forward to playing the field and entertaining romantic prospects on his forty-foot sailboat.

Dorsey Burnette

January 1960

Memphian singer, songwriter, and street fighter Dorsey Burnette is either laughing with us or at us; the distinction an important one, should his infamous temper flare and you happen to be on the receiving end of his fists.

The twenty-eight-year-old possesses a weird voice that sounds like the bastard child of Roy Hamilton and rockabilly queen Sparkle Moore. Tonight he'll sing his self-penned Era Records hit "(There Was a) Tall Oak Tree" on Tommy Edwards's *Landmark Jamboree.*

As members of the influential rockabilly group the Rock 'n' Roll Trio, Burnette and his brother Johnny were two of the earliest pioneers to heed rock 'n' roll's clarion call. But an illustrious past won't pay the bills, so Dorsey counts on the royalty checks he receives from writing some of Ricky Nelson's best songs, career highlights such as "It's Late" and "Believe What You Say."

Sue Evans

February 1960

The darn thing's bigger than she is! Pert and pretty singing harpist Sue Evans, all 5 feet 1½ inches of her, must have a heck of a time lugging around that big ol' Lyon and Healy semi-grand harp for personal appearances.

Rumor is she rolls up to hip jazz night-spots like Chicago's Black Orchid supper club in a ramshackle truck and unloads the instrument herself, an awkward behemoth that purrs when its Red-O-Ray strings are stroked by the twenty-seven-year-old New Yorker.

On the set of Tommy Edwards's *Land-mark Jamboree,* Sue likely rehearses her new 20th Century Fox single, "Rumble at Joe's / Mary Ellen, Give Me Back My Guy," an uncharacteristic stab at the pop market.

Lenny Welch

February 1960

Archie Bleyer thinks this kid is special. And as head of Cadence Records, what Bleyer thinks can make or break his artists' careers. He says this seventeen-year-old high school dropout with the sad, beautiful voice is a star. We'll see.

Archie challenges the singer with "You Don't Know Me," a great song that demands vocal control while delivering a strong emotional message. He sends the boy out on the road to sing the song over and over at every record hop for anyone who'll listen. But nothing seems to be happening; maybe it's the wrong song, maybe it's his delivery. Archie tells him to be patient. And he'll see.

In time, the single begins to sell. Lenny Welch is on his way to the stars. He'll come to love Archie Bleyer like a father, the one who nurtured the artist and believed in the boy.

I was in Cleveland many times in the late '50s and early '60s doing hops for Tommy Edwards and the other deejays. I was born in Harlem Hospital, New York City, May 31, 1940, and I grew up in Asbury Park, New Jersey. Everyone gets this info wrong. I was born Leon Welch, but in 1958, when I auditioned for Decca Records, the producer's secretary made a mistake. She thought I said my name was Lenny Welch. I told the producer that my name was Leon, but he said, "I think Lenny sounds better."
 —Lenny Welch, Los Angeles, California, April 2009

Dottie West and Kathy Dee

February 1960

Tired balloons, wilted leis, and Christmas lights—just some of the ingredients that go into WEWS-TV's country music show, *Landmark Jamboree.* Country pop duo the Kay-Dots handle vocal duties every Saturday night, backed up by a six-piece band. "Kay" is Kathy Dee (Dearth; right), a twenty-six-year-old competent songwriter and rather forgettable singer. "Dot" is twenty-seven-year-old singer and songwriter Dottie West.

Appearances by the top stars of country music notwithstanding, it's West's earthy voice and no-frills delivery that keep viewers loyal to the show. No one's more aware of this than *Landmark* host Tommy Edwards. In fact, that's why he hired her. A pretty girl who sings like she knows something about tragedy and loss? That's a potent combination that spells ratings.

Within a year, Dottie heads for Nashville and superstardom; an amazing journey in which she'll redefine what a female country music vocalist must be: an artist who earns the respect of her peers and the adulation of a mass crossover audience through savvy, sweat, and talent.

June Valli

June 1960

Like a scene straight out of an animated Disney production, thirty-year-old pop singer June Valli frolics amid the sparkling plastic blossoms in the dreamlike blur of Tommy Edwards's photograph. The powerful, quivering tremolo of Valli's voice saves her hit Mercury recording of "Apple Green" from drowning in sentimental schmaltz.

This tough Italian girl from the Bronx with the heart-shaped face has experienced all the highs and lows of the music business. Even so, the low-budget quaintness of the sets culled together for the *Landmark Jamboree* must amuse her just a bit.

I was married to June and was her conductor from 1966 until she died in 1993 from pancreatic cancer. June was always easygoing, which was why she never achieved the status she should have. She never really had a manager to fight for her, so everyone took advantage of her. Without a manager, the agents and record companies sell you down the river. But she always worked and was as busy as ever until she became ill. June was never too busy to sign an autograph. It all started for her in 1951. She went to a wedding in the Bronx, near Arthur Avenue. A man heard her get up and sing a song with the band and thought she was great. Through a cousin at the Arthur Godfrey *Talent Scout* TV show, he got her an audition, and she passed, went on the show, and won. From there things just snowballed and she was in show business. She never really cared for it. She would rather stay home, cook Italian food, and take care of her three dogs. I told June many times she had the talent but not the fight to be a superstar. You have to be a pit bull with a facade of an angel.

—Jimmy Merchant, Fort Lee, New Jersey, July 2010

About the Photographer

· ·

It's too bad that a man has to die before he

gets recognition that's long been due him.

—Tommy Edwards, "T.E. Newsletter," Vol. 4, No. 8,

November 30, 1956

Tommy Edwards's parting thought on the death of musician Tommy Dorsey proved prophetic in his own life. At the time of his death, July 24, 1981, when he was sixty, Edwards was, for the most part, a forgotten ghost from Cleveland's past. Only in retrospect do we see his amazing contribution to the historical preservation of 1950s music and culture.

Edwards's radio career begins in 1945, when he places an ad in *Broadcasting Magazine* looking for a job. He has no experience whatsoever, but a fine speaking voice lands him a job as an announcer at KICD in the little farm town of Spencer, Iowa. Within two years, he's program director and eager to advance his fortunes. By 1948, Tommy's at WOKY in Milwaukee, honing deejay skills, which will take him to the top of the profession. In April 1951, he accepts a job as staff announcer at WERE, Cleveland's most listened to station. Within three months, he's hosting his own daily pop music show. Within three years, he's

one of Cleveland's best-known radio personalities.

Backstage at the Grand Ole Opry on Saturday, June 25, 1955, most likely armed with a Kodak Pony camera loaded with Ektachrome film, thirty-four-year-old Tommy Edwards indulges his newest passion and begins to snap pictures of Nashville's elite as they warm up in the wings. By embracing the technology now available to the hobbyist, Edwards embarks on a six-year journey as a documentary photographer, making these archives a reality. As a prominent deejay, he enjoys unprecedented access to the recording artists responsible for shaping music's most inspiring decade of the twentieth century. Through his camera's eye, the stars become mere mortals and at the same time somehow even grander than before.

An early champion of Elvis Presley's music, Edwards uses his influential radio clout to lead rock 'n' roll music out of the backwaters of the south and into the concrete jungles of the north. He expands

Record Heaven, 4237 Fulton Road, October 20, 1969; Photo by Bill Nehez

radio's frontiers with the "T.E. Newsletter," an innovative industry first, and his color slide shows at record hops best MTV by twenty-five years.

Born Thomas Edward Mull in Milwaukee, Wisconsin, he serves his country valiantly in World War II. Following his discharge from the army in 1945, Tommy proposes to a pretty restaurant hostess he meets in New York City. From the start, it's a tumultuous love affair between two damaged souls. Ann Marie Lengle struggles with the psychological consequences of a botched abortion, while Edwards's horrific wartime experiences saddle him with an obsessive-compulsive desire to make order out of chaos. It might not be a coincidence that the arc of Tommy's radio career mirrors his eighteen-year marriage to Ann. She is his muse, steadfast supporter, and, ultimately, his downfall. Following their divorce in June 1963, Ann suffers a nervous breakdown, and Tommy loses all incentive to continue a career in radio.

He retreats into the semi-reclusive life of record-store proprietor, a job that holds none of the glamour and excitement of those heady days at WERE but still keeps him connected to the ever-changing music scene. The years pass, and a new generation of teenagers, born in the 1960s, begins to collect the records of the 1950s and listen to the stations that play the oldies. These sixteen- and seventeen-year-olds search Edwards out, frequent the record store, and regard him with reverence. They want to know what it was like to hang out with Elvis, Chuck Berry, and Bill Haley. "It was just a job," Edwards tells them, while a smile that beams with pride says otherwise.

It is sad that Tommy isn't around to enjoy this book and the wider recognition that's long been due him. Well, better late than never, T. E. Evelyn Pavella, Tommy's girlfriend just prior to his death, sums it up best: "Music was his life. And he had a great laugh."

Acknowledgments

· ·

I thank Keith Winters for his friendship and his belief in my ability "to make it happen." This book, along with all my other pipe dreams, would not have been possible without the unconditional support of my parents, Madelyn and Jerry. And if it weren't for my sister, Gloria, I wouldn't even be here. Susan Gaspar worked long hours creating an inventory and digitizing Tommy Edwards's extensive archives. Bonny and Bryan Fandrich and Jill and Mark Braithwaite were always ready with words of encouragement. I'm grateful to journalist David Barnett, who not only saved the "T.E. Newsletter" collection from a nasty fate but also graciously offered to share it with me, knowing I'd put the newsletters to good use. Michael Ruffing of the Cleveland Public Library's history and geography department provided invaluable research assistance, as did Sabrina Miranda, Debbie Nunez, and Denise Sanders at the microform center. David Carp, librarian for the Long Island Philharmonic, shed some much-needed light on the mysterious El Boy. I had many informative conversations with Barbara Stepic, president of the Brooklyn Historical Society Museum in Brooklyn, Ohio. John Ansley, head of archives and special collections at Marist College, supplied me with an audio copy of Rick Whitesell's 1981 interview with Tommy Edwards. And I give a big tip of the hat to all the librarians around the country who enthusiastically shared my excitement and came through in the clutch. Our libraries are national treasures, staffed by dauntless seekers of knowledge. Please visit them.

To Joyce Harrison, Will Underwood, and everyone at The Kent State University Press, thank you for showing Tommy Edwards the respect he deserves. Erin Holman was my copyeditor, and I'm a better writer as a result. Terry Stewart, president of the Rock and Roll Hall of Fame, has been my supporter from the start, even meeting me in Wisconsin to share the thrilling experience of viewing the photos firsthand. Marilyn Regan supplied the amazing *Pied Piper* photograph, and Joyce Topping Janicek sent in her 1956 shot of the Tom Edwards Fan Club. (She's the girl in the back row on Tommy's left wearing cuffed blue jeans, white bucks, and bobby socks.) Jerry Immel kindly made available Bill Randle's *Marty Conn Show* interview. Stanley Coutant ably assisted microphone identifications. Chuck Rambaldo at Tommy Edwards Records has done a tremendous job keeping the deejay's memory alive in Cleveland. Writers Rosecrans Baldwin and Hank Whittemore lent their expertise to the cause, and I'm grateful. WERE deejay Carl Reese always took my calls and supplied insightful commentary on Tommy Edwards's personal life, his marriage, and the drama of station politics. My warmest appreciation goes out to all the recording artists and celebrities who graciously shared their stories. To my boys, Milo and Quinn, you amaze me every day with your wonderful zest for life and your cool moves at our 45 rpm record dance parties. And finally, I'd like to thank my beautiful wife, Leslie, for her vision, talents, and endless inspiration.

Index

. .

A page number in bold indicates a main article. A page number in bold italics indicates a photograph.

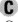